HOW TO SURVIVE
AND PROSPER AS
AN ARTIST

HOW TO SURVIVE AND PROSPER AS AN ARTIST

A Complete Guide
to Career Management

Revised and Updated

Caroll Michels

An Owl Book
Henry Holt and Company **New York**

Library of Congress Cataloging in Publication Data
Michels, Caroll.
How to survive and prosper as an artist.
"An Owl book."
Bibliography: p.
Includes index.
1. Art—United States—Vocational guidance.
2. Art—United States—Marketing. I. Title.
N6505.M46 1988 706'.8 87-15011
ISBN 0-8050-0604-4 (pbk.)

Revised and Updated Edition

Printed in the United States of America

3 5 7 9 10 8 6 4 2

The author is grateful to the following publishers for permission
to reprint the following copyrighted materials:

Watson-Guptill Publications for an excerpt from *The Artist's Guide
to His Market* by Betty Chamberlain. Copyright © 1970,
1975, 1979, 1983 by Watson-Guptill Publications. Reprinted by permission of
Watson-Guptill Publications. Madison Square Press, Inc. for excerpts from
Legal Guide for the Visual Artist by Tad Crawford. Copyright © 1986 by Tad Crawford.
Reprinted by permission of the publisher.
Van Nostrand Reinhold Company for excerpts from *The Professional Artist's Manual*
by Richard Hyman. Copyright © 1980 by Van Nostrand Reinhold Company.
Reprinted by permission of the publisher. *The New York Times*
for excerpts from " 'Sold Out' Performances that
Never Actually Took Place," by Jack Anderson, July 12, 1981.
Copyright © 1981 by *The New York Times*. Reprinted by permission.

ISBN 0-8050-0604-4

CONTENTS

ACKNOWLEDGMENTS

A very special thanks is in order to Annette Rosen and Marleen Finney for all of their help, guidance, and astute feedback. Also to Peter Bejger and Ward Mohrfeld of Henry Holt and Company, Inc., who made the preparation of this book a real pleasure; and to Dieter Klein and Shelia Walsh Booth for their time and efforts in making the project a reality.

A medal of bravery and patience beyond the call of duty goes to Dennis DiCalogero for putting up with my frantic schedule and upside-down existence for several months.

And a big thank you to Mom and Dad, in general.

PREFACE TO THE NEW EDITION

The new edition of this book contains over 350 new organizations, programs, and periodicals, reflecting the proliferation of resources for artists over the last few years.

I have added more resources for artists working in "craft" fields, a term that I reluctantly inserted, as I see no need to differentiate between artists working with oil and canvas, paper and pen, earth, bronze, glass, or clay, et cetera. Unfortunately, since so many artists have been brainwashed to believe that their work is outside of the "fine arts" field, I have used the term "craft artist" as a means of identification.

Resources for the corporate art market have also been expanded. When I originally wrote the book, information and reference materials about this new market barely existed.

Thanks to a very fulfilling and enlightening lecture tour in Canada, which has a highly sophisticated network of organizations, publications, and opportunities for artists, I have included my discoveries in this new edition.

INTRODUCTION

In 1978 I began counseling visual and performing artists and writers on career management and development. I set up my own business and called myself an "artist's consultant."

Ranging in age from twenty-one to over seventy, my clients have included painters, sculptors, graphic artists; poets, playwrights, novelists; cartoonists; journalists; photographers; craft artists; theater and film directors; film and video artists; performing artists; choreographers, dancers; classical, jazz, and pop musicians and composers; and opera singers. They have included well-known artists, unknown artists, emerging artists, mid-life career-changers, artists fresh out of school, and college dropouts.

My clients have also included groups of artists, art administrators, curators, art dealers, corporate art consultants, critics, art organizations, and theater and dance companies. I have assisted a rabbi, a retired executive of Macy's department store, a retired host of a television variety show, a gossip columnist, ex-offenders, and an editor of a leading science magazine.

Although the majority of my clients live in the New York City area, I have helped artists as far west as Oregon, as far south as Arkansas, and as far north as Buffalo, New

York. I have also worked with artists living in Paris, London, and Montreal.

I have advised and assisted artists in developing such basic career tools as résumés; exhibition, performance, and employment contacts and opportunities; grant applications; proposals; public relations and publicity; fund raising; and presentations. I have also counseled on complex and seemingly less tangible career problems, such as developing and focusing on goals; handling rejection as well as success; strategies for cultivating and maintaining art dealer, curator, and critic relationships; and helping artists see themselves in relation to the world at large and as participants in the specific world of art and its various components.

However, the most significant aspect of my work is helping artists find self-motivation and the ability to take control of their own careers.

Calling myself an artists' consultant and "hanging up a shingle" was not an easy task. For valid and comprehensible reasons, deep-rooted skepticism is intrinsic to all arts communities. Initially, it was difficult to reach and convince artists that what I had to say and offer was worthwhile.

I jumped this major hurdle when a writer from *The Village Voice* wrote an article about me and why my services were needed and necessary. It was only one journalist's opinion, but the endorsement was set in type, and I was deemed legitimate!

Literally an hour after the *Voice* article hit the newsstands my life changed drastically. I was swamped with phone calls from artists eager to set up appointments.

Nevertheless, after ten years of counseling artists, I find it is not uncommon to be questioned about why I am qualified to give artists advice. Some of my specific accomplishments are sprinkled throughout this book, cited to make or emphasize a point or convey an experience. I've always been proud that I have been able to live solely

off my earnings as an artist. I have exhibited at museums and cultural institutions throughout the United States and in Europe. I have a solid track record for winning grants and corporate contributions. I developed and implemented all of my own public relations and publicity. And I have been regularly published in newspapers and periodicals.

Managing my own career was something that *no one person* taught me. I learned from several individuals, positive and negative encounters, trial-and-error experiences, and personal intuition. This book contains information and advice derived from these experiences and encounters, as well as those of my clients. I've attempted to offer perceptions, observations, and advice that would have been invaluable to me when I first started to make a career as an artist.

What artists need most is objective advice, but what they usually receive is reinforcement of a myth of what it is like to be an artist. All too often artists are characterized as underdogs, and accordingly this image is reinforced throughout their careers. I can't promise that all of my advice is objective, since my personal experiences come into play, but the incentive to write this book came from realizing how much underdog philosophy was being published under the guise of "nuts and bolts" career management. Much of the reading material flatly states that the way the art world operates will always remain the same and it is naive to try to change it. Other publications are more subtle, but the tone is patronizing: "Yes, artists, you might be creative, talented, and have a lot to give to the world, but there are 'others' who *really* know what is going on, *others who know best.*"

This book addresses artists' roles in advancing and bettering their lot, taking control of their careers, learning to market their work, learning to exercise self-motivation, and approaching and managing their careers as other professionals deal with theirs. In other words, artists should

apply many of the same techniques that other self-employed professionals use to make their careers work.

You will rarely find the word *talent* used in the forthcoming pages. Talent is a subjective judgment, and there is no guarantee that a talented artist will be successful or that a successful artist is talented. When I use the words *success* and *successful* I am referring to the relative level of achievement within a specific category, not the inherent talent of an artist.

Measuring my success as an artists' consultant is very similar to measuring my success as an artist. In both professions I have achieved immediate success, long-range success, and no success. I have received direct feedback, indirect feedback, and no feedback. When I have felt successful about the work I am doing with clients, it has meant that my clients have followed up and used the leads, information, and advice that, for some clients, has resulted in winning grants from foundations, government agencies, fellowships to artist-in-residence programs in the United States and abroad, and invitations to exhibit and perform. Clients have received press coverage and have had their work published. In some instances I have been successful in providing information and advice that was put to immediate use, and in other cases it has taken up to four years to see any new development.

Although many of the examples and anecdotes I use to illustrate or make a point involve visual artists, performing artists and writers will also be able to identify with many of the situations. All artists in all disciplines will get something out of this book.

This book will not provide all of the answers an artist is seeking, nor does it contain everything an artist needs to know about the art world. However, it fills in the gaps that have been omitted, overlooked, or ignored in other publications; it elaborates on subjects that have been inadequately covered and challenges some basic notions about what being an artist is all about. It contains advice,

opinions, and impressions that will not be particularly palatable to members of the art world—*including artists*, the media, funding agencies, patrons, art dealers, administrators, curators, and critics—because it also explores the ills and injustices of the art world and sheds some light on who is to blame.

The art world is in dire need of reforms and structural changes. These changes will not happen overnight, but they *will* happen if more and more artists take control of their careers, reject the image of artists as sufferers, and refrain from practicing a dog-eat-dog philosophy when it comes to competing with other artists.

I recently gave this same lecture to a client who has been seeing me since I began counseling artists. He had been represented by a dealer for over three years, during which time his work substantially increased in sales and in value.

From the beginning of their relationship, much against my judgment, the artist refused to have a written contract with the dealer drawn up. However, the artist accepted and acted upon my advice to learn to market his work, independent of the annual one-person show he received at the gallery. Eventually, he became highly skilled in initiating new contacts and following up on old ones. Both initiatives resulted in many sales.

When the dealer saw what was happening, she added some new stipulations to their verbal agreement, which originally set forth a specified commission on all work sold through the gallery. She began charging "special commissions" for special circumstances, circumstances in which she was not directly involved either in initiating a sale or in doing the legwork or paperwork to make it happen. The artist, who was afraid to challenge the dealer because he felt that it would jeopardize their relationship, conceded to her demands.

I pointed out to the artist that, apart from money, a principle was at stake, and that each time an artist com-

promises a principle, his or her career and the status of artists in general, now and in the future, are set back another notch.

I advised the artist to confront the dealer with a proposal that was more equitable. If the artist must give the dealer a commission on every work sold, even if the sale did not originate through the gallery, the dealer should give the artist something in return, such as a monthly advance against future sales. I pointed out that if the artist had a written contract, chances are the dealer would never have tried to impose an arbitrary commission formula. I also pointed out that the artist had adequately proved his market value and selling power to the dealer, who was deriving steady revenue from the sale of the artist's work, a situation that the dealer would not want to give up easily. *It had not occurred to the artist that he had bargaining power.*

Such occurrences are common in the art world—unnecessary dilemmas and frustrations created by middlepeople who have usurped power from artists and by artists who allow their power to be usurped.

Artists, by the fact they are artists, have power. *Artists provide thousands of nonartists with hundreds of jobs!* For example, dealers, gallery staffs, curators, museum staffs, arts administrators, critics, journalists, corporate art consultants, and advisors; federal, state, and municipal employees; teachers; framers; accountants; lawyers; and art suppliers.

Yet more nonartists than artists make a living from "art," and nonartists make *more* money from art than artists! This inequity exists, as do many others, because artists, the "employers," individually and collectively have not yet recognized their power.

Many of the basic problems of artists trying to enter and sustain a career in the art world are created by artists and their weak and helpless self-image. There is a direct correlation between how artists see themselves and where

art-world power is currently centered. For example, the term "stable of artists" is commonly and casually used by both artists and dealers alike. It refers to the artists who are represented by a gallery, but it implies much more and, unfortunately, as a metaphor it works well. It suggests that artists are like herds of animals that need to be contained in an environment where their master can control their lives.

Another problem in the art world is the fragmentation of the community of artists. There are more artists than ever before, but as the community of artists multiplies it simultaneously divides into different factions, movements, trends, and in-groups. There are artists who segregate themselves into pockets of racial, sexual, and ethnic identity. Everyone is vying for the same bone; no one wants to share it.

On the other hand, some aspects of the artist community are in good shape and are getting better all the time, particularly the headway that has been made in art law, legislation, artists' rights, the opening up of more exhibition and performance opportunities, and the proliferation of general and specialized periodicals, publications, and newsletters on subjects of interest and importance to artists and their careers.

If I didn't believe that there is a lot of room in the art world for many artists to make a decent living, I certainly never would have started a consulting service or written a book about art-career management. There is ample opportunity for artists, even within the still imperfect art world.

The structural changes in the art world will come about only through artist pressure, artist initiative, and artist participation. While the prospects of radically changing the art world might seem overwhelming to any one artist, one of the most important contributions that any artist can make is to *restructure and take control of his or her own career.* The following chapters will elaborate on why

this is important and provide options, suggestions, and advice on how to make it happen.

The addresses of organizations, programs, and publications mentioned in the text are listed in the Appendix of Resources at the back of the book. I have also included my address in the Appendix section "Career Management, Business, and Marketing" in response to the numerous readers who complained that they had a difficult time contacting me, and for future readers who might need some help and advice.

·1·
Launching or Relaunching Your Career

If you walk, just walk, if you sit, just sit, but whatever you do, don't wobble.
—ZEN MASTER UNMON

Head Work: Tuning Up Your Psyche

Being an artist means believing you are an artist. Making a living as an artist necessitates convincing others that you are an artist. It is easier to convince others once you are convinced. But there is no set formula for achieving self-confidence. Some artists are born with it and for others it takes years to achieve. Maximizing creative productivity, mastering self-discipline, and overcoming creative blocks are part of the process. Some artists require massive dosages of positive feedback to maintain self-confidence; others require a teaspoonful from time to time.

As an artist you have experienced the exuberance of creating something you like, which might be the culmination of a direction in your work or might articulate something new. It felt good. The goodness screamed out. You mastered and controlled. The power felt good. Your expectations were rewarded.

However, producing something you like and believe in does not resolve the question of how to use your creation to survive and prosper. For artists, the question is particularly complex because of the difference between survival

and prosperity as defined by artists and those in other professions. For an artist, *survival* often means bare-bones existence, *prosperity* may be keeping your head above water. In other professions, *survival* is keeping your head above water, *prosperity* is success.

THE MYTH OF THE ARTIST

Over many years our society has created a myth about what it means to be an artist. Perpetuated consciously and subconsciously by artists and nonartists, this myth is based on trading off many of the things that other people value for the right to be an artist.

For example, the myth tells us that struggle, complexity, and suffering are necessary components of creativity, and without these key elements an artist will stagnate. The myth tells us that the desire for comfortable lives and financial success will ultimately poison and distort art, that a true artist is concerned *only* with art, and anyone else is a dilettante. The myth tells us that *real* artists do not discover themselves. Other people do, preferably when the artist is dead!

The myth warns us about *selling out*, although the majority of artists who are concerned about this issue are not in a position to sell out, nor are they quite sure what it means.

The myth says that artists are expected to be flamboyant, provocative, moody, weird, or antisocial. Writer and social critic Tom Wolfe suggests that this stereotyped image of the artist was formed at the beginning of the twentieth century, based on the style and behavior of writer and art critic Théophile Gautier. Wolf writes:

> . . . With Gautier's own red vests, black scarves, crazy hats, outrageous pronouncements, huge thirsts, and ravenous

groin . . . the modern picture of The Artist began to form: the poor but free spirit, plebeian but aspiring only to be classless, to cut himself forever free from the bonds of the greedy and hypocritical bourgeoisie, to be whatever the fat burghers feared most, to cross the line wherever they drew it, to look at the world in a way they couldn't see, to be high, live low, stay young forever—in short, to be the bohemian.[1]

The myth suggests that to be antibourgeois, a free spirit, and classless, one should not have an occupation; it implies that being an artist is a state of mind, not an actual job. The myth even casts great doubts on whether being an artist is a valid profession. For example, students in art school receive advice to take a lot of education courses to have something to fall back on. Or students are encouraged to study commercial art in lieu of fine art. Even a book published as recently as 1983 warns, "It is unrealistic, wishful thinking on the part of any fine artist to believe that he is going to earn his living by works of art. Should it happen in the course of time, it would be a great bonanza—but don't count on it."[2] The underlying emphasis is that an artist can seriously dabble in art but shouldn't take it seriously as a profession! If we were educated to believe that being an artist is a valid profession, there would be fewer artists needing an occupational backup. Has a law student ever been advised to take a lot of education courses to have something to fall back on?

Although the cautious advice given to artists comes from people who are trying to be helpful, it is advice based on the experience of people outside of the art community, as well as on hearsay and myths. Other people's reality should not be an artist's, nor can it be.

Believing in other people's perceptions is a disastrous trap. However, artists sometimes find it attractive, hop-

ing that it can shortcut the road to success or shield them from confrontations. Ralph Charell, author of *How to Make Things Go Your Way*, observes:

> If you filter the perceptions you receive through mediators, you deprive yourself of a direct encounter with the event itself. The more you come to depend on the perceptions and opinions of others, the less of yourself you are able to put into the equations of various experiences of your own life. Soon, if the process continues, your life becomes dim and pale and you are eventually at sea, tossed and buffeted, alone under a starless sky, without an internal compass of your own.[3]

To launch or relaunch a career that is earmarked for success, artists must emphatically reject the myth of the artist. The myth, like racial and religious prejudice, is subtle and sneaks up without warning. Do not underestimate the extent to which aspects of the myth can affect, influence, and limit an artist's career.

If artists go along with the myth, they must accept the consequences of leaving their careers in the hands of others. If artists do not develop and expand meaningful goals and act on these goals, their careers will be formed, manipulated, and eventually absorbed by people who have goals that are meaningful only to them. Artists become a means to the ends of others.

ENTERING THE MARKETPLACE

By the fact that an artist wants to sell work, he or she must enter the marketplace, a highly structured world comprised of many networks. There are two ways to enter—haphazardly or with a plan. Unfortunately, most artists enter haphazardly, which means short stays and unhappy endings.

Entering the marketplace with a plan means that your tools are lined up (see the next section) and your psyche is tuned up. How well you tune up your psyche depends on how thoroughly you have rejected the myth of the artist, have developed personal goals, and have been willing to act on these goals and get yourself moving. A good plan also includes having a well-thought-out philosophy about money: as an artist, how much you want to earn, and how much you are willing to spend in order to earn it.

How much is my work worth? How much am I worth? How much do I need this year, this month, this week? What can I afford? How much should I be earning? Thoughts of money are ever present and, depending on one's situation, the thoughts are in the forefront of one's mind or are nestled in the subconscious.

There are artists who have identified with poverty for so long that when money finally comes their way, they are consumed with enormous guilt, a theme that dominates their existence. There are artists who become Little Johnny-One-Notes, churning out whatever made money in the past, in fear that venturing in new directions will bring them back to Poverty City. And there are artists who attach so many stigmas to the concept of prosperity that they undervalue their work, riding the train to martyrdom.

The most common money-related mistake artists make is a reluctance to invest in their own careers. Although artists are willing to spend relatively large amounts of money on work materials and equipment, they are miserly and skimpy when it comes to other important aspects of career development, such as travel, presentations and publicity, and such preventive medicine as hiring lawyers and accountants. Subsequent chapters discuss why these expenditures are important and offer advice on how to raise the money to pay for them.

It simply boils down to this: *If you are not willing to invest in your career, who is?*

Homework: Lining Up Your Tools

The following homework includes basic investments necessary to launch, relaunch, and sustain an artist's career. Some investments require money, some require time, and some require both.

READ, NOTE, FILE, AND RETRIEVE

During the last fifteen years the art trade publications field has expanded and diversified, with each of the art disciplines having at least two or three newspapers, tabloids, and magazines that focus on *real art news* rather than reviews and critical essays. These publications contain valuable information on numerous aspects of the business of art and the business of being an artist, including grant, exhibition, and employment opportunities, legal and accounting advice, health hazards related to the arts, arts-related legislation, et cetera.

There are publications with a regional focus, such as *Artweek*, devoted to artists living in the Northwest, Southwest, Alaska, and Hawaii; *Art New England* and *Art Papers*, geared to artists in the Southeast. There are also publications of national interest, such as *Art and Artists. Discriminating Palette, Artviews*, and the *CARO Bulletin* are some of the publications that serve Canadian artists. In addition, there are periodicals that specialize in various disciplines, such as *American Craft, The Crafts Report, International Sculpture*, and *Afterimage*. The addresses of these periodicals can be found in the Appendix

sections "Career Management, Business, and Marketing" and "Periodicals."

With the plethora of information available, there is no excuse for artists not to be well versed about what is going on in their own profession. Publications, as well as other excellent reference tools, are listed in the Appendix.

Read, note, file, and retrieve—or practice what authors Judith Appelbaum and Nancy Evans refer to as the "pack-rat system."[4] Set up a file and contact system that is imaginative and considers the present and the future. Contacts and information that might not necessarily be of interest or apply to your career now could be important and relevant in the future.

Review the files on a regular basis. Unless you have a photographic memory, you will forget a lot of information that has been clipped out and stored away.

Set up files for various categories, those that make sense and have meaning to you. My file system includes the following categories: grants (visual arts, general arts, performing arts, music, film/video, and writing); artist-in-residence programs; art colonies; international exchange programs; alternative space galleries; museums; corporate art consultants, advisors, curators and collectors; professional art organizations; management organizations; loan resources; consulting services; legal, accounting, and insurance information; employment opportunities; mailing lists; and Percent for Arts programs.

I spend an average of three hours a month in the library updating and adding to the files. Developing the system and organizing and deciphering cryptic notes and messages that I had written over the years took about three weeks of work. It was a mere three-week investment, but it has paid off in many ways. For example, much of the material contained in my files was used to write this book.

AN ARTIST'S RESUME

The purpose of an artist's résumé, like an employment résumé, is to impress the reader with an artist's credentials. The specific purpose of an artist's résumé is to impress gallery dealers, curators, collectors, grant agencies, juries, and anyone else whom artists put in a position to give their careers upward mobility. Since an artist's résumé has purposes other than employment, it requires its own special structure.

Résumés are important because many people are insecure and need to use them to determine whether it is okay to like an artist's work. For example, a gallery dealer must feel secure in order to sell an artist's work to a collector, and a collector needs to feel secure in order to buy it. Thus, a résumé can be a tool to help indecisive people make a decision in an artist's favor.

A résumé should reflect achievements you have made in the arts field. It should not be a thesis about what you hope to achieve or that explains the meaning of your work. Keep résumés pure—free of narratives that justify or describe your work's inner meanings.

If your achievements amount to more than what can be listed on one sheet of paper, use another sheet. Who said that our lives have to be limited to one page? On the other hand, if you have substantial achievements, consider a résumé as a tool that highlights your accomplishments and eliminates minor credits. Use the phrase "exhibition highlights" or "selected exhibitions" to convey that this is only a sampling.

The following are suggestions for structuring a résumé and the order in which categories should be listed:

NAME, ADDRESS, AND PHONE NUMBER.

PLACE OF BIRTH. Places of birth can be good icebreakers. You might share a regional or local background with the reader.

BIRTH YEAR. Artists under twenty-four and over fifty sometimes object to putting their birth year on a résumé in fear of the stigma of being considered too old or too young. If a person is negatively influenced by your age, it is a strong indication that his or her judgment is poor, and you wouldn't want to be associated with that person under any circumstances.

EXHIBITIONS/PERFORMANCES. List the most recent exhibitions/performances first. Include the year, exhibition/performance title, name of the sponsor (gallery, museum, or organization), city, and state. In addition, list the name of the curator and whether it was an invitational or a juried show. (If you won an award, mention it under the "Awards and Honors" category described below.)

If you have had four or more one-person shows, make a special category for "Single Shows" and begin the "Exhibitions/Performances" section of the résumé with this category. Make another category for "Group Exhibitions." If you have had less than four one-person shows, include the shows under the general heading "Exhibitions/Performances," but code the one-person shows with an asterisk (*) so the shows stand out, and note the code on the résumé. For example:

EXHIBITIONS (*Single Shows)
 1986 *Smith Wheeler Gallery, Chicago, Illinois.
 OBJECTS AND IMAGES, Alternative Space Museum, New York City. Curated by Charlie Critic. Invitational.
 SPRING ANNUAL, Hogan Gallery, Detroit, Michigan. Juried. Judges: Peggy Panelist and Joe Jurist.

COMMISSIONS. List projects or works for which you have been commissioned, including the name of the project or medium, the sponsor (institution, company, person, etc.), and date.

COLLECTIONS. List the names of institutions that have purchased your work, as well as corporations, well-known collectors, and well-known people. If you haven't been "collected" by any of the above, omit the category (unless you need to pad the résumé with the names of relatives and friends).

BIBLIOGRAPHY. List all publications in which you have been mentioned or reviewed and any articles that you have written related to art. Include the name of the author, article title, name of the publication, and publication date. If you have been published in an exhibition catalog, include the name of the exhibition and the sponsor. If something was written about you in the catalog, credit the author.

AWARDS AND HONORS. Include grants or fellowships you have received. List any prizes or awards you have won in exhibitions or competitions. Include artist-in-residence programs or any other programs that involved a selection process. If you won an award that was associated with an exhibition, repeat the same information that was listed in the "Exhibitions/Performances" category, but begin with the award. For example:

> First Prize. Sculpture, SPRING ANNUAL, Hogan Gallery, Detroit, Michigan. Juried. Judges: Peggy Panelist and Joe Jurist, 1986.

LECTURES/PUBLIC-SPEAKING ENGAGEMENTS. Use this category to list any lectures you have given and/or radio and television appearances.

EDUCATION. This should be the *last* category. Many artists make the mistake of listing it first. This suggests that the biggest accomplishment in your life was your formal education!

The following is a sample résumé.

Terry Turner
15 West Main Street
Yourtown, U.S.A. 12000
500-832-4647
Born: Washington, D.C., 1958

SELECTED EXHIBITIONS (*Single Shows)

1987 WINTER INVITATIONAL, Whitehurst Museum, Whitehurst, Illinois. Curated by Midge Allen.

OBJECTS AND IMAGES, Alternative Space Museum, New York City. Curated by John Hope.

1986 *Smith Wheeler Gallery, Chicago, Illinois.
SPRING ANNUAL, Hogan Gallery, Detroit, Michigan. Juried. Judges: Peggy Panelist and Joe Jurist.
ILLUSIONS, Piper College, Lakeside, Pennsylvania. Curated by Abraham Collins.

1985 *Pfeiffer Gallery, Düsseldorf, West Germany.
*Limerick Gallery, San Francisco, California.
TEN SCULPTORS, Kirkwood Park, Denver, Colorado. Sponsored by the Denver Arts Council. Invitational.

1984 PITTSBURGH BIENNIAL, Pittsburgh Cultural Center, Pittsburgh, Pennsylvania. Curated by Mary Clark and Henry North.
HANNAH, WRIGHT AND TURNER, Covington Gallery, Houston, Texas.

1983 THE DRAWING SHOW, traveling exhibition organized by the Southwestern Arts Center, Tempe, Arizona: Seattle Museum, Seattle, Washington; Minneapolis Museum, Minneapolis, Minnesota; Virginia Museum, Richmond, Viginia; and Miami Museum, Miami, Florida.

COMMISSIONS

Outdoor sculpture, Plymouth Airport, Plymouth, Massachusetts. Sponsored by the Plymouth Chamber of Commerce. 1986.

Mural, Bevington Department Store, New York City. Sponsored by the Bevington Corporation. 1985.

Outdoor sculpture, Hopewell Plaza, Chicago, Illinois. Sponsored by the Downtown Citizen's Committee in conjunction with the Chicago Arts Council. 1974.

PUBLIC COLLECTIONS

Whitehurst Museum, Whitehurst, Illinois.
Pittsburgh Cultural Center, Pittsburgh, Pennsylvania.

CORPORATE COLLECTIONS

Marsh and Webster Corporation, New York City.
Avery Food Corporation, New York City.

BIBLIOGRAPHY (*Reviews)

Nancy Long, "Winter Invitational at Whitehurst Museum," *Museum Quarterly*, Winter 1987.

*John Short, "Emerging Artists Featured at Whitehurst Museum," *Whitehurst Daily News*, January 16, 1987.

Midge Allen, *Winter Invitational Catalog*, Whitehurst Museum, Whitehurst, Illinois, 1987.

*Bradley Mead, "Terry Turner Opens at Smith Wheeler Gallery," *Chicago Artist News*, February 1986.

Beth Ryan, "Ten Sculptors Show at Kirkwood Park," *Sculptor's Monthly*, June 1985.

Mary Clark and Henry North, *Pittsburgh Biennial Catalog*, Pittsburgh Cultural Center, Pittsburgh, Pennsylvania, 1984.

AWARDS AND HONORS

First Prize. Sculpture. SPRING ANNUAL, Hogan Gallery, Detroit, Michigan. Juried. Judges: Peggy Panelist and Joe Jurist, 1986.

Fellowship. Denver Arts Council, Denver, Colorado, 1986.

Fellowship. Minerva Hills Artist Colony, Minerva Hills, Montana, 1985.

Second Prize. Sculpture. International Sculptor's Competition, Essex, Ontario, Canada, 1984.

Project Grant, Pittsburgh Cultural Center, Pittsburgh, Pennsylvania. Juried, 1983.

LECTURES/PUBLIC-SPEAKING ENGAGEMENTS

Lecture, Pratt Institute, Brooklyn, New York, 1987.

Lecture, Art Department, University of Colorado, Boulder, Colorado, 1986.

Interview, "Culture Hour," WRST-TV, Detroit, Michigan, 1986.

Lecture, Covington Gallery, Houston, Texas, 1984.

Interview, "The Drawing Show Artists," WXYZ-Radio, Tempe, Arizona, 1983.

EDUCATION

Art Department, Ross College, Huntington, Iowa. B.F.A., 1981.

Thin Résumés

Few of us can begin careers with heavyweight résumés, full of fancy exhibition/performance credits and citing articles and reviews in leading publications. But the anxiety of having a thin résumé should not prevent you from putting a résumé together. I like the reaction of a painter whom I was assisting with a résumé. She studied the various category headings and replied: "How exciting. I can't fill in all of these categories, but look at all of the things I can look forward to."

While it is not advisable to pad résumés with insignificant facts and data, a few things can be done to fill up a page so that a résumé does not look bare. For example, double-space between each entry and triple-space between categories. Use "Collections" to list the names of any well-known people or institutions who have your work, even if they did not purchase it. Include student shows under the "Exhibitions/Performances" category and use "Awards and Honors" to list any scholarships or teaching assistantships you have received in graduate or undergraduate school. If you have teaching experience in the arts, list this experience under a new category, "Career-Related Experience" or "Teaching Experience."

Updating Résumés

The following advice might sound silly, but artists are often very negligent about résumés: as career changes and accomplishments occur, update your résumé. If you have been invited to participate in an exhibition/event in the future, add a new category to the résumé, "Forthcoming Exhibitions." If an article is planned in the future, add a new category, "Forthcoming Articles."

A painless, time- and cost-effective way of updating a résumé is to have it word-processed on a computer. Once the information is stored, a résumé can be updated in a matter of minutes.

Excerpts from Publications

If you have received good reviews, excerpt the most flattering quotes on a separate sheet of paper and attach it to your résumé. Credit the author, article, publication, and give the date. If you have not been published in a periodical but have been included in an exhibition catalog that contains prose about your work, include the relevant quotes on a separate sheet of paper, credit the author, and give the exhibition title, sponsor, and date. Although many artists present an entire article, unless the key sentences or thoughts are *underlined*, chances are the article will not be read.

Biographies

A biography is a synopsis, written in prose, of your career accomplishments. It highlights various credits listed on your résumé. In certain instances, a bio is used in lieu of a résumé, such as a handout at exhibitions and to accompany a press release (see page 38). (The narrative style makes it easy for a writer to include biographical information.) A biography can also be used to accompany a résumé when you are submitting slides to dealers, curators, and corporate art consultants and advisors. Following is an example of a biography, based on the sample résumé on pages 10–12:

Terry Turner was born in Washington, D.C., in 1958. She has had one-person shows at galleries in the United States and in Europe, including the Smith Wheeler Gallery, Chicago; the Limerick Gallery, San Francisco; and the Pfeiffer Gallery, Düsseldorf, West Germany.

Ms. Turner's work has been featured in several group shows at museums and cultural centers, including the Whitehurst Museum, Whitehurst, Illinois; Piper College, Lakeside, Pennsylvania; and in "The Drawing Show," a traveling exhibition which toured major museums throughout the United States, organized by the Southwestern Arts Center, Tempe,

Arizona. In addition, her work is in public and corporate collections, including the Pittsburgh Cultural Center and Avery Food Corporation, New York City.

Ms. Turner is the recipient of numerous awards and honors. In 1986 she received fellowships from the Denver Arts Council and the Minerva Hills Artist Colony, Minerva Hills, Montana. This year, she won first prize in sculpture at the Hogan Gallery's Spring Annual, in Detroit, Michigan.

Ms. Turner attended Ross College, Huntington, Iowa, and received a B.F.A. in 1981.

As with a résumé, a biography should not be a thesis to explain the meaning of your work. Save this exercise to prepare an artist statement.

Artist Statements

An artist statement can be used in several ways: as a tool to help dealers and corporate art consultants and advisors sell your work; and as background information in helping writers, critics, and curators prepare articles, reviews, and exhibition catalogs. In addition, an artist statement can be incorporated into grant applications (see Chapter 7).

An artist statement can focus on one or more topics, such as the meaning, purpose, or philosophy behind your work, materials and techniques, and a particular theme or issue underlying your work. Avoid using negative phrases, such as "I am attempting" or "I am trying," which reflect insecurities, confusion, or unsuccessful feelings. The statement should be coherent and to the point.

MAILING LISTS—THE USUAL AND ESOTERIC

Starting and developing a good mailing list requires a lot of time and energy, but it is well worth the effort. As with a file/contact system, a mailing list can and should

be used over and over again. It should be updated on a regular basis to reflect the changes you are making in your career (new contacts) and the ever-changing scene in the art world (e.g., the names usually stay the same, but the institutions and organizations might fluctuate). A good list implies quality more than quantity, meaning that your list should include the names and addresses of people who can do something for your career—directly or indirectly—now or in the future.

Do not wait until you need to use a mailing list to put one together. Develop a list when "nothing's happening" so that when something happens it will not become one of the thousand other chores you have to do in connection with exhibition/performance planning.

It is common practice for artists to buy mailing lists from arts organizations and galleries. I have screened many such lists and find that they are rarely (if at all) updated and contain many duplications. In addition, gallery lists tend to include everyone who has signed the gallery guest book, which does not necessarily mean that all the people are of interest to you. Other artists' lists include other artists' contacts, contacts that, again, might be of no use to you. Particularly in view of the rising cost of postage, a mailing list should be well screened.

In the long run it is best to start a list from scratch because you will then have total control of the contents. Start off with the following categories:

FANS AND COLLECTORS. Include anyone who has purchased or expressed interest in purchasing your work.

GALLERIES AND ALTERNATIVE SPACES. Be selective. Many galleries specialize in certain styles, periods, and disciplines (as well as ethnic groups, gender, etc.). Include the galleries that are relevant to you.

MUSEUMS. Include the names of curators that are associated with your particular discipline (e.g., photography, sculpture, drawing, painting, etc.). Their names, addresses, and areas

of expertise are listed in the *American Art Directory* (see "General Arts References" in the Appendix).

DOMESTIC AND INTERNATIONAL ART PUBLICATIONS. Include the names of editors and associate editors. Also note the names of contributing editors, but send material to their home address or to the publication where they spend the most time. For example, if a contributing editor writes for daily, weekly, and monthly publications, chances are that he or she spends more time at the office of the daily or the weekly (see "Periodicals" in the Appendix).

INTERIOR DESIGN AND ARCHITECTURE PUBLICATIONS. Again, include the names of editors and associate editors. Also note the names of contributing editors, but send material to their home address or to the publication where they spend the most time (see "Interior Design and Architecture" in the Appendix).

TRADE PUBLICATIONS. This is one of the most underexplored areas of artists' mailing lists. Trade publications often include articles about new and unusual uses of the materials that they promote. For example, if you are a sculptor working with glass, include the names of trade publications in the glass industry. The names of trade publications can be obtained from *The Encyclopedia of Associations* and *Writer's Market* (see "General Arts References" in the Appendix). It is highly conceivable that articles in trade publications can lead to corporate commissions, acquisitions, and sponsorships.

NEWSPAPERS. Include the names of feature and news editors and journalists who write about the arts.

CRITICS. This is one category where I suggest a mailing-list duplication. Include, if possible, a critic's home address as well as the address of the publications for which the critic most frequently writes. That is, if a critic writes for a daily newspaper and a monthly art journal, include the name of the daily newspaper.

CORPORATE CONSULTANTS/ADVISORS, GALLERIES, AND CURATORS. (See "The Corporate Art Market" in Chapter 4.) The

names of corporate consultants/advisors and galleries can be found in the Yellow Pages under "Art Consultants"; in the index of *Art in America Annual Guide to Galleries, Museums and Artists* (see "General Art References" in the Appendix); and in *The Corporate Art Advisors Directory* (see "Corporate Art" in the Appendix). Fortunately, there is an excellent source to obtain the names of corporate curators, the *Directory of Corporate Art Collections* (see the "Corporate Art" section of the Appendix).

INTERIOR DESIGNERS AND ARCHITECTS. Include the names of interior designers and architects you personally know, and use your list of interior design and architecture publications to reach this group. In addition, the names of architects and interior designers in your area can be obtained through local chapters of the American Institute of Architects and the American Society of Interior Designers (see "Corporate Art" in the Appendix).

TELEVISION AND RADIO STATIONS. Include the names of news people who cover cultural events, as well as the names of producers, directors, and hosts of cultural programs.

HOMETOWN NEWSPAPERS. If you are living in a place other than where you were born or raised, include the names of newspapers in your hometown. (Write a cover letter to accompany any material that is sent, pointing out that you are a native of the area.)

ALUMNI PUBLICATIONS. Include the name(s) of alumni publications issued by the college or university you attended. (Send a cover letter with any material you send them, pointing out that you are an alumnus.)

FOUNDATIONS AND ARTS COUNCILS. Include the names of officers and directors of foundations where you have applied for grants or are planning to apply. Include the names of key personnel in your discipline in local and state arts councils.

FREE LISTINGS. Include the names of publications that offer free listings to announce an exhibition, performance, or cultural event.

Buying Mailing Lists

Under certain circumstances you might want to purchase a mailing list to reach certain markets. For example, Unique Programs sells specialized mailing lists for artists that include a regional breakdown of galleries that exhibit contemporary work; art competitions and exhibitions; museums and university galleries; corporate collectors; and art publishers. Resources Mailing Lists sells numerous lists that include foreign art organizations; foundations; granting agencies; press and publicity; and patrons of experimental art. The addresses of these companies and other resources are listed in the Appendix section "Mailing Lists."

SLIDE/PHOTO PRESENTATIONS

The slide/photograph viewing system was designed in the best interests and for the convenience of dealers, curators, and jurists, not for artists. After a work is completed, an artist has the burden of creating an "artificial" viewing situation to show the work in such a way that it looks good in a photograph or slide, which (unless the work happens to be a photograph) is not the way it was intended to be viewed or experienced. Often, because of the importance placed on good photographs, an artist is guided and influenced during the creation process by how well the work will photograph!

There are very few dealers and curators who will view original work at a first meeting. Thus, most artists are stuck with the slide/photograph system. Here are some pointers on how the system can work best for you.

Photograph your work yourself only if you can really do it justice. If not, use a photographer experienced in art photography. Decide before the shooting how you want the work to look in a photograph and what features you

want emphasized. If the final result falls short of your expectations, reshoot, and, if necessary, continue to reshoot until you have what you want. If your work contains details that get lost when the piece is photographed as a whole, shoot separate photographs of the details you want emphasized or clarified.

Since you are going through the time and expense of a photography session, shoot in color and in black and white. Color slides and prints can be used immediately (for dealers, curators, grant applications, slide registries, etc.). Black-and-whites, as well as color prints, can be used later for public relations and press packages (see page 47 for requirements).

Since slides and photographs are the lures to get dealers and curators to see the work in person, if they are unimpressed with the work via photographs, it is unlikely that they will get to your studio. However, for photographic purposes, do not glamorize a piece of work with special effects that misrepresent what the viewer will actually see in person. Ultimately, the deception will catch up with you.

When I discussed the slide system with a curator, she said that artists tend to submit many more slides than are necessary, and without discrimination. If you have never had your work photographed, shoot all of the work, but reserve the older work for personal documentation and future use. Dealers and curators are interested in your current direction and do not want to see a slide retrospective at the first meeting. It is also important that you *show slides of only one medium.* If you paint and draw, show slides of your paintings or drawings, but not both. This advice sounds strange, and it is, but dealers, curators, and jurists want consistency. Keeping art media separate is part of their definition of consistency! However, you can work around this illogical rule by showing one dealer slides of paintings and another dealer slides of drawings.

What you show to whom depends on your research of galleries, including what kind of work they are showing and what kind of work a particular curator is interested in.

Although a dozen to twenty slides are recommended for presentations, do not take this rule of thumb as gospel. If you fall short of a dozen, don't wait until you have twelve to start showing the slides around. Twelve is not a magic number, and you can get feedback with fewer slides.

One of the biggest problems with slides is that many people do not really know how to read them. Therefore, a viewer should be spoon-fed. All slides and photographs should be *labeled* with the dimensions of the work, the medium, the title (if any), your name, and the date. Notations should be made on the frame or margin to indicate the direction in which the slides or photographs should be viewed. It is intimidating for a viewer to have to hem and haw over the right way to view work. Their embarrassment can create a negative atmosphere, meaning that your work is not being viewed under the best circumstances, and this can lead to a negative response.

Another effective way of presenting work in photographic form is to enlarge some of the slides to at least 5" x 7" color prints or use large transparencies. This helps to eliminate doubt about whether a viewer can read the slides. Transparencies are excellent for this purpose.

Make a minimum of a dozen duplicate sets of the slides. The greater the number of slides in circulation, the greater the chances that something positive will happen.

VIDEOTAPES

In some instances, using a videotape to present work is a successful alternative to slides and photographs. It is particularly advantageous to sculptors. Dancers and per-

formance artists have been using video for a number of years. However, the use of video as a presentation tool is limited to the galleries, museums, funding agencies, et cetera that are equipped with video equipment.

RESEARCH AND RESOURCES

Become aware of all of the numerous local, regional, national, and international arts service organizations, and take advantage of their various programs, services, and publications. Throughout the Appendix, many service organizations are listed that have a national or international focus.

For example, the Foundation for the Community of Artists (see the "Arts Service Organizations" section of the Appendix), based in New York, provides many excellent and unique services for visual and performing artists and writers throughout the United States. Many of its programs and services are described and referred to throughout this book. The National Association of Artists' Organizations' *Directory of Artists' Organizations* (also listed under "Arts Service Organizations" in the Appendix) lists many of the organizations that offer assistance to visual and performing artists, writers, and filmmakers, with detailed information on services, publications, programs, and facilities. In addition, *International Resources for Canadian Artists*, published by Visual Arts Ontario (see "General Arts References" in the Appendix) lists opportunities for all artists, not only Canadian, throughout the world.

Cultural Directory II (listed under "General Arts References" in the Appendix), published by the federal government, details information on all of the programs that federal agencies offer in the arts and humanities. Although many artists are familiar with the National Endowment for the Arts and the National Endowment for the

Humanities (see Appendix, "Grants"), other government agencies provide and sponsor arts-related programs—such as the Department of Justice's Artist-in-Residence Program (see Appendix, "Employment Opportunities" and "Art Colonies, Artist-in-Residence, and Exchange Programs").

Arts service organizations have also been organized to serve the needs of special interest groups, for example, the Disabled Artists Network, Deaf Artists of America, Inc., the Association of Hispanic Arts, Inc., the National Center on Arts and the Aging, and Women in the Arts Foundation, Inc. The addresses of these and other arts service organizations are listed in the Appendix section "Arts Service Organizations."

More Homework: Down to the Basics

KNOW THE LAW

Twenty years ago a friend of mine lost approximately 150 paintings in court. He gave his work to a Washington, D.C., gallery owner on consignment, without a receipt or any form of written agreement.

After six months he asked to "borrow" some of his paintings in order to enter a juried show. The dealer said that she didn't have his paintings and didn't know what he was talking about.

The artist hired a lawyer. It took another six months for the case to go to court. The day of the trial the dealer brought a majority of the lost paintings to the courtroom. She had a simple explanation: she told the judge that the artist had given her all of the paintings as a *birthday present*. The judge believed her. She was free to keep the paintings and do with them what she wished. Case dismissed.

With new legislation and changes in laws that protect artists from being victimized, much has changed in twenty years. But undoubtedly a day does not pass that some artist is ripped off by an opportunist or discovers a hitch in what seemed a straightforward deal. *The majority of new legislation will not do an artist any good unless he or she bones up on the legal rights of artists and understands how these rights affect or may affect an artist's work and career.*

"Artists should never feel intimidated, helpless or victimized. Legal and business considerations exist from the moment an artist conceives a work or receives an assignment. While no handbook can solve the unique problems of each artist, the artist's increased awareness of the general legal issues pertaining to art will aid in avoiding risks and gaining benefits that might otherwise pass unnoticed,"[5] writes Tad Crawford in his book *Legal Guide for the Visual Artist,* which should be on the top of your list of books to buy. This book is written in down-to-earth language and covers a comprehensive range of subjects that should be near and dear to an artist's heart, including copyright, wills and estates, sales by galleries and agents, income taxation, studies and leases, et cetera. It includes examples of sample contracts and agreements for a vast number of situations that an artist might and probably will encounter.

Legal Guide for the Visual Artist is among several publications available that zero in on the nitty-gritty of art law. It would be superfluous for me to paraphrase or try to cover the ground that has already been covered by people far more experienced and knowledgeable on the subject. However, the "Law" section of my Appendix provides a solid list of references, both publications and organizations. Many of these publications and organizations provide sample contracts, as well as advice for numerous arts-related legal situations. If you require additional information before a contract is signed, or if

you find yourself in the unfortunate situation of needing legal advice after an agreement has been consummated, or for whatever reasons, there are many excellent places to turn.

Not being able to afford a lawyer is no longer a valid excuse! For example, Volunteer Lawyers for the Arts, in New York City, offers free legal consultation and legal services, at minimal administrative fees, to artists and nonprofit organizations. Over forty Volunteer Lawyers for the Arts programs are located throughout the United States (see the "Law" section of the Appendix).

In addition, law clinics are sprouting up all over the country, which offer legal advice and services at reasonable fees. The National Resource Center for Consumer Legal Services will supply you with a list of legal clinics in your area.

Last, but certainly not least, an important collection service is offered to artists by the National Artists Equity Association in conjunction with ANPA/CBI (Credit Bureau, Inc., a subsidiary of the American Newspaper Publishers Association). The service will collect on any amount of money owed to artists for sales or commissions. In return, an artist pays ANPA/CBI 20 percent of any payment that results. ANPA/CBI will pursue legal action when necessary.

For the address of the National Artists Equity Association Collection Service as well as other legal resources mentioned above, see the Appendix, "Law."

COPYRIGHT

Without a copyright, once a work of art enters the public domain, the artist loses all rights to that work. This means that if a work of art is sold or exhibited without a copyright it can be freely published and reproduced. The artist has nothing to say about it and is not eligible for any kind

of financial remuneration. Therefore, it is imperative that all work have a copyright.

The 1978 Copyright Act has made copyright procedures very simple. It is not retroactive, so all copyright transactions prior to January 1, 1978, are governed by the old law. But the 1978 law is straightforward and easy to comply with. Simply stated, *all artworks are protected by copyright as soon as the work comes into being* as long as an artist places on the work a copyright notice. This consists of writing "Copyright," "Copr.," or ©, the artist's name, and the year conceived. The copyright lasts for the duration of the artist's life plus fifty years.

Copyright protection is available to artists working in every medium, including printing, photography, painting, sculpture, drawing, graphics, models, diagrams, film, tapes, slides, records, compositions, et cetera. There are special copyright laws for audiovisual materials.

Although you are not required to formally register your copyright, there are certain advantages that mainly concern your rights if anyone tries to infringe on your copyright.

All of the ins and outs of copyright and how it affects the visual and performing arts are comprehensively covered in *The Visual Artist's Guide to the New Copyright Law* by Tad Crawford. In addition, a *Copyright Information Kit* can be obtained free of charge from the Copyright Office (see under "Law" in the Appendix).

ACCOUNTING

Closely allied to the subject of law is accounting—your tax status or lack of status, whichever may be the case.

A few years ago I was invited to speak at a conference dedicated to the business of being an artist, sponsored by a college in an affluent suburb of New York City. The audience was comprised of artists from the area, and

from the tone of questions and concerns I quickly ascertained that this was not a group of full-time artists but rather of the "Sunday-painters' " milieu. The college had also invited guest speakers from the visual and performing arts and from the publishing industry. During the discussion period I was surprised to find that the person who received the most questions was the guest accountant, and from the level and content of questions it was easy to tell that this audience was very abreast of tax laws governing artists, particularly those related to deductions.

This situation is quite a contrast to the attitude of the many full-time artists I am in touch with. How often I encounter serious and devoted artists who are living underground as far as the IRS is concerned, afraid to prepare a tax return for fear they will have to pay taxes on meager earnings. It is ironic that the artists who probably have the hardest time proving themselves "professional" versus "hobby" artists in the eyes of the IRS are the ones most up-to-date and knowledgeable on tax issues.

I am not going to expound on the morality or virtues of paying or not paying taxes, but what is of concern is that too many artists are spending too much energy agonizing over taxes, energy that takes them away from being artists.

One of the reasons artists are squeamish about taxes is the deep-seated myth that being an artist is not a valid occupation and the government will tax an artist in an arbitrary way. The fact is that the occupation of artist has been duly recognized by the IRS for a number of years, and most specifically in the 1969 Tax Reform Law.

"An artist actively engaged in the business or trade of being an artist—one who pursues art with a profit motive—may deduct all ordinary and necessary business expenses, even if such expenses far exceed income from art activities for the year,"[6] writes Tad Crawford in *Legal Guide for the Visual Artist*. "The regulations set forth

nine factors used to determine profit motive. Since every artist is capable, in varying degrees, of pursuing art in a manner which will be considered a trade or business, these factors can create an instructive model. The objective factors are considered in their totality, so that all the circumstances surrounding the activity will determine the result in a given case. Although most of the factors are important, no single factor will determine the result of a case."[7] (The nine factors are listed in Crawford's book.)

Federal tax laws frequently change, and many of the changes directly affect artists. The Tax Reform Act of 1987 will have an adverse affect on artists in many ways. For example, income averaging (which was very helpful to artists whose income varied widely from year to year) has been abolished. Under the old law a business had to be profitable two out of five years to avoid being treated as a hobby. Under the new law the business has to be profitable three out of five years; and the new law makes it tougher for self-employed artists to take their home-office expenses as a deduction. This deduction cannot exceed an artist's net income from the art business, as opposed to the gross income limit under the old law, and the portion of home space claimed as an office or studio must be used *only* for the art business, and on a regular basis.

Some business-related tax deductions artists should be aware of include insurance premiums; studio and office equipment; telephone bills and telephone answering service; attorney's and accountant's fees; dues in professional organizations; books, publications, and professional journals; admission charges to museums and performances; protective clothing and equipment as well as associated laundry bills; commissions paid to dealers and agents; promotion expenses, including photographs, ads, résumés, and press releases; repairs; training and education expenses and tuition for courses that improve or

maintain skills related to your profession; shipping and freight charges; the cost of business meetings (such as meals) with agents, patrons, professional advisors, dealers, et cetera, regardless of whether the relationship is established or prospective; business gifts; and automobile expenses for traveling to an exhibition or performance, delivering or picking up work at a gallery, purchasing supplies, driving to courses and seminars, et cetera.

These are only some of the tax deductions that affect artists. The list certainly is not all-inclusive, and many of the deductions listed above are qualified with special rules and regulations governing their application. Because of the intricacies involved in knowing tax regulations and tax-law changes, if you personally do not keep abreast of the ins and outs and changes, it is very important to *maintain a relationship with an accountant who specializes in the tax problems of artists.*

"You can, through reading, taking courses, and asking others, operate a business without the aid of an accountant, but you'll be like the man who doctors himself: You'll never be certain you're doing right until you get sick,"[8] writes Richard Hyman in *The Professional Artist's Manual.* This book provides an excellent chapter on bookkeeping, with examples of completed ledger sheets. Hyman writes, "An accountant can analyze your business, organize it properly, and set up a bookkeeping system. He can oversee your affairs at regular intervals, provide ongoing, up-to-date advice, help with your taxes, forestall and assist with audits, show legitimate ways to avoid the unnecessary payment of taxes, and help prevent costly or even disastrous errors."[9]

I had been doing my tax returns for years without the aid of an accountant and I always managed to get some taxes refunded, but it was not until I used an accountant that I received a very sizable refund, based on monies that should have been refunded in three previous years.

Accountants who specialize in the arts often advertise

their services in art trade publications, such as the ones listed in the "Periodicals" section of the Appendix. If you are unable to find an accountant through a good recommendation, do not hesitate to ask the accountant you do find for a list of references of artists whom he or she has helped in the past. Check out the references to make sure that the clients have been satisfied customers.

Arts service organizations can recommend an accountant or even provide assistance. For example, the Foundation for the Community of Artists (see under "Arts Service Organizations" in the Appendix) offers a financial service for artists, including tax preparation, pension planning, financial advice, and bookkeeping systems.

INSURANCE: INSURING YOUR HEALTH, WORK, AND FUTURE

Health Insurance

One of my clients broke his leg and was in the hospital for three weeks and then was an outpatient for several more weeks. During the first week he was hospitalized he learned that he had won an art competition, with a cash award of $5,000. But his jubilation over the award was eclipsed when he also learned that his bare-bones hospitalization policy (a so-called fringe benefit of the college where he was teaching) would pay only meager benefits toward his hospital bills and doctors' fees. Thus, his entire cash award had to pay the bills.

One could elaborate for pages about similar and even worse stories involving artists who do not have health insurance or who are not adequately covered. For many years artists were subjected to exorbitant *individual* rates for health insurance. They were ineligible for *group* rates because of the nature of being a self-employed artist, a unit of one. However, times have changed, and there is no longer an excuse for an artist not being adequately

covered by health insurance. Many arts organizations throughout the United States offer group plans. Some of the national organizations that offer group rates to members include the American Craft Council, the American Institute of Graphic Arts, National Artists Equity Association, College Art Association of America, the Foundation for the Community of Artists, and Chicago Artists Coalition.

Additionally, National Home Life Assurance Company of New York offers a supplemental hospital protection plan, which is excellent for self-employed persons. If you are hospitalized, you are paid in addition to other plans that you might have. Payment begins the very first day you are hospitalized for accidents and after three days for illness. The premiums are very reasonable, and the money is sent directly to you.

The addresses of National Home Life Assurance Company of New York and of other organizations mentioned above are listed under "Insurance and Medical Plans" in the Appendix.

Artists' Health Hazards

Before leaving the topic of health, it is important to raise the subject of health hazards to artists, a relatively new area of study, because it has only been recently recognized that various materials that are used by artists are directly responsible for a multitude of serious health problems, including cancer, bronchitis, and allergies.

Solvents and acids used by printmakers are responsible for many health problems; dirt and kiln emissions have created problems for potters; resins and dirt that are in a sculptor's working environment, and gases and vapors used in photography are also responsible for various ailments. Toxic chemicals in paints are directly linked to cancer, including pigment preservatives used in acrylic emulsions and additives such as those used to protect acrylic paints during freeze-thaw cycles. In addition, im-

proper ventilation is a common abuse, and its side effects are directly responsible for temporary discomfort as well as permanent damage.

Artists in the performing arts are also directly affected. Toxic chemicals are found in concert halls, theaters, on stage, in dressing rooms, makeup rooms, et cetera. Health problems are created by such things as poor ventilation, certain types of aerosols, acrylics, and plastics used in sets and costumes; and by photographic chemicals, asbestos, sawdust, gas vapors, dust, and machine oil, to mention a few.

If you are not already aware that the materials you might be using in your studio or work environment are considered taboo, it is time to investigate.

The Center for Occupational Hazards is a national organization that disseminates information on the hazards of arts and crafts materials. The center also publishes *Art Hazard News*. The executive director of the center, Dr. Michael McCann, has written an important book, *Artist Beware—The Hazards and Precautions in Working with Art and Craft Materials*.

Additional information about the above-mentioned resources is listed under "Health Hazards" in the Appendix.

Studio and Work Insurance
Until recently, artists who tried to obtain insurance for their studio or work embarked on an exercise of frustration. Information was scarce, and if and when insurance was available the costs of premiums were prohibitive.

However, in 1981, "all-risk" insurance policies were inaugurated, specifically designed for artists and their particular needs. "All-risk" policies, for example, include those developed by National Artists Equity Association and the International Sculpture Center (see "Insurance and Medical Plans" in the Appendix).

The National Artists Equity Association's policy in-

sures artwork created by the insured (paintings, drawings, sculptures, etchings, and similar works) during the course of completion; or work that has been completed and is being held for sale; or work that has been sold but not delivered. The policy also covers artists' materials, tools, and supplies. It does not cover studio furniture, an art library, or works of art by others in your possession or care.

The policy insures against risk of direct physical loss or damage to the insured property, with the following *exceptions*: wear and tear, inherent vice, latent defect, gradual deterioration, insects, vermin, mechanical breakdown, and damage sustained because of or resulting from any process or actual work upon the property; breakage of fragile property; extreme temperature, war risks, nuclear radiation, and weather exposure; delay or loss of market or use, unexplained loss, mysterious disappearance, inventory shortage, or loss or damage from fraudulent, dishonest, or criminal acts; loss or damage occurring in transit by mail, except registered mail; and theft from any unattended vehicle (but not applicable to property in the custody of a public or common carrier).

The policy covers insured work on your premises, on exhibit, and in transit within and between the United States, its territories or possessions, and Canada. There is a $250 deductible for each claim. The minimum amount of insurance you can purchase is $15,000.

The International Sculpture Center offers insurance that covers artwork and work in progress in your studio, in transit, and on exhibition. It covers your artwork as well as that of others you may have in your possession. Perils covered include fire, windstorm, breakage, theft, collapse, riot, vandalism, explosion, hail, water (including flood), earthquake, collision, et cetera. There is a choice of deductibles that applies per loss. Commissioned work is insured at the full commissioned price.

Pensions Plans: Insuring Your Future

Not everyone is going to retire. Some of us reject the notion on principle, and others will not have any choice in the matter because they will not have stored up a nest egg. If you are heading for the latter category, or fall into the first category and are forgetting that bad health might necessitate a change in your plans, or if you are in neither category and basically haven't thought about retirement because you are just getting started, consider this: artists can now participate in pension plans, a fringe benefit once bestowed only to members of society who were willing to devote most of their lives to working for someone else. Now there are pension plans for self-employed persons that *offer financial security for your future.* All of the interest earned on pension-plan funds is not taxable until you retire and begin to use the money.

The Keogh Plan is for self-employed persons. With it you can invest and deduct from your taxable income up to 15 percent of your adjusted income until the ceiling of $7,500 is reached. A certified public accountant explains it this way: "If you earned $20,000 after all business expenses were deducted, you could invest and deduct $3,000, making your taxable income $17,000. If you are single, your tax on the $20,000 would be $3,829, but with the Keogh pension plan your tax is only $2,913, a savings in tax of almost $1,000. The government is actually paying you the $1,000 to invest. . . . $1,000 invested each year at 8 percent will amount to over $133,000 in 30 years."[10]

The Individual Retirement Account (IRA) plan is open to everyone, regardless of whether you are self-employed or have an employer. You can also invest up to 15 percent of your adjusted income in the plan, but the ceiling is $2,000 per year. Money invested in an IRA is tax-deductible only for those who are ineligible for another

pension plan or for self-employed persons who do not have a Keogh Plan.

With both the Keogh and IRA plans you can withdraw your funds without penalty at the age of fifty-nine, and at that time you begin to pay taxes on the amount you withdraw, on the basis of your taxable income.

For further information on self-employed retirement plans, write to your local Internal Revenue Service, the Federal Trade Commission, and the Pension Benefit Guaranty Corporation. The addresses of these agencies, as well as other pension-plan resources, are listed in the Appendix under "Pension Plans."

·2·
Public Relations: Keep Those Cards and Letters Coming In and Going Out

In 1981, choreographer Laura Foreman and composer John Watts distributed a poster throughout New York City announcing an upcoming collaboration called *Wallwork*. The poster included the dates, place, and times of the performances, as well as a phone number to make reservations. However, if you called the number you were informed that there were no seats available and no new names were being added to the mailing list.

The fact was that *Wallwork*, as a dance and music performance, *did not exist*. However, *Wallwork* did exist as a conceptual performance: "a performance which completely emancipated itself from the performance medium. What you see—the poster, the sign, the image, the expectation, the media fantasy—is what you get."[11]

Wallwork could have quietly transpired, its purpose and existence known only to the artists who conceived it. But in order for *Wallwork* to achieve optimum effectiveness, its message had to reach a large audience. So as posters were being distributed, Foreman and Watts sent out a special news release to members of the press, defining *Wallwork* and its purpose:

. . . WALLWORK aborts the audience's expectations and critiques the medium of performance while using it; . . . creates a found audience of thousands of people—all those who pass by the posters become participants in the (conceptual) creation of the performance.

WALLWORK asks questions such as these: Is art what the artist says it is? Is it publicity or is it "art"? Is art beckoning you into a vacuum? What is the nature of performance? Do the fantasies of artists feed the expectations of an audience? Who is the audience? Why do people most desire that which they can't have? How does an artist "perform"? After a performance, is there anything left? Can an artist create a performance of the mind?[12]

Although it was not the intention of the artists to use *Wallwork* as a self-promotion vehicle, publicity was a key part of the performance and key to making it a success. Several newspapers in New York covered the story, including *The New York Times*. Critic Jack Anderson wrote:

The final paradox of a paradoxical situation is that *Wallwork*, a non-existent dance, is more interesting than many dances that do exist. It stimulates thought. It conjures up ideas. And one does not have to sit through it in an airless studio or on a hot night. One can think about it at leisure. *Wallwork*, though something of a hoax, has its own strange validity.[13]

Many artists are offended by self-promotion because they believe it taints their work and self-image. Others are offended by some forms of publicity but accept other forms that they consider in *good taste*. Still others are averse to publicity only because they are not receiving it. And some artists are offended by self-generated publicity but do not question publicity generated by an art gallery, museum, or organization on their behalf. Often, in such cases, an artist does not believe that the gallery, museum, or organization is doing enough.

Daniel Grant, when editor of *Artworkers News*, gave two perspectives on the publicity issue:

> Publicity has become a staple in the art world, affecting how artists see themselves and how dealers work. On its good side, it has attracted increasing numbers of people to museums and galleries to see what all of the hullabaloo is about and consequently expanded the market for works of art. More artists are able to live off their work and be socially accepted for what they are doing. On the other hand, it has [made] the appreciation of art shallow by seeming to equate financial success with artistic importance. At times, publicity becomes the art itself, with the public knowing that it should appreciate some work because "it's famous," distorting the entire experience of art.[14]

The questions that Grant raises about what constitutes art appreciation and good art and what distorts the art experience have been asked for hundreds of years, many years before the great media explosion came into being. They are questions that will continue to be debated and discussed, within the context of publicity and without. In the meantime, this chapter will discuss basic public-relations tools and vehicles for developing an ongoing public-relations program for your career.

Public appearances, demonstrations, and lectures are vehicles that offer excellent exposure and can also provide income. This is discussed in Chapter 8, "Generating Income: Alternatives to Driving a Cab."

The Press Release

A press release should be written and used to announce and describe anything newsworthy. The problem, however, is that many artists are too humble or too absorbed

with aesthetic problems or the bumps of daily living to recognize what about themselves is newsworthy, or they view the media as an inaccessible planet that grants visas only to Louise Nevelson and Roy Lichtenstein.

A press release should be issued when you receive a prize, honor, award, grant, or fellowship. It should be issued if you sell your work to an important local, regional, national, or international collector. Use a press release to announce an exhibition, regardless of whether it is a single show in a church basement or a retrospective at the Whitney or a group exhibition where you are one of two or one of one hundred participants. A press release should be issued to announce a slide and lecture show, demonstration, performance, or event. It should also be issued to announce a commission.

In addition, a press release should be issued after you have lectured, performed, demonstrated, exhibited, completed the commission, et cetera. Some publications are primarily interested in advance information, but others are interested in the fact that something took place—what happened, what was seen, said, heard, and who reacted.

A press release should also be issued if you have a new idea. New ideas are a dime a dozen, particularly if you keep them to yourself. What might seem humdrum to you could be fascinating to an editor, journalist, host of a radio or television interview program, or a filmmaker looking for a subject. Personality profiles also make their way into the news.

WHY BOTHER?

Press releases can lead to articles about you. Articles can help make your name a "household" word or at least provide greater recognition. Articles can lead to sales and commissions. Articles can lead to invitations to partici-

pate in exhibitions or performances and speaking engagements. Articles can help lead to fellowships, grants, honors, and awards.

A press release does not have to be published to generate a response. For example, a press release can lead to an invitation from a curator to participate in an upcoming theme show.

Press releases that I wrote and distributed concerning some of my own projects generated articles in *The New York Times, Life, Art Direction, Today's Art, Architectural Forum, House and Garden, Playboy, New York* magazine, *The Washington Post,* and *Progressive Architecture,* and syndicated articles in over one hundred newspapers throughout the United States (via Associated Press and United Press International). In Europe, my press releases generated articles in *The New York Herald Tribune, Paris Match, Der Spiegel, Casabella,* and *Domus.* These articles then generated invitations to exhibit at museums and cultural centers throughout the United States and in Europe. In addition, some articles led directly to commissions and sales.

An excellent way of keeping track of whether your press release was reprinted, or whether you were mentioned or featured in publications, is to use a clipping service. For a reasonable fee, a clipping service will monitor specific geographic regions and send you copies of articles that mention your name. The names of clipping services can be found in the Business-to-Business Yellow Pages under "Clipping Bureaus."

DOs AND DON'Ts

A press release should tell the facts but not sound like Sergeant Friday's police report. It should whet the appetite of the reader, arouse the interest of a critic to visit the show, the interest of an editor to assign a writer

to the story, the interest of a writer to initiate an article, the interest of television and radio stations for news coverage and interviews, and get dealers, curators, collectors, influential people, and the general public to see the exhibition or event.

The fact that an exhibition or event is taking place is not necessarily newsworthy. What the viewer will see and who is exhibiting can be. A press release should contain a *handle*, a one- or two-sentence summary that puts the story in the right perspective. Handles do not necessarily have to have an aesthetic or intellectual theme. They can be political, ethnic, scientific, technological, historical, humorous, and so on. Editors and writers are often lazy or unimaginative about developing handles. Give them some help.

Although a reporter might not want to write an article exclusively about you or your show, your handle might trigger a general article in which you are mentioned.

Press releases have an amazing longevity. Writers tend to keep subject files for future story ideas. Although your release could be filed away when it is received, it could be stored in a subject file for future use. Releases I have issued have resulted in articles or mentions in books as long as six years after the release was issued!

If writing is not your forte, do not write a press release. Get someone to do it who is good with words, understands the concept of handles, likes your work, and finds the experience of writing in your behalf enjoyable. *You serve as editor.* Too often artists are so excited about a press release being issued that they relinquish control of its content and let a description pass that understates or misinterprets their intentions. The press has its own field day in this area. They do not need any encouragement.

Many artists believe that they do not have anything to say. Use a press release to articulate your thoughts about your work and motivations. Learning to do so is particularly useful for preparing grant applications and for face-

to-face encounters with people who are in a position to advance your career. It is also a good way to prepare for interviews.

Do not use a press release as an opportunity to exercise your closet ego or show off your academic vocabulary. Who wants to read a press release with dictionary in hand? Avoid using art criticism jargon and long sentences that take readers on a wild-goose chase. Writing over the heads of readers is guaranteed to breed intimidation. This kind of release ends up being filed under "confusion"—the wastebasket. Here is an example:

> The . . . exhibition presents the work of six differently motivated artists. . . . They each arrive at their own identity through an approach based on the dynamic integration inherent in the act of synthesis, synthesis being the binding factor which deals comprehensively with all the other elements involved in the creative process, leading ideally to an intuitively orchestrated wholeness which informs both the vision and the process.[15]

LETTERHEAD

When possible, issue a press release under the auspices of the sponsor of your exhibition, event, prize, award, commission, or whatever. Request permission to use the sponsor's letterhead even though the sponsor plans to issue its own release, with the understanding that the sponsor can approve the final copy. The release should include, as a courtesy, a paragraph about the sponsoring organization or gallery, for example, a historical sketch, a description of its activities or purpose.

If the sponsor does not have a qualified person to handle public relations, put your name and home telephone number as the press contact. To determine whether the sponsor's public-relations representative is qualified, use the following criteria: the person is willing to cooperate

and is not threatened by your aggressive pursuits toward good press coverage; you have a good rapport with the person; and he or she *really* understands your work.

WHAT TO INCLUDE

The headline of the release should capture the handle and announce the show, award, commission, or event. The first paragraph should contain the handle and give the who, what, when, where, and sometimes why or how. Subsequent paragraphs should back up the first paragraph, contain quotes from the artist, and when possible, quotes from critics, writers, curators, and others. Let them toot your horn; it is more effective.

A short biography should also be included (see page 14). The biography should highlight your important credits. In addition, it should mention where you were born (see page 8); where you went to school; and collections, prizes, awards, fellowships, exhibitions, and other significant accomplishments.

Publicity for Upcoming Exhibitions and Performances

If you are invited to exhibit or perform, do not rely or depend on the sponsoring organization to do your public relations. Create an auxiliary campaign (which might end up being the primary campaign). Try to persuade the sponsor to cooperate with your efforts. If the sponsor agrees to collaborate, volunteer and *insist* on overseeing the administration.

Doing your own public relations or taking control of the sponsor's operation is important because of the following: (1) For various illogical reasons, sponsors can be

lax, disorganized, and unimaginative in the public-relations area. Many sponsors do not realize that if they develop an effective, ongoing public-relations program they not only promote their artists but also make better known their institution or gallery—both of which can offer prestigious and financial rewards in the present and future. (2) If you are in a *group* show or performance, the sponsor will probably issue a "democratic" press release, briefly mentioning each participant, but little more. Your name can get lost in the crowd. Sometimes participants are not even mentioned. (3) Sponsor's mailing lists are usually outdated, full of duplications, and very few lists show any imagination for targeting new audiences. (4) Sponsors can be negligent in timing press releases and announcements so that they coincide with monthly, biweekly, weekly, and daily publication deadlines. Sometimes they do not take advantage of "free listings," or if they do, they send only one release prior to the opening of the exhibition or performance, even though the show runs for several weeks.

ADVERTISEMENTS

If *you* have to pay for your own advertising space to announce an *exhibition*, think twice about spending your money. (Paid advertising to announce a performance or event where tickets or reservations are required is entirely different.) Unless you are willing and able to buy multiple ads, week after week, bombarding the public with your name (just as an ad agency launches a campaign to promote Brand X), I am not convinced that paid advertising is a worthwhile investment.

However, if you have no qualms about participating in bribery, sometimes an ad will guarantee that your show will receive editorial coverage. Some of my clients have had firsthand experience in this area. For example, a sculptor telephoned a weekly New York paper about get-

ting press coverage for a group exhibition. She was transferred from department to department until someone in advertising told her that if she would buy a display ad there would be a good possibility the show would be covered. Another client was approached by the editor of an art publication after he had written an excellent review of her work. He asked her for a payoff. Instinct told her no, and she politely turned down his request, but she had many misgivings about whether she had done the right thing.

On the other hand, if your gallery or sponsor is willing to buy advertising space in your behalf, by all means tell them to go ahead. Many galleries have annual advertising contracts with arts publications (and some publications make sure that their advertisers are regularly reviewed, a corrupt but accepted practice).

Obviously, dealers find it very worthwhile to buy advertising space, for they are pouring thousands of dollars into it every year. "The art magazines . . . are publicity brochures for the galleries, sort of words around the ads, and [create] a total confusion between editorial and advertising," observes critic Barbara Rose. "The only way you can really get your statement, your vision, out there to the public is to put it up on the wall. And to be willing to be judged."[16] If Rose's observation is correct, and I am convinced it is, it implies that whoever is buying or exhibiting art on the basis of seeing it published in art magazines cannot differentiate between a paid advertisement and a review or article. Thus, everything that is in print becomes an endorsement.

STEP BY STEP

The following schedule is based on a six-month time period. Not everyone has six months to plan a public-relations campaign. If you have a year spread the respon-

sibilities accordingly, but don't start the two-month or three-week (for example) plan until two months or three weeks before the actual opening. If you have only a month to get your plans together, the schedule will have to be condensed, but do not eliminate the following tasks.

Six Months Before Opening

- ESTABLISH A PUBLIC-RELATIONS BUDGET. Find out what the sponsor is doing about public relations so that your efforts are not duplicated. Try to coordinate efforts. Make it clear what the sponsor is paying for and what you are paying for. Budgetary considerations should include postage, printing (press releases, photographs, duplication of mailing lists, invitations, posters, catalogs, or any other printed materials), and the opening. If you are involved in a group show, try to coordinate your efforts with other participants. If the sponsor has little money to appropriate toward public relations, take the money out of your own pocket. Don't skimp. But squeeze as many services out of the sponsor as possible (e.g., administrative, secretarial, and clerical assistance, photocopying, use of tax-exempt status for purchasing postage, materials, supplies, etc.).

- PREPARE MAILING LIST. See "Mailing Lists" in Chapter 1. Study the mailing list and decide how many press releases, invitations, posters, and catalogs you need. Information listed under "Two Months Before Opening," "Three Weeks Before Opening," et cetera will help you ascertain who should get what.

- WRITE PRESS RELEASE. (See the section "The Press Release" earlier in this chapter.)

- WRITE FREE-LISTINGS RELEASES. Many publications offer a free-listings section. Special releases should be written for this group and a listings release should be sent

to the attention of the listings editor. Free-listings columns are very economical about words used to announce an event. Therefore, your release should contain the basic who, what, where, and when information. Why and how can be included if you can succinctly explain it in one or two short sentences. Otherwise, the description will not be used. Several free-listings releases might be necessary. Write a release for each week the event will take place. For example, if the exhibition or performance is for four weeks, write four listings releases and date each release with the date you wish to have the free listing appear. These dates should correspond to the publication's cover-date schedule.

- WRITE COVER LETTERS. A cover letter is actually a short note to remind people who you are, where you met, how you know them, why they would be interested in your work, and that you hope they can attend the exhibition. Cover letters should accompany invitations, press releases, posters, catalogs, et cetera. Be selective and study your mailing list to ascertain who might need a cover letter. Your cover-letter list might include critics, curators, gallery dealers, collectors and potential collectors, members of grant agencies, and so forth.

- PLAN AND DESIGN INVITATIONS, POSTERS, AND CATALOGS.

- SELECT PHOTOGRAPHS OF YOUR WORK. Choose photos that you want disseminated to the press (see in Chapter 1, "Slide/Photo Presentations"). Publications require glossy 8″ x 10″ or 5″ x 7″ photographs. If a publication uses both color and black-and-white photographs, send them a selection of both types. Many free-listings columns and gallery guides also publish photographs, so include these publications in your photo mailing.

- RESOLVE THE ISSUE OF PAID ADVERTISEMENTS. (See "Advertisements" section in this chapter.) If you are plan-

ning to buy advertising space, decide on the publication(s) and obtain all of the relevant information pertaining to closing dates for text and artwork.

- PREPARE A MAILING SCHEDULE. Decide who gets what and when. Use the following guidelines to help establish the exact mailing dates, but it is important to check with the publications to confirm their closing-date schedules.

Three Months Before Opening

- GO TO PRINT. Print photographs, invitations, posters, press releases, catalogs, and any other printed matter that you are using.

Two to Three Months Before Opening

- MAIL PRESS PACKAGE. Mail photographs and press releases to *monthly* publications. *Important:* mail material by the first day of the month, two months before the opening. For example, if the opening is May 15, the press packages should be out in the mail by March 1.

- MAIL LISTINGS RELEASES TO MONTHLY PUBLICATIONS. Use the same mailing schedule formula as described above. Send photographs to the publications that publish photographs in the listings section.

Three Weeks Before Opening

- SEND OUT PRESS PACKAGE. Mail photographs and press release to *weekly* publications.

- SEND LISTINGS RELEASES TO WEEKLY PUBLICATIONS. Also send photographs to the publications that publish photographs in the listings section.

- CONTACT ART CRITICS. Send critics an invitation, poster, catalog, press release, and cover letter, if appropriate.

- COMPLETE MAILING TO EVERYONE ELSE ON YOUR LIST. Send out invitations, posters, catalogs, press releases, and cover letters, if appropriate.

Two Weeks Before Opening

- SEND PRESS PACKAGE TO DAILY PUBLICATIONS.

- SEND PRESS RELEASE TO RADIO AND TELEVISION STATIONS.

- SEND SECOND LISTINGS RELEASE TO WEEKLY PUBLICATIONS.

One Week Before Opening

- SEND THIRD LISTINGS RELEASE TO WEEKLY PUBLICATIONS.

Day After Opening

- SEND FOURTH LISTINGS RELEASE TO WEEKLY PUBLICATIONS.

PRESS DEADLINES

The above schedule is a general rule of thumb, and it is very important to check with the various publications regarding their copy deadlines. For example, some weeklies require listings releases to be submitted ten days before the issue is published, but other weeklies require as much as a twenty-one-day deadline, and if you *mail* the listings release twenty-one days before the cover date, you will miss the deadline.

OPENINGS

Many artists would rather go to the dentist than to their own opening, or to any opening for that matter, and many guests feel the same way. Most openings are lethal: cold, awkward, and self-conscious. But it doesn't have to be that way. You worked hard to open. Your opening should be your party, your celebration, and your holiday. Otherwise, why bother?

Do not look at the opening as a means to sell your work or receive press coverage. If it happens, great, but many critics boycott openings, and rightfully so, for with all of the people pressing themselves against the walls (hoping they will be absorbed in the plaster), how can anyone really see the art? And many serious buyers like to spend some quiet time with the work, as well as with the artist and dealer, and an opening is not the time or place to do it. Some openings are planned around a lot of booze to liven things up, and while things can get peppy, often in the high of the night people make buying promises they don't keep.

When the exhibition "11 New Orleans Sculptors in New York" opened in 1981 at the Sculpture Center, the eleven New Orleans artists surprised their guests with a creole dinner. It was an excellent opening, and some of the best openings I have attended (including my own) involved the serving of food (other than cheese and crackers). The menus were not elaborate, but something special, which indicated that the artist actually liked being there and liked having you there; that the artist was in control and was "opening" for reasons other than that it was the expected thing to do. In addition, the breaking of bread among strangers relieved a lot of tension.

Choreograph your opening and be involved in the planning as much as possible. Not all dealers are willing to relinquish control and try something new, but push hard.

The opening shouldn't be a three-ring circus, mixing marshmallows with oranges, structured for hard sell with a little goodie (glass of wine) thrown in as a fringe benefit. This is your show, and the opening should be structured accordingly.

Critics and Reviews: Their Importance and Irrelevance

I have always liked and believed in the adage that "a painting is worth a thousand words." I have never appreciated or enjoyed reading art reviews. I like to know how history affected and influenced art, but I do not care for art history. Such are my own personal biases and interests, and it is tempting to launch into a tirade about the ironies and ambiguities of art criticism and how unintelligent it is that we have allowed subjectivity to have such devastating power to *make or break* visual artists, writers, and performers. However, as the emphasis on the importance of being reviewed grows so out of proportion to its intrinsic humanistic value, it is necessary to meet the monster head-on and deal with, rather than complain about or worship, its existence.

Critic John Perrault comments:

> . . . I know that artists in general will do almost anything to get a review. I have had artists tell me, "Please write about my show. I don't care if you hate it but write something about it." It's very important for artists to have that show documented in print somehow. Often artists don't think that they exist unless they see their names in print.[17]

Also, some dealers, curators, and collectors don't think an artist exists unless the artist's name is in print!

DEALING WITH THE REVIEW SYSTEM

It is all too easy to say that one should stay clear of *review junkies*, those who depend on the printed word to form their opinions or convictions about whether your work is good, bad, worthy, or unworthy, and whether or not you're a good bet and someone to watch in the future. Many such people have camouflaged their weakness so skillfully that one would never suspect that they have less self-confidence than an overweight teenager with pimples. But a lot of insecure people are currently ruling the art world. Therefore, it is necessary to pursue media coverage and the attention of critics to please these junkies. But the pursuit should be a routine task, using public-relations channels (such as those suggested in this chapter) and at the same emotional level as any other routine. *It is not worthy of obsession.*

Not everyone in the vast, complicated art world is vulnerable to the press. People still exist who trust their own gut feelings and intuition. But you have to track them down. How to find these people necessitates another routine: establishing a broad base of contacts (although they might not necessarily be part of the art world's current upper crust). Establishing new contacts can begin with a twenty-two-cent stamp. More about this in the next section, "Public Relations Is a Daily Job."

It is also important to keep your contacts warm and remind people that you exist. For example, at my urging, a client who was literally destitute, out of work for several months, and being evicted from his apartment, contacted a music critic at *The New York Times*. Two years before, the critic had written a highly enthusiastic and flattering review about the musician. He reminded the critic of who he was and laid on the line his current dilemma. Consequently, the critic was instrumental in finding the musician work, which not only helped him

over a huge financial crisis, but also helped him restore faith in himself, in his work, and in humanity.

My own good breaks came from several different circles: insecure people with power, secure people with heart, and those with both heart and power. Ultimately, I have to take credit for putting this kind of constellation together because dealing with the review system also means putting together a backup system so the possibility exists that *your career can flourish with or without reviews.*

Public Relations Is a Daily Job

Public relations is and should be a daily job. Not a week should slide by that you have not attempted to make new contacts. Set aside time every day or a few hours a week for phone calls, letters, and packaging slides and résumés to solicit and generate interest in you and your work. The more contacts you make the greater the chances that you will find yourself being at the right place at the right time.

Do not underestimate the value of this phenomenon. For example, a sculptor who had recently moved to New York from the West Coast asked me to assist her with contacts. I provided her with a list of exhibition spaces that I thought would be interested in her work. The first alternative space that she contacted immediately accepted her work, as it precisely fit into the theme of an upcoming show. Both the sculptor and the show received excellent reviews. The sculptor was then invited to participate in a group exhibition at a museum (as well as another alternative-space gallery); a dealer from a well-known gallery saw the museum show and singled out the sculptor and invited her to exhibit at his gallery. This scenario took place in less than three months!

Once a rhythm is established for a daily approach to

public relations, the job becomes easier and less time-consuming. The letter that once took you hours to compose, just trying to find the right words, will become a snap. And if you keep up on your homework (see "Read, Note, File, and Retrieve" in Chapter 1), you will never exhaust the list of people, organizations, and agencies to contact.

If you consider the law of averages, the more contacts you make (and reestablish), the more opportunities you create to let people know that you and your work exist, the greater the chances that something will happen that will accelerate your career development. Each time you receive a letter of rejection (or of noninterest), initiate a new contact and send out another letter. The "in and out" process feeds the law of averages, increases your chances of being at the right place at the right time, and also puts rejection in a healthier perspective. (Rejection is discussed in Chapter 6.)

·3·
Rationalization and Paranoia—The Crippling Duo

Energy is Eternal Delight. He who desires but acts not, breeds pestilence.

—WILLIAM BLAKE

Rationalization

If you want to avoid fulfilling your potential as an artist, it is easy to find an excuse. When excuses linger unresolved too long they become rationalizations. Webster defines the word *rationalize* as "to attribute [one's actions] to rational and creditable motives without analysis of true and especially unconscious motives," and "to provide plausible but untrue reasons for conduct."

Rationalization in one form or another is common to the human species, and sometimes it can be used constructively. However, when rationalization is used to evade fulfilling one's potential, it is being used to disguise a lack of self-confidence and/or fear of rejection.

There are two primary areas within the context of an artist's career where rationalization is often practiced: rationalizations to *avoid the work process*, and rationalizations to *avoid getting your work out of the studio and into the public domain*, the marketplace.

AVOIDING WORK

"I'll get going once I find a work space" and "I'll get going when I have the right working environment" are rationalizations I hear most often to postpone or avoid knuckling down. Artists who engage in this form of rationalization do little or nothing to alter their status, financially or motivationally, in order to attain their goal of finding a suitable work space.

There are many variations on the theme: the artist who tells me he can't begin work until he can afford stationery embossed with his studio address. He believes that no one will take him seriously until he has a business letterhead. Another artist, who has spent the last four years traveling, tells me she needs more life experience in order to paint, and another artist tells me that he is waiting for technology to invent the right material that he needs for sculpture. Chances are that when the letterhead, life experience, and new technology are attained, the artists will quickly find another excuse to avoid confronting their work.

For the artist who chronically finds an excuse to avoid work, the consequences of rationalization are not limited to getting nothing accomplished. Guilt sets in because he is not doing what he thinks he wants to be doing and is practicing self-deceit. Animosities and tensions develop internally and toward others, whom you blame for your circumstances. Jealousy and contempt surface their miserable heads, directed toward any artists (and nonartists as well) who have managed to put their life together in such a way that they are accomplishing, or are really trying to accomplish, what they want.

With so much negativity festering, no wonder work is impossible. The distance between what you want to achieve and what you are actually achieving grows wider. And if you try to work you find each product of self-

expression tainted and influenced by your anger and hostility. Creativity is used to vent frustration and addresses nothing else.

AVOIDING PUBLIC EXPOSURE

Some artists have no problem working but begin the rationalization process when it comes time for their work to leave the studio and enter the marketplace. To insure yourself against experiencing any form of rejection, a new range of rationalizations begins: your work isn't ready, you don't have enough work to show, you don't fit into the latest trend, you're working for your own pleasure and do not want to derive money from art, and no one will understand your work anyway—it's too deep!

One of the more popular rationalizations is the *perpetual search for the perfect agent.* Once this person is found he or she will take your work to the marketplace. This person, you tell yourself, will shield you from criticism and rejection; schlepp your slides from gallery to museum; bargain, negotiate, and establish your market value; arrange exhibitions; write letters; attend cocktail parties; and make important connections. In addition, the agent will have excellent press contacts and your work will be regularly featured in leading publications, with critics fighting among themselves for the opportunity to review your shows. And of course, this agent will fill out grant applications on your behalf and will be very successful in winning the interest of foundations to subsidize your career. And when cash flow is a problem, the agent will tide you over with generous advances. When your ego needs stroking, the agent will always be on call. All you have to do is stay in your ivory tower and work.

I estimate that 75 percent of my clients have the notion in the back of their minds that I will fulfill this fantasy and provide the buffer zone they are seeking. Apart from

my belief that within the visual-arts field this fairy god-person is practically nonexistent (or inaccessible to artists who have not yet been "discovered" and obtained a high market value), I strongly believe that artists are their own best representatives. More on this in Chapter 5.

Meanwhile, the search for the perfect agent, the supposed saint of all saints, continues while the artist's work accumulates in the studio, only to be seen by four walls.

Rationalization can become a style of life—an art unto itself. Artists who use rationalization as a style of living tend to associate with other artists who are skilled at the same game, supporting and reinforcing each other, pontificating in unison that "life is hell," and that it's everyone or everything else's fault. It's less lonely going nowhere fast in a group than by yourself.

Paranoia

Rationalization has a twin: paranoia. Webster defines *paranoia* as a "tendency on the part of an individual or group toward excessive or irrational suspiciousness and distrustfulness of others."

Sometimes the twins are inseparable and it is difficult to know where rationalization ends and paranoia begins. Sometimes rationalization is the aggressor and paranoia takes over, and other times paranoia prevails on its own. But the twins always meet again at the same junction, called *insecurity*.

For example, a painter tells me she dislikes showing her work to dealers because when she invites them to her studio she believes that her invitation is interpreted as a sexual proposition. I asked whether she had encountered this kind of experience. "No," she replied, "but I know what they are all thinking." Consequently, dealers

are not invited for a studio visit. Thus, she eliminates any possibility of being rejected or hearing that her work isn't good enough. Another artist, who was part of a group that I was assisting with public relations for an upcoming exhibition, told me that he did not want press coverage in certain newspapers and on television in fear that the "wrong kind of people" would come to the show. I could never figure out who the "wrong kind of people" might be—street gangs, muggers? Nor could the artist shed light on the subject when I asked for an explanation. But in his mind there was a special group of people who were not meant to view or buy art.

The belief that there *is* a special group of people who are not meant to view or buy art is a common point of view among artists. It translates into the "creating art for friends" syndrome, a principle that, on the surface, sounds very virtuous, but all too often means that anyone who likes your work is worth knowing, anyone who doesn't isn't. It is a tidy black-and-white package: a hand-picked audience that you create for the purpose of lessening the possibility that you will be rejected and increasing your sense of security and self-esteem.

I don't mean to understate or underrate the importance of support and compliments, but there are many dangers in being paranoid about new audiences. In addition to propagating elitist notions about art, it also creates incestuous attitudes and incestuous results. To continuously create what you know will please your peanut gallery impedes your creative growth and limits your creativity. The fear of new audiences also applies to artists who are afraid to leave their gallery or expand into new local, regional, national, and international territories.

One of the environments where paranoia runs rampant is within the so-called community of artists. Artists are often fearful of ideas being stolen, competition, and losing the status quo. By this reasoning every artist is a potential enemy.

An artist who served as an apprentice for two years to a well-known sculptor was preparing a grant application and needed three letters of recommendation. He felt comfortable asking his former employer for a letter, because on numerous occasions the sculptor had praised his talents. Yet the sculptor turned him down, saying that on principle he does not give artists letters of recommendation.

Reading between the lines, it is likely that the younger artist posed a threat to the sculptor's status. The sculptor needed to feel that there was no more room at the top, and just to ensure that no one else would inch his or her way up, he thwarted every opportunity that might give someone else upward mobility.

A painter who had recently moved to New York and was eager to begin making gallery contacts told me that she had a good friend who was with an established New York gallery where she would like to exhibit. I suggested that she ask her friend for a personal introduction. "I already did," she glumly replied. "But she said that *she* would be heartbroken if the dealer didn't like my work."

In this example, the artist tried to disguise her own insecurities with a protective gesture. She would not allow herself to be put in a position where her "taste" would be questioned and/or she saw her friend as a potential threat to her status in the gallery. A realistic enough threat to warrant cutting her friend out of a network.

I once asked a sculptor who was sharing a studio with other artists whether her colleagues were supportive and helped each other with contacts. "Oh, no," she replied, "just the opposite. Whenever one of the artists has a dealer or curator over for a studio visit, the day before the appointment she asks us to cover up our work with sheets." Then she added, "I don't blame her. If I were in her position I would do the same."

In this example there is little room to read between

the lines. It is a blatant example of paranoid behavior. Oddly enough, her studio mates complied with the outrageous request because they deeply identified with and understood the artist's fear.

Paranoia also manifests itself in the hoarding and concealment of information. I have seen artists smother in their bosoms any tidbit of information, data, or any "leads" that they believe will be a *threatening weapon in the hands of other artists.* A dancer told me that she holds back information from colleagues about scheduled auditions; a sculptor complained that his best friend entered a competition whose theme was very relevant to his own work. When he learned of the opportunity only after the deadline closed, his friend nonchalantly said, "Oh, I thought I mentioned it to you." A photographer suspiciously asked me how many other photographers I have advised to approach a certain gallery.

Overreacting to Competition

Some of the examples cited above might sound familiar. So familiar and ordinary that you most likely never thought to consider them examples of rationalization and paranoid behavior. This is part of the problem. In the art world, illogical and unsubstantiated fears and scapegoating have become the norm.

One of the basic reasons why rationalization and paranoia are condoned in the art world is overreaction to competition. Everyone tells us how competitive the art world is, how competitive being an artist is. We hear it from critics, curators, dealers, educators, our parents, and other artists. We enter contests, juried shows; vie for the interest of dealers, collectors, patrons, critics; fight for

grants, teaching jobs, commissions, and artists-in-residence programs. We write manifestos to be *more profound* than others.

Yes, the art world is competitive. But who are the contestants and who are the judges? What are the stakes? What do you hope to win, and what are the consequences of losing? Is it worth the effort? Whose rules are you using, and are they meant to be broken?

Competition is an occupational hazard in every profession; it is not exclusive to the art world. But in the art world we have let rivalry assume the predominant role in how we relate to one another. Just the thought of being judged is so overwhelming to some artists that they won't even allow themselves to compete. Other artists plunge into the match, but let animal instincts, a dog-eat-dog mentality, pilot their trip. These are artists who backstab, hoard information, and exercise selective memories. Some artists try to deal with competition by establishing elitist values, adamantly contending that only a select few were meant to understand their work. Trying to win the interest of a select audience makes competition seem less threatening. Other artists have concocted a myth that dealers, curators, and collectors are incapable of simultaneous appreciation of or interest in more than a few artists. Such artists cultivate a brutal "It's me or you" attitude.

Rationalization and Paranoia Are Dangerous to Your Health and Career

Until competition in the art world is recognized for what it really is, rationalization and paranoia will continue to be used by many artists as tools of the trade. They are odious, unproductive, and self-defeating props, which are

dangerous to your health, career, and the present and future of the art world.

There is no need to expound on why it is unhealthy to live a life predicated on fear, lies, and excuses and what it can do to us physically and mentally. Some artists are at least consistent, allowing self-destruction and self-deceit to govern all facts of their existence. But other artists have a double standard: honesty, intellect, courage, discipline, and integrity are principles that rule the nest, except when it comes to their art and career!

Those who let rationalization and paranoia rule their careers in order to avoid rejection, placate insecurity, and fend off competition must face the fact that their careers can come to a screeching halt, limp along in agonizing frustration, or be limited in every possible sense. Their work suffers (reflecting lies, excuses, and fears) and their network of friends and contacts will degenerate to the lowest common denominator, as they will stop at nothing to eliminate what is perceived as a possible threat.

·4·
Exhibition Opportunities: Using Those That Exist and Creating Your Own

More than ever before there are now many opportunities to exhibit and sell work outside the commercial gallery system (which is discussed in the next chapter, "Dealing with Dealers and Psyching Them Out"). Credit must be given to a new art movement that started in the late sixties, in which "style" was inconsequential, and expanding exhibition opportunities for artists was top priority.

Alternative Spaces

The *alternative-space movement* emerged in reaction to the constrictive and rigid structure of commercial galleries and museums. Artists took the initiative to organize and develop their own exhibition spaces, using such places as abandoned and unused factories, and indoor and outdoor public spaces that previously had not been considered a place to view or experience art. Some alternative spaces acquired a more formal structure, such as artists'

cooperatives, and became institutionalized with tax-exempt status.

Alternative spaces mushroomed throughout the United States under such names as the Committee for Visual Arts, the Institute for Art and Urban Resources, and the Kitchen, all in New York City; the Los Angeles Institute of Contemporary Art; the N.A.M.E. Gallery in Chicago; the Washington Project for the Arts, Washington, D.C.; and the Portland Center for the Visual Arts in Oregon.

The alternative-space system continues to spread, providing general exhibition and performance opportunities, as well as exhibition opportunities for specific artists. For example, there are alternative spaces dedicated to black artists, women artists, black women artists, Hispanic artists, and artists born, raised, or living in a specific neighborhood of a city. There are alternative spaces dedicated to mixed media, photography, performance, sculpture, et cetera.

When the original alternative spaces were established, their goals were simple and direct: to "provide focus for communities, place control of culture in more hands, and question elitist notions of authority and certification."[18] While on the surface the goals of the newer alternative spaces might appear to be in harmony with those of their predecessors, many, unfortunately, have other priorities. Although some spaces are still being run by artists, others are being administered by former artists who have discovered that being an arts administrator or curator is a quicker route to art-world recognition and power. Some alternative spaces have been infiltrated by bureaucrats, who are self-appointed spokespersons for what's "in" and important in art. They work hardest at attaching themselves to *movements*, believing that every great and successful curator must hitch his or her wagon to a movement. Thus, they seek out and feature only the artists who fit into their bag.

Consequently, the goals of some alternative spaces are not necessarily in the best interests of artists or the communities they were originally intended to serve. An *alternative elite* has arisen, so it should not surprise an artist that the reception he or she receives when contacting an alternative-space gallery could well be reminiscent of the reception encountered at a commercial gallery.

Of course, there are alternative spaces that remain pure to the ethic and purpose of what an alternative space is and, generally, the alternative-space system has many good attributes.

The biggest and most important difference between an alternative space and a commercial gallery is that the former is nonprofit in intent, and therefore is not in business to *sell* art or dependent on selling for its survival. Basically, its survival depends on grants and contributions, which is another kind of financial pressure. But without the pressure of having to sell what it shows, the alternative space is able to provide artists with exhibition space and moral support, and feature and encourage *experimentation* (a word that can cause cardiac arrest for many dealers). This is not to imply that work is not sold at alternative spaces, for it is, but an artist is not obligated to pay the ungodly commissions required by commercial galleries. If an alternative space has a commission policy, it is usually in the form of a contribution.

Alternative spaces have many other good points. For example, they offer an artist a gallerylike setting in which to show his or her work. This can help a dealer visualize what the work would look like in his gallery. Do not underestimate the value of this opportunity: many dealers have remarkably little imagination. Also, alternative spaces are frequented by the media and critics, providing artists with opportunities for press coverage, which, as discussed in Chapter 2, can often be an important factor

in career acceleration. And alternative spaces provide artists with a chance to learn the ropes of what exhibiting is all about.

Curators and dealers include alternative spaces in their regular gallery-hopping pilgrimages, for glimpses into *what the future might hold* as well as to scout for new artists. Some of my clients' alternative-space experiences skyrocketed their careers or took them to a new plateau.

Many artists have misconceptions about the value and purpose of an alternative space and regard it as a stepchild of the commercial-gallery system. They think that it should be used only as a last resort. This is not true. While alternative spaces provide valuable introductory experience into the art world and exhibition wherewithal, *it is counterproductive to abandon the alternative-space system once you have been discovered by a gallery.* Balance your career between the two systems. Until a commercial gallery is convinced that your *name alone* has selling power, you will be pressured to turn out more of what you have thus far been able to sell. You might be ready for a new direction, but the dealer won't want to hear about it. Those offering an alternative space do!

Alternative spaces are not closed to artists who are already with commercial galleries. In fact, including more established artists in alternative-space exhibitions adds to the organization's credibility, and for an alternative space whose survival depends on grants and contributions, there is a direct correlation between reputation and financial prosperity.

The names and locations of alternative spaces throughout the United States are listed in the *Art in America Annual Guide to Galleries, Museums and Artists* (see the Appendix section "General Arts References") and in *The Directory of Artists' Organizations* (see the Appendix section "Alternative Exhibition/Performance Opportunities, Places, and Spaces").

Cooperative Galleries

Cooperative galleries are based on participation. Artists literally run the gallery and share in expenses (in the form of a monthly or annual fee) in return for a guaranteed number of one-person shows within a specified period, as well as group exhibitions. Gallery artists make curatorial decisions and select new artists for membership.

Because of its participatory structure, the cooperative system, at its best, offers artists a rare opportunity to take control, organize, and choreograph their own exhibitions and be directly inolved in formulating goals, priorities, and future directions of the gallery. At its worst, since a member must accept group decisions, you might find yourself in compromising situations, having to abide with decisions that are in conflict with your own viewpoints. And you might also find yourself spending more time squabbling and bickering over co-op–related matters than on your artwork!

It is always difficult to know what you are getting yourself into, but before rushing into a cooperative, talk to the members to ascertain whether you are on the same wavelength. Obviously, if you receive an invitation to join a co-op, the majority of members approve of you and your work. You should determine whether your feelings are mutual.

Co-op memberships are limited and correspond to the single-show policy and space availability of the gallery. For example, if the co-op agrees that members should have one-person shows for one month every eighteen months,the membership will be limited to eighteen artists. Or if the gallery has the facilities to feature two artists simultaneously, the membership might be limited to thirty-six artists. Some co-ops have membership waiting lists; others put out calls for new members on an annual basis or when a vacancy occurs. In addition, some

co-ops have invitationals and feature the work of artists who are not members.

Some cooperatives do not take a sales commission; others do, but the commissions vary and are far lower than those charged by commercial galleries. If commissions are charged, they are recycled back into the gallery to pay for overhead expenses.

The "Cooperative Galleries" section of the Appendix lists some resources where you can learn more about the cooperative-gallery system and has suggestions for forming your own cooperative.

Vanity Galleries

Beware! Not all cooperative galleries are really cooperatives. Opportunists have aligned themselves with the co-operative system and put together galleries that are defined as "cooperatives" but are really vanity galleries in disguise. Their only selection criteria is the availability of the almighty dollar: "If you've got the bread, have I got a space for you!" And more often than not the space is not remotely close to what you envision as a decent exhibition environment.

For a *Village Voice* article, journalist Lisa Gubernick posed as an artist and went undercover to learn more about what artists experience when making the gallery rounds. With a set of borrowed slides, she contacted numerous galleries in New York City, including the vanities. At the Westbroadway Gallery, she was offered a show in the gallery basement, called "Alternative Space Gallery," for $850. In addition, she described her experience at the Keane Mason Woman Art Gallery as follows:

... I had a draft contract in my hands within 20 minutes ... $720 for 16 feet of wall, a mini-solo they called it.

The date . . . was contingent upon "how I wanted to spread out my payments," according to the assistant director. In an embarrassingly blatant ploy she put red-dot adhesive stickers—the international "sold symbol"—on each of the half-dozen slides she deemed suitable for my show, all the while emphasizing various corporations' interest in the gallery. . . . The shows I saw at Woman Art were hung poorly. Wall labeling was crooked, and the gallery gerrymandered with partitions to eke out more space.[19]

Once, when a gallery dealer deflated the ego of one of my clients, he trod over to a (now-defunct) vanity gallery, much against my advice, like the guy who discovers his mate has been unfaithful and marches off to a prostitute. He signed up for a show, signed the dotted line on the contract, and wrote a check for several hundred dollars. In addition to the "exhibition fee," he had to pay for all of the publicity, including invitations, announcements, press releases, and postage, and wine served at the opening. Although the show did nothing for his career, he felt victorious. He had shown the dealer!

Stay clear of vanity galleries. They require maximum energy and money and lead to minimum results. If artists made a concerted effort to boycott vanity galleries, the galleries would disappear and the worms who own them would crawl back into the ground (but undoubtedly surface with a new kind of scam).

Juried Exhibitions

Hundreds of local, regional, national, and international juried exhibitions are held each year. Juried shows offer artists opportunities for exposure and recognition, as well as cash prizes and awards. If you were so inclined, you

could enter a juried exhibition every day of the year. The Appendix, under "Juried Exhibitions," lists resources to learn where and when these shows take place.

Some juried shows are more prestigious than others because they are sponsored by a highly respected institution; they have a reputation for showing artists whose careers can accelerate just by the fact that their work was selected (for example, the Whitney Biennial); or the jury is comprised of "big name" art-world personalities.

Many juried shows require entry fees, which are used to cover legitimate expenses, such as paperwork, administration, transportation, insurance, and other costs related to the exhibition, as well as the exhibition purse for cash awards. However, there are also juried exhibitions where only a small percentage of fees is actually used for legitimate expenses, with the bulk of the money going directly into the pockets of the "fat cat" organizers.

For example, one New York gallery sponsors a juried competition in which artists are required to pay a registration fee of thirty dollars for up to four slides, five dollars for each additional slide; a ten-dollar nonrefundable repacking and handling fee "even if hand-delivered"; and a 40 percent commission on all sales!

Juried competitions have become so controversial that the National Artists Equity Association's *Declaration of Artists' Rights* includes guidelines for juried exhibitions:

> National Artists Equity is unalterably opposed to artists bearing the cost of exhibitions in the form of entry fees. Furthermore, Equity expects exhibiting sponsors will provide insurance and adequate security while juried work is in sponsors' possession.
>
> The selection of judges and jurying of exhibitions should be accomplished so that aesthetic considerations are maximized and extraneous biases are minimized. To this end, judging should be done in terms of the work itself. Neither

age, sex, religion, nor the race of the artist should be quali-
fication or deterrent for the work submitted to any govern-
ment-supported exhibition. In general, local judges should
not be selected because of a possible bias.

National Policy Guidelines for Juried Shows is pub-
lished by the National Artists Equity Association. For
further information see the Appendix section "Juried Ex-
hibitions."

Before submitting work to a juried exhibition, even if
it is sponsored by the most reputable museum, institu-
tion, or organization, do your homework. Find out who
is on the jury and make sure the sponsor will provide a
contract or contractual letter outlining insurance and
transportation responsibilities, fee structures, submis-
sion deadlines, and commission policies. If you pay an
entry fee, you should not have to pay a commission on
work that is sold. And find out what the physical prop-
erties and dimensions of the exhibition space are. *Art-
workers News* reported on a juried show called "Emerging
Artists," which was held in New York City at Madison
Square Garden at the end of 1981. Artists were charged
$200 for a ten-foot stretch of wall; $400 for forty feet; and
another $16 to rent a chair. "The walls in fact were non-
existent. The booths were divided by pipes and drapes
and at the opening a number of these fell down. Some
work was totally destroyed; other work was dented and
scraped; frames were damaged. With the collapse of the
booths went the collapse of goodwill between artists and
the promoter."[20]

Slide Registries

An active slide registry is used by many people: by cu-
rators and dealers to select artists for exhibitions, by col-

lectors for purchases and commissions, and by critics, journalists, and historians for research. It makes a lot of sense to participate in the registry system, but not all registries are equally used. Before going through the expense and energy of submitting slides, find out if the registry is really used.

My first encounter with a registry occurred when I was preparing an exhibition at a museum in New York City and spent a lot of time in the curatorial chambers. The curators meticulously went through their registry, on the lookout for artwork that would fit into a theme show they were preparing (eighteen months in advance). When they found something they liked, regardless of whether the artist lived in Manhattan, New York, or Manhattan Beach, California, they invited the artist to participate.

It is very important to *continually update the slides that you submit so the registry reflects your most recent work.* A person reviewing the registry will assume that whatever is there represents your current work, but, unless your slides are up-to-date, this might not be the case. For example, one of my clients was invited to participate in a museum exhibition by a curator who had seen her work in a registry. It would have been her first museum show, but she learned that the curator wanted to show only the work that she had seen in the registry. The artist was mortified: a year before she had destroyed the entire body of work, and the curator was not interested in her recent work. It was a big letdown, and the artist was depressed for weeks.

The addresses of various slide registries are listed in the Appendix under "Slide Registries" and "Public Art."

Ongoing Commission Opportunities

FEDERAL GOVERNMENT

The federal government commissions artists to produce works of art for various government projects. In the Government Services Administration (GSA) Art-in-Architecture Program, artists are commissioned to produce works of art that are incorporated into the architectural design of new federal buildings. In addition, artwork is commissioned for buildings undergoing repair or renovation, as well as for federal buildings in which artworks were originally planned but never acquired.

Commissioned work includes (but is not limited to) sculpture, tapestries, earthworks, architecturally scaled crafts, photographs, and murals.

One-half of one percent of a building's estimated construction cost is reserved for commissioned work. Artists are nominated through a cooperative procedure between the GSA, the National Endowment for the Arts (NEA), and the project architect.

The architect is asked to submit an art-in-architecture proposal that specifies the nature and location of the artwork, taking into consideration the building's overall design concept.

The NEA appoints a panel of art professionals who meet at the project site along with the architect and representatives of the GSA and NEA. They review the visual materials (which are submitted through the GSA's slide registry) and nominate three to five artists for each proposed artwork. The NEA forwards the nominations to the administrators of the GSA, who make the final decision.

The Veterans Administration's Art-in-Architecture Program is similar to that of the GSA, but it has its own operating budget.

MUNICIPAL AND STATE GOVERNMENTS

The precedent of allocating a certain percentage of the cost of new or renovated public buildings, as described in the GSA's Art-in-Architecture Program, has also been legislated by many counties and states throughout the United States, including Miami, Honolulu, San Francisco, Philadelphia, Chicago, Seattle, New York City, Phoenix, Denver, Boston, and Baltimore. Canada has similar programs. In addition, in 1986, *The Percent for Art Newsletter* was initiated; it lists open competitions for public art projects in Percent for Art programs throughout the United States. Additional information about the *Newsletter* and Percent for Art programs can be obtained in the Appendix under "Public Art."

In addition, the National Endowment for the Arts' Art in Public Spaces Program provides grants to nonprofit organizations to commission artists to create art for public spaces. The addresses of the NEA and other agencies mentioned in this chapter are listed in the Appendix in the "Public Art" section.

MASS TRANSIT AGENCIES

Other public art projects have been initiated in conjunction with mass transit facilities. For example, in New York City, the Art for Transit Program, in cooperation with the New York City Transit Authority, Metro-North Commuter Railroad, and the Long Island Rail Road, commissions art for several types of projects, including Adopt-a-Station, Creative Stations, Percent for Art, Exhibition Centers, and Music Under New York. Arts on the Line in Cambridge, Massachusetts, commissions artists and purchases work for the Massachusetts Bay Transit Authority; and the Downtown Seattle Transit Project

commissions artists for subway and tunnel projects. The addresses of these agencies are listed in the Appendix under "Public Art" and "Slide Registries."

Museums

Generally speaking, museums are leaving their doors more open to new and emerging artists. Some museums are actually leaving their doors ajar. My first exhibitions were sponsored by museums, contrary to the notion held by many artists that one must be affiliated with a commercial gallery before being considered by a museum. In many instances, the initial contacts that led to exhibitions at museums were a set of slides, a résumé, and a show proposal (see the section "Develop and Circulate a Proposal" in this chapter). Other exhibition invitations came as a result of both long- and short-term professional relationships with museum directors and curators.

My own experience in gaining museum shows is not unlike the steps outlined by Patterson Sims, associate curator of the Whitney Museum:

> On the basis of slides and exhibition notices the curators will call for appointments with individual artists for studio visits. . . . Calls from friends, collectors, and gallery owners about the work of an artist are another means of introduction. . . . Conversations with artists, art writers, and museum personnel will bring an artist's name to a curator's attention.[21]

Sims also described the process of how artists are actually invited to exhibit at the Whitney: "Decisions . . . [are] made at curatorial staff meetings. It is up to the individual curators to promote the work of an artist they feel has fresh style, a sense of quality, and a provocative outline.

If a curator can convince others . . . the group will decide to invite an artist to participate."[22]

The unilateral support system that Sims describes is one of the biggest snags in the exhibition process of some museums. It is debatable whether the artist who is presented for consideration on the basis of slides and a studio visit has the same leverage as an artist who was brought to the attention of curators by "friends, collectors, and gallery owners." Many artists believe that the Whitney, for example, is a closed shop to artists not affiliated with a well-known commercial gallery. Judging from who *is* invited to participate in the Whitney Biennials, this is a logical conclusion. On the other hand, one of my clients who had no particular gallery affiliation was invited to participate in a Whitney Biennial. She concluded that she was a "small fish that slipped through the net!"

There are curators who have autonomous power and are able to make their own decisions rather than succumb to peer or dealer pressure. So do not let hearsay discourage you from submitting slides to the Whitney or other so-called power bases, but be prepared with alternative plans as well. Regional museums that show contemporary art, for example, are excellent resources. These museums have an innate sense of pride in featuring local artists, and another kind of pride in exhibiting artists from big cities.

Colleges and Universities

Colleges and universities are often receptive to sponsoring exhibitions and performances, and their interest is not necessarily limited to alumni, although approaching a college or university of which you are an alumnus or alumna is a good beginning. Colleges and universities have their own network, and from my experience, once you

have an exhibition at one of them, word spreads fast and more invitations follow.

The first step is to contact the colleges and universities with a proposal. This process is described in the section "Creating Your Own Exhibition Opportunities" in this chapter.

Exhibiting at colleges and universities can also offer other rewards. Sometimes, as a result of exhibitions, artists' works are purchased for the school's collection, and artists are commissioned to do projects for particular campus sites.

The names and locations of college and university galleries throughout the United States are listed in the *Art in America Annual Guide to Galleries, Museums and Artists* (see "General Arts References" in the Appendix).

THE CORPORATE ART MARKET

The corporate art market offers artists numerous exhibition and sales opportunities. Over the last ten years, corporate art collecting has increased dramatically, not only in the number of corporate collectors but also in the amount of art being purchased and the money being spent.

Corporations have recognized that art can be used as a means of improving client and community relations, and employee morale. Although many of the motives behind corporate collecting are basically self-serving, the corporate marketplace has become a very viable arena for many artists to sell and exhibit work.

Generally, corporations steer away from work that is political, overtly sexual, or religious. Otherwise, the field is open.

"The term 'corporate art' is actually a misnomer," says Dorothy Solomon, a corporate art consultant and founder and president of The Art Collaborative, Inc., in New York City. "Interest in purchasing art has extended to hospitals

and health-care facilities, restaurants, hotels, and real estate developers."

There are several ways to reach the corporate market: using corporate art consultants/advisors and corporate art galleries; directly contacting corporations through staff curators; and contacting architects and interior designers.

If work is sold or you are commissioned to do a project through a corporate art consultant/advisor or corporate art gallery, you must pay a commission fee, usually about the same as what a commercial gallery would charge.

The names and addresses of corporate art consultants and advisors are listed in *The Corporate Art Advisors Directory* (see the Appendix section "Corporate Art"); in the index of the *Art in America Annual Guide to Galleries, Museums and Artists* (see the Appendix section "General Arts References"); and in the Yellow Pages under "Corporate Consultants." The names of corporate galleries are also listed in the *Annual*.

The names of corporate collections and curators can be found in the *Directory of Corporate Art Collections*. Although the *Directory* lists over 450 corporate collections in the United States and in Canada, it is not all-inclusive. If some corporations in your area are not listed in the *Directory*, it is worthwhile to make some phone calls to inquire whether they have collections.

Many large architectural and interior design firms delegate a project manager or project designer to select work and/or maintain a slide registry. In some instances a resource library/slide registry of artists is organized by the staff librarian. The names of architects and interior designers in your area can be obtained by contacting local chapters of the American Institute of Architects and the American Society of Interior Designers or through the national headquarters of the AIA and ASID (see the Appendix section "Corporate Art").

In addition, the names of architectural and interior design firms can be gleaned from architectural and design

publications, which often feature artwork in their articles. The names and addresses of many of these publications in the United States, Canada, and abroad are listed in the Appendix section "Interior Design and Architecture."

Creating Your Own Exhibition Opportunities

Even though your slides are circulating in registries, museums, commercial galleries, alternative spaces, et cetera, don't sit around waiting to be asked to exhibit and don't depend on someone to suggest a context in which to exhibit your work. Create your own context and exhibition opportunities.

THEME SHOWS

Curate your own exhibitions or performances, based on themes that put your work into a context. Theme shows can feature your work exclusively or include the work of other artists. A theme show implies more than a straightforward exhibition. At their best, theme shows increase and enhance art-viewing consciousness, demand the participation of many of our senses, and help the public as well as the art community understand and learn more about what an artist is communicating and the motivating influences revealed in the work. For example, the group exhibition "A, E, Eye, O, U, and Sometimes Why" contained two-dimensional pieces that used "a variety of media to express the concerns and reactions to different social, informational, and psychological situations, through the combined use of words and images."[23] The theme show "Top Secret: Inquiries into the Biomirror"[24] featured the work of artist Todd Siler and was comprised of

a "32-foot, 3-dimensional sketch of a Cerebreactor, drawings and detailed studies which introduce Siler's theories on brain and mind, science and art."[25]

For emerging artists, another asset of theme shows is that it is far more likely that you will obtain funding for a theme show with *broad educational value* than for a show called "Recent Paintings."

Develop and Circulate a Proposal

A proposal should describe your idea, purpose, intentions, and audience. It should tell why the theme is important, how you plan to develop it, and who will be involved. Supporting materials should include information about the people involved (résumé, slides, etc.), and indicate your space or site requirements. Depending on to whom you send the proposal, it could also include a budget and ideas on how the exhibition will be funded.

The proposal should be circulated to museums, colleges, galleries, alternative spaces, cultural organizations, and funding organizations. It very well could be that you will only need one of these groups to complete the project. On the other hand, you might need all of these groups, but for such different reasons as sponsorship, endorsement, administration, facilities, funding, and contributions.

A book published in 1981 by the Smithsonian Institution Traveling Exhibition Service (SITES) called *Good Show! A Practical Guide for Temporary Exhibitions* is an excellent resource for artists interested in curating exhibitions and is also helpful for proposal writing, as it covers the complete range of factors that need to be taken into consideration (e.g., advance planning, preparation, fabrication, illumination, and installation). The book also includes a good bibliography for each of the subjects it covers. For further information see "Exhibition Planning" in the Appendix.

OTHER ALTERNATIVE SITES AND SPACES

In addition to the traditional types of exhibition spaces in commercial galleries and museums, there are many other kinds of spaces available to artist-initiated exhibitions. Mimi and Red Grooms's "Ruckus Manhattan" exhibition opened in a warehouse in Lower Manhattan and ended up at the Marlborough Gallery. Artist Richard Parker turned the windows of his storefront apartment into an exhibition space for his work and received a grant from the New York State Council on the Arts to support the project. Bobsband, a collaborative of artists, convinced New York City's Department of Transportation to let them use the windows of an unused building in midtown Manhattan to exhibit their work and the work of other artists. They started the project with their own money and eventually received financial support from federal and state arts agencies. Banks, barges, parks, alleys, rooftops, building façades, and skies are only a sampling of other alternative sites and spaces that artists, dancers, performers, and musicians have used as focal points, props, and backdrops for projects.

Additionally, the General Services Administration's Living Buildings Program makes space available to individuals and groups in federal government buildings throughout the United States. Lobbies, courtyards, plazas, auditoriums, cafeterias, et cetera are made available for a wide range of cultural, educational, and recreational activities (including exhibitions, dance, theater, performance, concerts, festivals, and films). The spaces are available at no charge for lunchtime and after-hour use. (If additional heat, air-conditioning, maintenance, or guard service is needed, a fee is charged.) Some of the Living Building resources in New York City include 20,000 square feet of courtyard/plaza space in Federal Plaza; the lobbies

of the U.S. Courthouse, U.S. Courthouse Annex, and U.S. Customs; and 2,000 square feet of lobby space and 2,000 square feet of plaza space at a federal building located at John F. Kennedy International Airport! "Alternative Exhibition/Performance Opportunities, Places, and Spaces" in the Appendix lists the addresses where information can be obtained about the Living Buildings Program, as well as other resources for alternative-exhibition ideas and information.

ARTIST FEES

Often artists let the excitement of an exhibition opportunity interfere with clear thinking, and overlook various exhibition costs. The most neglected item in budget planning is an artist's *time*. For example, the time involvement even before an artist receives an invitation to exhibit, time spent, for instance, conceptualizing an exhibition, researching and contacting galleries and museums, and preparing and sending proposals and/or presentation tools. Then there is the time for preparing, installing, and dismantling the exhibition. The list could go on and on.

Although some alternative and nonprofit galleries pay artists a fee to help offset exhibition expenses, this practice has not been widely adopted nor is it widely recognized by artists that they have the right to request a fee, particularly a *realistic* fee.

Canada is far ahead of the United States in acknowledging the need for *realistic* artist exhibition fees. For example, the Canadian arts service organization Canadian Artists' Representation Ontario (CARO) recommends minimum exhibition fees that artists should charge when exhibiting in public or nonprofit museums and galleries. Recommendations take into account a wide variety of exhibiting situations, including single, two-, three-, and

four-person, and group; regional, interregional, national, and international touring and nontouring; and juried and nonjuried shows. CARO's recommended fees are published in the *CARFAC Recommended Minimum Exhibition Fee Schedule* (see the Appendix section "Exhibition Planning").

·5·
Dealing with Dealers and Psyching Them Out

Although this chapter is primarily about gallery dealers, much of the information, advice, perspectives, and views are also applicable to other people in the art world, including curators, critics, administrators, collectors, and artists. Although some of my impressions and character-izations are severe, the purpose of this chapter is not to throw all of the blame for the ills and injustices in the art world on dealers, curators, and the like. *Artists must also accept responsibility for the way things are,* namely because most artists participate or try to participate in the dog-eat-dog system without trying to change it.

In 1983, I wrote that the "restructuring of the com-mercial art gallery might not be too far off, though not necessarily because of the inequalities or injustices of the system," but because at that time there had been a "marked decline in the sale of art, reversing an upward trend that [had] lasted almost twenty years." I also wrote that "gal-leries may have to make some fundamental changes in the way they do business if they are to survive."

By 1985, my prediction started to happen, not because of a decline in the art market, but because of the high costs of running a gallery. Some dealers have given up their galleries to become agents (see page 100), having dis-

covered that it is much more economical to sell without "walls."

This change could well be indicative of an eventual disappearance of the gallery system. If dealers are beginning to recognize that art can be sold without a gallery, artists should also question the necessity. Perhaps by the year 2000, the commercial gallery will be viewed as a relic of the past, replaced by artists who exhibit work in their studios and sell directly to the public. But for the time being, since the gallery system still exists, the following opinions and advice about dealing with dealers are aimed at helping artists acquire more control over their careers and relationships with those who currently run the show.

How Dealers Find New Artists

In 1979, *Artworkers News* published the first comprehensive survey of New York City galleries that show contemporary art.[26] The study was based on a questionnaire completed by ninety-nine galleries. The galleries were selected from those listed in *Locus Gallery Guide* and *Gallery Guide*; from a list of galleries where various artists listed in *Who's Who in American Art* had exhibited; and with the assistance of the board members of Women in the Arts.[27]

Although the main purpose of the study was to investigate the extent to which galleries were excluding artists on sexual or racial grounds,[28] the survey results unearthed some valuable insights into the gallery system in general. For example, the study showed that while seventy-five of the galleries viewed slides of unreferred artists, fifty galleries had not taken on an unreferred artist in the past two years. Twelve galleries reported that they got new artists primarily from viewing slides of unreferred artists.

The study also revealed that while the majority of galleries viewed slides, the main intent was not to look for new artists. Reasons cited for viewing slides included not wanting to discourage young artists, keeping in touch with the kind of work currently being done, and looking for artists whose work the dealers would be interested in following over a period of years.[29]

Although you might find the above statistics depressing, do not use the findings to rationalize why it is a waste of time to have your slides reviewed by dealers. Instead, turn the findings around and look at the situation in another light. For example, the study showed that the gallery *slide-viewing system is not a total dead end.* Some galleries *do* invite unreferred artists to exhibit; some galleries *do* want to keep an eye on new artists; and gallery dealers in general *do* want to know what's going on outside of their own confines, and logically so, for their livelihood depends on artists, a fact that artists tend to forget.

REFERRAL SYSTEMS

The study also revealed that the main ways galleries get new artists are through artist referrals *and* referrals from other "art-world figures." The study indicated, however, that artist referrals are the *primary* source.[30]

The following is a good example of how the artist-referral system works: one of my clients, a painter, approached a well-known New York gallery dealer. He set up an appointment, showed his slides, and the dealer responded with the "Come back in six months" routine. Several weeks later, while the painter was working as a waiter, he noticed that a famous artist was sitting at one of the tables. He introduced himself to the celebrity and asked whether he would come to his studio to see his work. The painter and celebrity exchanged telephone numbers, and within the next few weeks the celebrity

paid the artist a visit. The celebrity was impressed with the painter's work, so impressed that he bought a painting and insisted that the painter show his work to a specific gallery dealer, coincidentally the same dealer who had rejected him a few weeks before. The celebrity called the gallery dealer, raved about the artist, and shortly afterward my client returned to the gallery. This time he was greeted with another routine, but one more pleasing to his ear: "Where have you been all my life?"

Relatively few new artists are admitted into galleries; assuming that dealers heed mainly the advice of other artists, my contention that artists are not "referring" each other to the extent to which they should seems accurate. This is discussed throughout Chapter 3.

On the other hand, although artist referrals do exist, I am skeptical as to whether the gallery dealers who responded to the *Artworkers News* questionnaire were honest about artists being the primary referral source. It sounds good for the record, but compared to artist referrals, referrals from other art-world figures offer more mileage and reverberation. For example: curator tells dealer that critic wrote an excellent review about artist. Dealer checks out artist and invites artist into gallery. Dealer tells curator that artist is now part of gallery. Curator tells museum colleagues that artist is part of gallery and has backing of critic. Curator invites artist to exhibit at museum. Curator asks critic to write introduction to exhibition catalog in which artist is included. Dealer tells clients that artist has been well reviewed and is exhibiting at museum. Clients buy.

There are other variations on the same theme, including curator/dealer/critic conspiracies, which involve each buying the work of an unknown artist for very little money. Press coverage and exhibition exposure begin, and within a short period of time the dealer, curator, and critic have substantially increased their investment. They can also

take credit for discovering the artist, which adds points to their careers and status within the art world.

New York art dealer Richard Lerner acknowledged the importance of the art-world–figure referral system when he discussed his criteria for inviting new artists into his gallery. He described his selection process, which sounds more like a shampoo-judging contest, in this way:

> For the benefit of the people that are already in the gallery, it's imperative, if I add names, I add names that already have some luster . . . I mean peer approval . . . who are recognized curatorially, critically as having importance in the mainstream of American art.[31]

The rewards of the artist-referral system in its current form cannot compete with those of the art-world–figure referral system. Ideals of support, compassion, and brother-sisterhood have much less weight than art-world status and prestige. Unfortunately, the existence of a *real* artist-referral system is a joke at this time, and the words of W.C. Fields, "Never give a sucker an even break," are the ruling philosophy.

Dealers and Their Personalities

I am reminded of an artist who telephoned me to make an appointment to discuss her career. She called back a few days later to cancel, saying that her slides weren't ready, then quickly changed her mind about the excuse she had offered and lashed into a tirade that ended with: "And who in the hell are you to judge my work? I don't want to be put in a position to be judged."

It took me a while to regain composure, but when I did, I told her that, in my capacity as an artist's consultant,

I did not judge work, and even if I did, *I didn't call her, she called me and set up the situation!*

Artists have an "attitude" about dealers and are often unwilling to give them the benefit of the doubt that they might be good people. They reserve obnoxious personality quirks for the occasions when they have a dealer's attention. There have been countless times when I have watched an artist transform from Dr. Jekyll to Mr. Hyde without the slightest provocation.

Once at a cocktail party where artists were in the majority, a painter used the opportunity to verbally abuse a dealer he had just met for the first time. At the top of his lungs he held him personally responsible for the hard time he was having selling his work, and he tried, unsuccessfully, to goad his colleagues into joining his tirade. The scene served no other purpose than to add some excitement to what, up to that point, had been a very dull party. The dealer left in a huff, followed by the artist, who was angry that he received no support or encouragement from his peers.

On another occasion a meeting I had with a client and his dealer centered around the artist's career. As long as this was the case, the artist was enthusiastic and amiable. However, when we finished the subject at hand and drifted onto other topics, the artist began yawning, squirming in his chair, and nervously rapping on the table. When he saw that neither the dealer nor myself intended to respond to his body language, he started ranting that he was bored with our conversation. With one conciliatory sentence the dealer placated the artist with such ease and skill that I realized how familiar and experienced he was with this kind of behavior.

Arrogant and *temperamental* are adjectives frequently used to describe both artists and dealers. Who started the name-calling first? Was it the arrogance of an artist that forced a dealer to retaliate with the same weapon? Or was it a temperamental dealer who triggered the same re-

sponse from an artist? Is it a chicken-and-egg situation or a matter of simultaneous combustion?

Arrogance is a self-defense tactic to disguise insecurities; and frustration is often demonstrated through a temperamental personality. Artists and dealers have a lot of insecurities. What about frustration? It is easy to understand and explain why artists are frustrated. Why should a dealer be frustrated?

Many dealers are frustrated artists who did not have the tenacity, perseverance, and fortitude to stick it out. Consequently, they are jealous of anyone who did. Some dealers' wrath pours forth when they spot weak work or weak personalities. This particular kind of artist reminds them of themselves, memories that bring little pleasure. Other dealers behave like bulls that see red: all artists are threatening. They do not differentiate.

Because many dealers are unable to produce provocative work, and *showing* provocative work does not gratify their frustrated egos, they compensate by cultivating provocative personalities. Some dealers are so skilled in verbal delivery, they lead others to believe that they know what they are talking about. These dealers begin to believe that their reputation gives them the right to make outrageous, irresponsible demands and give outrageous, irresponsible advice. These dealers also believe that reputation alone exempts them from operating from a vantage point that includes morality or integrity, let alone courtesy.

A painter once came to me for advice about his dealer, with whom he had been for several years. The dealer gave him single shows on a regular basis, and the artist sold well at all of them. However, the dealer, one of the more well-known in New York, had been badgering the artist for months to stop doing free-lance work for a national magazine. The dealer contended that if the artist continued to work for the magazine he would not be taken seriously as a *fine artist.* The artist began to question the

dealer's judgment only when it infringed on his financial stability. Until then, he had let the dealer's opinions influence and control his life.

In response to his problem, I simply stated that it was none of the dealer's business how an artist made money, but the artist looked at me as if this was the biggest revelation of the century!

Another client was told by a dealer who had just finished rejecting him to be careful about showing his work to other artists because they might steal his ideas. The artist didn't know what to do with the backhanded compliment. On the one hand, the work wasn't good enough for the dealer. On the other hand, it was good enough to warrant having ideas stolen. Up until that point the artist was not paranoid about other artists stealing his ideas, but the dealer successfully instilled a fear: beware of the community of artists!

Dealers take great delight in giving artists advice on how their work can be *improved*. The lecture begins with a critique of the artist's work that quickly transforms into an art history class. And artists listen. They listen in agony, but they listen.

IT TAKES TWO TO TANGO

If dealers are sadistic, then artists are masochistic for letting them get away with so much abuse. The following episode illustrates the point loud and clear.

A painter took her slides to a dealer. While he was viewing her work, he lit up a cigar. After examining the slides he said that he wasn't interested, her work was "too feminine." He then proceeded to give the artist a lecture on the history of art, all the while dropping cigar ashes on her slides.

The artist watched in excruciating pain, but didn't say a word. When the dealer finished the lecture, the artist

collected her slides and left the gallery. But she was so devastated by the symbolism of the ashes on her work that she put herself to bed for three days.

Regardless of whether the dropping of ashes was sadistic or inadvertent carelessness, the question remains, why didn't the artist say something? For example, "Excuse me, but you are dropping ashes on my slides!"

One wonders: if the dealer had been pressing his foot on her toe, would she have allowed him to continue? When the dealer said that her work was "too feminine," she should have immediately left the gallery (with a curt "Thank you for your time") or stayed to challenge his idiotic statement.

Just as artists tend to forget that, to a great extent, a dealer's livelihood depends on an artist's work, dealers also forget, and they need to be reminded. Reminding them won't necessarily mean that they are going to like your work any more or less, but it can give you some self-satisfaction, and it puts things in perspective, something that the art world desperately needs.

The Private World of an Art Dealer

If art dealers do not mix business with pleasure more than people in any other profession, they certainly give that impression. Art dealers seek out clients and clients seek out dealers. One reason that particular dealers are sought out is that they are able to make clients believe that they are in the nucleus of "culture," and many people believe it. People who are involved in culture are socially in demand, for it is presumed that they have the "inside word." The inside word can be, for example, "who's in" and how much an art commodity could be worth in the future.

Successful dealers do not sit in their galleries and wait for a buyer to enter. They have to hustle. They hustle in the gallery, outside the gallery, and everywhere they go.

They make, arrange, and negotiate deals with collectors, corporate buyers, curators, other art dealers, magazine editors, and members of the press. They give and attend cocktail parties, dinner parties, previews, and openings. They travel to other cities and other countries.

Unfortunately, artists and collectors are paying the bills. Collectors, with the monies they pay a dealer for buying art, and artists, through their commissions.

Artists should ask themselves: Are all of these expenditures by a dealer necessary to sell and buy art? Dealers are convinced they are. And why not? They have developed a very pleasant life-style for themselves under the umbrella of marketing and sales. While dealers will tell you that it is hard, exhausting work (which I do not question), it is work that gives them a lot of pleasure as well as financial security and status. But does an art collector, regardless of whether he or she is collecting for investment to hedge inflation, for purely aesthetic reasons, or for collecting's sake, need to be wined, dined, and pampered to buy a piece of art?

Most artists do not question anything a dealer does in the name of *selling*. Many artists are so in awe of anyone who can sell their work, they relinquish control of the methods and principles used. This is part of the marketing mystique.

I am not convinced that fringe benefits are necessary to sell art. Although communication between dealer, patron, and artist is important, the content of the communication should glitter, not the expenses attributed to setting up a communicative situation. I have heard many dealers say that anyone who spends over $5,000 on a piece of art demands and expects something "more." But often dealers conveniently misinterpret what collectors mean by "more," and collectors are used as scapegoats to justify

why a dealer's overhead is so high and therefore why a dealer has to charge artists a high commission.

If artists do not learn to *cultivate their own market* and become less dependent on dealers for sales, artists will find themselves paying commissions in the neighborhood of 75 percent and up, just to support dealers in the style to which they are accustomed! Some preliminary groundwork is laid for cultivating an artist's controlled market in Chapters 1, 2, and 4. The information that follows in this chapter, which is intended primarily to help in approaching and dealing with curators, corporate buyers, and collectors, will also be helpful in assisting artists to develop their own markets.

Presenting Yourself and Your Work

... Dealers are so whimsical: I mean, who knows who is going to like what? I just tell people that I know it's a humiliating, horrible process. I don't approve of it at all, the way artists have to trundle around with their wares. I hate being in a gallery when an artist is in there showing slides. It makes me sick to my stomach—I mean, whoever the artist is. But the fact remains, that's how it works and I'm not going to be able to change it singlehandedly. If artists get upset about it, maybe they will do something about it.[32]

Most artists can probably identify with the circumstances and feelings described here by author and critic Lucy Lippard. But showing your work to a dealer, curator, or collector doesn't have to be a painful, heart-throbbing experience. Doing everything possible to put yourself on the offensive will make the process easier.

The first step is to understand that many dealers play games. Just *realizing that games are being played will give you an edge*, making it less likely that the games

will be played at your expense. Having an edge can give you the self-confidence and perception necessary to respond with precison, candor, wit, or whatever the circumstances call for. Compare this power with the many times you have walked out of a gallery thinking of all the brilliant retorts you wished you had said while you were there!

How you enter a gallery can also put you on the offensive. You can walk in cold, lukewarm, warm, or hot. Walking in cold means that you are coming off the streets without setting up an appointment or bothering to inquire whether the dealer has regular viewing hours. Chances are you will be interrupting one of the numerous tasks and appointments that consume a dealer's day. Walking in cold leaves you vulnerable to many uncertainties, except the fact that you will receive a cold reception.

Walking in lukewarm means that you have sent your slides in the mail as a prelude to an appointment or that you have set up an appointment in advance. If a dealer consents to an appointment without seeing slides, take advantage of the opportunity. Personal meetings can be effective and rewarding. Your personality and demeanor can influence a dealer in a positive way, but most important, face-to-face encounters give you more experience in psyching out dealers and untwisting your tongue.

If you have to send slides in advance, follow up with a telephone call about ten days later. Keep calling until you get a reaction and are sure that the slides have been *viewed by the dealer*. Dealers complain that they are pestered with phone calls, but it is the only way to circumvent procrastination and vagueness. Keep phoning. As long as the slides remain unviewed, you are losing valuable time. They could be in the process of review elsewhere, in the right place at the right time.

Walking in warm means that you have taken advantage of a connection within the referral system, that you have

been personally referred by an artist or art-world figure. You still might have a hard time getting an appointment, but be persistent. Persistence is not making one telephone call and giving up.

Walking in hot means that someone has taken the initiative to contact a dealer in your behalf with a strong recommendation.

DON'T SHOW YOUR WORK TO SUBORDINATES

Under no circumstances should you show your work to any gallery subordinate (e.g., receptionist, secretary, gallery assistant, manager, assistant manager, etc.) unless you have previously met with the dealer. Although there are exceptions, subordinates rarely have any power to influence a dealer's decision, and you should not put them in a position to interpret their boss's tastes. Too many artists make the mistake of allowing their work to be judged by gallery underlings. Subordinates are capable of giving compliments, but your ego is in sad shape if you need to hang on to the opinion of each and every staff member who happens to be hanging out at the gallery. Everyone on the staff, except the dealer, is basically an apprentice. Always get the final word from the horse's mouth!

Additionally, do not let subordinates discourage you from seeing a dealer. There are always a million excuses why an appointment is impossible. For example: "Mr. Smith is much too busy; he's going to Europe." "He's just returned from Europe." "He's preparing an opening." Don't translate this overprotectiveness of the boss to be necessarily maternalistic or paternalistic. On the contrary, it can be one of the many gimmicks used by people who feel powerless to usurp what they don't have. In some cases, subordinates want to see your work so *they* can reject it. In other cases, subordinates derive pleasure

simply by informing an artist that a dealer is unavailable. Of course, not all subordinates are involved in these power games, and there are those who are sincerely interested in seeing your work. But keep in mind that subordinates are not in a position to make the decision as to whether your work will be accepted by the gallery. Their enthusiasm or discouragement is opinion, not gospel.

There are cunning ways to penetrate the protective shields that surround a dealer. Lying is one method, for instance, "What a coincidence. I'm on my way to Europe, too. I *must* talk to Mr. Smith before he leaves so that we can get together over there!" Name-dropping can also work. And then there is basic honesty, letting the person know that *you know* that he or she is playing a power game and why. Honesty is a very effective tool in disarming someone's weapons.

PRESENTATION MATERIALS AND "STYLE"

When you meet with a dealer bring slides and photographs, a résumé, and exhibition catalogs and/or excerpts from reviews and articles. If you received press coverage that included good photographs of your work, bring the entire article. *Take care to follow the advice in Chapters 1 and 2 about these essential presentation elements,* and what and what not to include.

Make it clear from the beginning what you want from the dealer and why you are interested in his or her gallery. Prepare your answers in advance. If you address these points even before the dealer has seen your work, it will make you distinctive, setting you apart from other artists that dealers review. Dealers are unaccustomed to hearing clarity and decisiveness from artists in a review situation.

Addressing these issues is certainly not an automatic guarantee that a dealer will accept you into the gallery sanctuary, but your strong posture sets an excellent prec-

edent should a relationship develop or when you return to show the dealer a new body of work.

DON'T SEND A SUBSTITUTE

Even if a friend, mate, spouse, or relative is trying to be supportive and offers to take your work around to galleries, turn the offer down. Do not send a substitute. Sending a substitute is unprofessional and it weakens your position. (Although many dealers thrive on the weaknesses of artists, "cloning" is one weakness that even dealers can't tolerate!) A dealer wants to know, and has every right to know, with whom he or she is dealing. Likewise, an artist has the same rights and should have the same concerns. If a dealer delegates the responsibility to see an artist's work to a subordinate, an artist will not feel that he or she is being taken seriously. And if an artist is unwilling to confront a dealer, the dealer could conclude that the artist is not serious about exhibiting at the gallery.

A money factor also comes into play. If an intermediary succeeds in getting an artist into a gallery, an artist should pay a commission to both the intermediary and the dealer. Since the going rate for a dealer's commission is 50 percent, if one has to pay an additional percentage to a middleperson, there are slim pickings left for the artist.

AGENTS

The use of agents is an accepted practice and has sometimes proved to be an effective vehicle for marketing and selling art that is *commercially used*. For example, photographers, illustrators, and fashion and graphic designers use agents ("reps") to establish contacts, obtain commissions, and sell their products.

In such cases, the artist pays a commission to a rep, but not to anyone else. For an agent to make a decent living, he or she must represent several artists simultaneously. The nature of the commercial art business makes this feasible. A rep may work with many publishers, whose business requires and needs many artists, with different styles and different areas of expertise. Thus, a rep can handle many artists without anyone being neglected (although I am sure some commercial artists would argue with me on this point).

In the first edition of this book, referring to agents trying to represent artists to galleries, I pointed out that "if an agent tries to represent several artists, none of the artists receives the tender loving, undivided, and careful attention that is so very necessary in developing a successful career. The person most qualified to provide this careful attention is the person with the most vested interest: the artist."

However, what has started to change in the last few years is the emergence of a new breed of fine-art agents who bypass galleries and sell work directly to museums, corporations, real estate developers, and individuals. Many of the new agents are former gallery owners. They realize that it is more cost-effective to represent artists without high gallery-overhead costs, and that they could use their contacts and networks in a new way. Essentially the agent is actually a dealer without a gallery. The agent goes directly to the client, and two commissions are not involved.

I described an artist's fantasy about finding the perfect agent in Chapter 3. Until your career really gets rolling, and only if you have a *good* dealer, agent, or curator who is looking out for your best interests, will you then be relieved of some of the many tasks and responsibilities that consume an artist's career. A dealer is not going to devote sufficient time or energy until convinced that you are a sure bet. Until this happens, manage yourself.

STUDIO VISITS

Believe it or not, dealers dread the first studio visit as much as artists dread having them visit. Both parties are nervous and uncomfortable. Dealers are uneasy because they do not like to be put on the spot on an artist's turf. They feel more comfortable about rejecting an artist or being vague in their own territory. Dealers also feel anxious about the reception they will receive. They fear that an artist will use the studio visit to give the dealer a taste of the same medicine the artist received in the gallery!

Artists are nervous about the judgment that a studio visit implies. They are anxious about being rejected, or feel hostile, validating a dealer's worst fears that the studio visit will be used as an opportunity to "get even."

One dealer told me that she had to prepare herself mentally weeks in advance of a studio visit. "They are always a nightmare. Artists are so arrogant and hostile." I asked her how she coped with such situations. "I am indecisive and unresponsive. This drives them crazy!"

Don't go out of your way to be cold and bitter. If you find that it comes easily, be restrained. You have the power to set things up so that the studio visit accomplishes something positive. You also must take some of the responsibility if the visit turns out to be unsatisfactory. A successful studio visit should not depend on whether the dealer offers you an exhibition. Many of my clients are able to score some excellent referrals through studio visits. Although the dealers didn't believe that the work was right for their galleries, they were impressed enough to contact other dealers or curators in the artists' behalf, or offered to let artists use their name to set up appointments (enabling them to "walk in warm").

When you host a studio visit, be yourself and don't turn your life upside down. A curator who had spent a concentrated month visiting artists' studios observed that

artists who lived and worked in the same space often made a conscious effort to create an atmosphere that suggested their lives were devoid of other living entities. Although the curator saw relics and signs that indicated that the premises were inhabited by dogs, cats, babies, children, and other adults, the studio was conspicuously "cleared" of all of these other forms of life. She felt very uneasy, as if the artist had a special life-style reserved for curators. She sensed that the artists viewed her as subhuman. The strange atmosphere actually diverted her attention away from the art. She couldn't give the artists or their work her undivided concentration.

Avoid extremes. Don't brown-nose dealers or pretend that you are preoccupied with more important matters. Even though you might not yet have had a gracious or civilized gallery experience, treat a dealer the way you would want to be treated when you enter his or her domain.

Sometimes circumstances occur that are beyond your control. The worst studio visit I ever had involved a well-known art critic who came to look at my work for the purpose of writing an article in a national news magazine. The meeting was going well, but just as he began to select photographs to accompany the article, our meeting was interrupted by an emotionally unstable artist acquaintance who decided to pay me a visit. Before I had a chance to make introductions the artist lashed into a series of incoherent insults, *impersonally* directed at anyone who happened to be in the room.

While the art critic quickly packed up his gear, I tried to make apologies. The critic was unresponsive. He had assumed that the artist's insults were directed at him because he was a critic. He departed and I never heard from him again, although I wrote a letter of apology. I was guilty by association.

At first my anger was directed at the artist, but the more I thought about it, I decided that the critic and artist

had much in common: they were both devoid of clarity and powers of reason.

I lost the article, but I also lost my awe of the critic. This was an important gain.

Criteria for Selecting Galleries

AN OVERVIEW

The most common advice given to artists about selecting galleries is to start small and avoid big cities. The advice is not based on any great truism or profound knowledge; it is simply a matter of the way it is done. However, there is no guarantee that if you start with a small, low-prestige gallery you will end up in a large, high-prestige gallery, just as there is no certainty that if you start big you will automatically be turned away. Since neither of the formulas are insured to work, *approach all galleries.* Keep all of the options open and do not let supposedly pragmatic advice narrow the possibilities.

Ask yourself questions such as these when you are about to select a gallery: What can the gallery do for me? Does this coincide with my current goals? Will exhibiting at the gallery help me attain goals that I have set for the future? Does the gallery have an ethical business reputation? Are its business practices fair to both its artists and clients?

LET YOUR FINGERS DO THE WALKING, AND WEAR A DISGUISE

The *Art in America Annual Guide to Galleries, Museums and Artists* (see the Appendix section "General Arts Ref-

erences") is a very helpful tool for locating galleries throughout the United States. It lists the names, addresses, and phone numbers of galleries on a state-by-state, city-by-city basis. It also lists the names of gallery directors and describes the type of art and/or medium each gallery handles, and the names of artists represented. Use the *Annual* to compile a list of galleries corresponding to the various descriptions that apply to your work (i.e., works on paper, sculpture, photography, painting, decorative arts, etc.).

Follow up by visiting each gallery to ascertain whether the gallery is right for you. Consider this to be an "exploratory" visit, and not the time to approach a dealer about your work. On the contrary, *disguise* yourself as a potential collector. You can glean much more valuable information if a dealer thinks you are there to buy! Dealers have all the time in the world to answer the questions of potential collectors. By asking the right questions, you can learn quite a lot about a gallery's profile, including its price range, the career level of artists represented, and whether the dealer is an effective salesperson.

On the basis of your experiences from personal gallery visits, eliminate from your list the galleries that are no longer of interest, and concentrate on approaching those that have made an impression.

WHAT A GALLERY CAN DO

A gallery has the potential to provide artists with many important amenities that are valuable in the present as well as the future. The optimum services to artists can include selling work through single and group exhibitions; generating publicity; establishing new contacts and providing entries into various network systems; developing and expanding markets in all parts of the world; arranging to have work placed in collections; arranging

exhibitions in museums and other galleries; and providing artists with financial security in the form of cash advances and/or retainers.

The minimum gallery services can include selling work on consignment (without an exhibition), providing an artist with general gallery experience, adding résumé credits, and endorsing the fact that the work is good enough for a gallery.

Naively, artists either (1) believe that once they are accepted into a gallery, the optimum services will automatically be provided, or (2) enter a gallery relationship without any expectations, thus missing the amenities that a gallery could provide. Keep in mind that dealers in big galleries do not provide any more or fewer amenities than dealers in small galleries. *It really depends on the dealer.*

There are various reasons why some dealers are more supportive than others. In some instances, it is because a dealer is so busy promoting one particular artist that other gallery artists are treated like second-class citizens. Often it is a case of downright laziness. For example, an artist was told by his dealer that he had been nominated for *Who's Who in American Art.* However, not only had the dealer let the deadline pass for providing the required biographical data, but for over two months she had been "sitting" on sixty-five written inquiries, which had resulted from the artist's work being published in a magazine.

Since there are no guidebooks available that evaluate dealers by strengths or weaknesses or list the services of commercial galleries, the best way to track down this information is to talk to artists who are with a gallery or artists who have left one.

Finally, don't be afraid to leave a gallery if you find that it is no longer serving your best interests. Give a dealer a chance to respond to your needs or requirements, but if he or she is unresponsive, leave.

ETHICAL BUSINESS PRACTICES

Whether a gallery is ethical depends on its moral integrity and financial integrity. Abuses in moral integrity can be less tangible and are not always apparent until an artist is already involved in a formal relationship with a gallery. In this chapter I've described some morally abusive dealers, including those who engage in head games, who make outrageous demands on their artists, and who give outrageous advice. Some artists are willing to be morally abused by a dealer as long as the dealer keeps the financial arrangement on the up-and-up. But this is not a good situation.

In the area of finance, there are certain disreputable dealers who are easy to identify, for they blatantly nickel-and-dime artists for every expense that is directly or indirectly related to an exhibition. Up until the time work is placed in a gallery, an artist is financially responsible for the costs of preparing the work for exhibition and transporting the work to a gallery. But once the work is in the gallery, an artist should not have to pay for any costs other than a dealer's commission, and then only if the work is sold! The two exceptions are (1) an artist-sponsored auxiliary public-relations campaign (which I totally recommend: see "Publicity for Upcoming Exhibitions and Performances" in Chapter 2); and (2) additional insurance coverage if the gallery's policy does not cover the total value of the work.

Unethical dealers will try to charge an artist all sorts of incidentals, such as "hanging fees," "sitting fees," or "guard fees." They might request a "commission guarantee," meaning that if the work doesn't sell, they are still compensated (above and beyond all the other fees). Some unethical dealers will ask artists to incur total financial responsibility for public relations, promotion, and the cost of an opening.

If you are invited to present your work in an unfamiliar gallery, and you are unable to get feedback from gallery artists about the dealer's business practices, the Better Business Bureau or local chapters of the National Artists Equity Association are good resources to contact. Ask whether complaints have been registered against the gallery. You should inquire about the gallery's reputation from both an artist's and a client's point of view. I once knew a dealer who sold the same piece of work to different people at the same time. She stalled delivery to the first buyer until she found another buyer who was willing to pay more. She informed the first buyer that the artist had "a change of heart," and didn't want to sell the piece, but she then suggested that perhaps if the client offered the artist more money, the artist would reconsider. All of this was going on behind the artist's back, but if an art scam involves a client, the artist is automatically dragged into the mud, just on the basis of association with the dealer.

Negotiating with Dealers

PRICING: HOW MUCH ARE YOU WORTH?

The Artist in the Marketplace by Patricia Frischer and James Adams and *The Professional Artist's Manual* by Richard Hyman (see "Pricing Work" in the Appendix) each devote an entire chapter to the subject of pricing and how to establish a value for your work. The Hyman book explains the nuts and bolts of pricing, including such considerations as overhead, an hourly wage, cost of materials, promotion, and adding a profit over and above these expenses. The Frischer and Adams book includes this same information, but goes on to discuss more ab-

stract considerations, such as the reputation of both the artist and the dealer, and how to assign a value to a limited body of work.

However, arriving at a value is not as problematic as getting a dealer to agree to the value. Both of the above-mentioned books, as well as other publications I've come across that discuss the pricing issue, generally advise artists to acquiesce to a dealer's judgment. I do not necessarily agree. A dealer's main concern is that the work "move" quickly. Thus, dealers tend to approach work of new artists as bargain-basement specials. If a dealer believes that you have underpriced your work, by all means increase your prices. But as you become more knowledgeable about the wheelings and dealings in the art world, and develop more self-esteem, most likely you will ascribe a fair market value to your work.

Earlier in this chapter I suggested that you might visit many galleries *disguised as a potential buyer*. This approach can also be helpful in determining the market value of your works. Select a gallery artist or artists whose works are allied to your own. Ask the dealer for price information and request to see the artist's résumé. From the résumé you can determine an artist's career level. To arrive at a general price range for your work, compare the other artist's career level to your own; take into consideration the prices galleries are charging.

Once an artist becomes well-known, pricing becomes less of a problem. For emerging artists the issue is critical, and it is vital to take a firm position at this early stage of your career. At the risk of losing a dealer's interest, do not be afraid to bargain or stick to your guns. On several occasions I have assisted artists in negotiating prices with dealers. In one case, although a dealer thought the artist was overcharging, the artist would not budge from her position. The dealer "passed," only to return six months later to make a deal based on the artist's original asking price.

In another instance, I told an artist to value her work a few hundred dollars over the price she actually wanted. This way the dealer would have some bargaining leverage and believe that he had participated in the pricing decision. She got what she wanted.

Another situation involved a more well-known artist who had consistently sold a minimum of 75 percent of his work in previous single shows. A new show was coming up and he wanted to double his prices. However, the dealer was afraid the artist was pricing himself out of the market. A compromise was reached. The artist doubled the price of the pieces that were near and dear to his heart and increased the price on the other work by 50 percent. He sold work in both price ranges.

Artists sometimes wonder if they should charge certain prices in large cities but lower the price if the work is shown in the boondocks. The answer is an emphatic no. Regional pricing is insulting. It penalizes your market in large cities and patronizes your market elsewhere. It also supports elitist notions that people in small cities or rural areas are incapable of "valuing" art.

The chances are, if you are an artist in a rural area or small city and are affiliated with a local gallery, a dealer has persuaded you to price your work at what the local market will bear. But if you then connect with a gallery in Chicago, for example, where your prices are higher, make sure the prices in the local gallery are in accord with what the dealer in Chicago is charging.

Whenever you give a dealer, corporate art consultant, or *anyone* a price list, it should state the *retail* price of your work (versus wholesale). This means that you have already taken into account the dealer's commission. Although there is no way to guarantee that an unscrupulous dealer will not sell the work for a higher price and pocket the difference, you have more control if you and the dealer are on the same wavelength. All too often, and mostly because of miscommunication, a dealer assumes a whole-

sale price list is "retail" and consequently will underprice and eventually sell the work accordingly. Obviously this creates a very messy and disappointing situation, particularly for the artist who expects a larger check.

EXCLUSIVITY AGREEMENTS

Exclusivity agreements come in many shapes, sizes, and packages. In simple terms this kind of contract means that an artist gives a dealer authority to *exclusively represent* him or her in one particular city, region, country, or group of countries, or in the entire world. Exclusives can be limited to certain media as well (e.g., only paintings, only drawings, only prints).

A dealer is entitled to a commission on every sale of work that occurs within the geographic area in which the exclusive is in force. It also means that if your studio is located in this geographic region, you must *pay a dealer a commission on any sales from your studio.*

Although few artists think about it in these terms, a dealer's responsibilities and commitments should correspond to the amount of territory that an artist has relinquished. In other words, it is very important that *before* entering into an exclusivity arrangement, you know *exactly* what the dealer will do to make it worth your while. *All of this information must be put into a contract.*

Be aware that a dealer could promise to make a concentrated effort to promote and market your work in a specific geographic region, and technically fulfill his or her end of the bargain by making a few token phone calls, from which nothing results. Of course, it is in the best interests of dealers to hustle and really make an effort, but, as pointed out before, dealers can be negligent. Until you know a dealer's track record on exclusives (ask other gallery artists who have similar agreements), do not enter into a long-term exclusive agreement.

PUT YOUR NEGOTIATION RESULTS
IN WRITING

This chapter certainly doesn't cover all of the many points that should be considered negotiable between an artist and a dealer. All too often artists accept "gallery policies" as rules of the trade. But don't forget that "for every rule there is an exception."

All negotiated points (as well as unnegotiated points) *must* be put into writing. The section on "Law" in the Appendix lists some resources for obtaining legal advice and publications that contain *sample* contracts for various situations that involve artists and dealers, as well as collectors. I emphasize *sample* because the contracts should be considered as *guidelines*. No two artists, their situations, or work are 100 percent similar, and contracts should reflect these distinctions accordingly.

Beware of those dealers who won't sign contracts (or contractual letters). Requesting someone to enter into a contractual agreement does not imply that you are distrustful. It merely attests to the fact that being human lends itself to being misunderstood and misinterpreted. Contracts can help compensate for this human frailty.

Be equally aware of "prepared contracts." Just because a contract is *ready*, don't assume that its contents are "professional" or necessarily in your best interests. A contract is a *symbol* that a transaction is being handled in a "professional" manner. What the contract contains is the heart of the matter.

Once a relationship is established with a gallery it can be difficult for an artist to collect money within a reasonable amount of time on artwork sold. For various reasons dealers have been known to delay paying artists. A written agreement should incorporate the payment terms.

An artist friend whose written agreement did not specify the amount of time within which the dealer was ob-

ligated to pay him waited over a year for money owed on the sale of three paintings. The dealer lived in another city, and each time the artist telephoned he was told "the check is on the way."

Although the artist wanted to confront the dealer *in person*, he was afraid that if he arrived at the gallery unannounced, the dealer would "have another appointment." Or if the dealer knew that he was coming, she would make a point of being called out of the gallery at the last minute.

We put together a scheme that assured that the dealer would be in the gallery on a specific day at a certain time, but without knowing that the artist was also planning to show up. I had telephoned the dealer and told her that I was a curator from a well-known New York museum and was interested in some of her gallery artists. Of course she was eager to see me, and an appointment was set up for the following day. The "curator" didn't show up at the prescribed time but the artist did. We will never know whether she eventually figured out our plan, but the artist returned to New York with a check in hand!

Although our scheme worked, we gambled on a long shot, as there was no guarantee that the artist would receive a check if he confronted the dealer in person. If the payment term had been specified in the gallery contract, all of the acrobatics, frustration, and delays could have been avoided.

·6·
Dealing with Rejection

Rejection as an Asset

An artist described her experience with rejection in this way: "I, like most young artists, romanticized the idea of 'being an artist' and in so doing anticipated a degree of rejection, but had I known the degree of rejection that would be in store . . . I might have chosen to become a doctor instead. Frankly, I don't get it."[33]

There are many reasons why an artist's work is rejected. Artists are constantly turned down from galleries, museums, alternative spaces, juried shows, teaching jobs, and the like. A bad review is a form of rejection and so is *not being reviewed.*

Some artists are rejected for reasons over which they have no control. But others are rejected for reasons for which they are *ultimately responsible* and for *these* artists rejection can be an asset. It might be the only indication an artist has that his or her career is being mismanaged.

If an artist is *really* willing to be self-analytical and take responsibility for rejection, corrective action can be

taken. Artists who are responsible for rejection include those who neglect to strengthen the odds for *acceptance* by taking the initiative to create opportunities for things to happen. Examples of such artists have been described throughout this book: those who haphazardly enter the marketplace; those who are afraid to confront gallery dealers and send representatives; those who walk into galleries cold; those who prepare poor presentations; and those who can't abandon the "myth of the artist."

Some artists rely on moods to get in the marketplace. A burst of energy tells them it is time to make contacts and take action, and for the next week, two weeks, or month they are sincerely dedicated to showing their work around. But the goal is instant gratification, and if expectations are not rewarded, they retreat. Depending on the artist, it can take months—sometimes years—for anything constructive to happen.

Artists who are controlled by moods further encourage self-defeat by drawing the conclusion that rejection is an absolute: once they are rejected, a gallery's doors are always closed. Consequently, these artists will not return to the gallery with a new body of work.

These problems are not insurmountable. Do not let moods dictate your life. Discipline and consistency can be vital medicine.

Stop putting all of your eggs in one basket. If you are not creating opportunities for things to happen, try another approach.

Think big and broad. Submitting one grant application a year or seeing one gallery every six months is only a gesture. Strong, affirmative results do not come from gestures.

Make inroads in many directions simultaneously. Submit grant applications while you hustle galleries, and hustle galleries while you look for press coverage. Don't trade in one facet of career development for another. *What you want are lots of baskets filled with lots of eggs.*

The section "Public Relations Is a Daily Job," at the end of Chapter 2, describes the rhythm needed for establishing contacts. Each time you receive a letter of rejection, initiate a new contact, send out another letter, or pick up the phone. Replace feelings of rejection with a sense of anticipation. This process strengthens the odds for acceptance and as such keeps your psyche in good shape.

Building Immunities to Rejection

Artists are not responsible for rejection caused by subjective forces, including "taste buds," trends, norms, and other people's priorities. These forces can be illogical, arbitrary, and basically unfair.

I once had a grant application rejected. The grant's panel had confused me with another artist whose name was similar. That artist had previously received a grant from the same foundation, but had misused the funds. It was only by accident, and many months later, that I learned what had happened.

This was luxurious rejection: I could not take it personally or hold myself responsible, and I was able to learn the *real* reason. It is rare, though, that artists know the real reasons why they are rejected. Consequently, they think they are untalented and that their ideas are without merit.

The side effects of rejection are more horrendous than the actual rejection. For this reason, once you have ascertained that you are no longer responsible for the situation, it is important to build up an immunity against being affected by rejection.

Artist Billy Curmano described his immunity system in *Artworkers News*: "One day, while reflecting on . . .

accumulated rejections, I composed an equally imper-
sonal rejection rejection and have begun systematically
sending it to everyone in my file. . . . Striking back im-
mediately becomes a ritual to look forward to."[34] Hence,
Mr. Curmano composed the following letter.

Hello:

IT HAS COME TO OUR ATTENTION that you sent a
letter of rejection concerning BILLY CURMANO (herein-
after the "Artist") or his work dated _____ to the Artist.
BE IT KNOWN TO ALL, that the said MR. CURMANO
no longer accepts rejection in any form.
KNOW YE THAT, this document, as of the day and year
first written, shall serve as an official rejection rejection.
IN WITNESS WHEREOF, Artist and Counsel have set their
hands and seals as of the date above first written.[35]

Mr. Curmano provided space for his signature as well as
his counsel's and ended his rejection rejection notice with:
"We are sorry for the use of a form letter, but the volume
of rejections received makes a personal response impos-
sible."[36]
One starting point for developing an immunity to re-
jection is to look at rejection in terms of its counterpart—
acceptance, or what is commonly referred to as *success*.
Rejection and success are analogous for various reasons.
What artists define as rejection and success are usually
borrowed from other people's opinions, values, and prior-
ities. Artists who measure success and rejection in terms
of what society thinks have the most difficult time coping
with both phenomena.
Both success and rejection are capable of producing an
identity crisis. Some artists who attain success find them-
selves stripped of goals, direction, and a sense of purpose.
The same holds true for artists who are rejected.
Stagnation is a by-product of success and rejection. Art-
ists who are rejected can be thwarted, diverted, and blocked

in their creativity. Artists who attain success can lose momentum and vision.

It *is* possible for artists to be unscathed by rejection or success, and continue with new goals, directions, and explorations, irrespective of other people's aesthetic judgments.

The sooner you lose an obsession over rejection, the sooner your real potential develops, and the better equipped you will be to handle success. Save obsession for important causes, such as clarity, overview, and soul-searching.

If you accept the premise that the reasons for rejection are not truths or axioms, analyze rejection under a microscope. Reduce it to its lowest common denominator. Who is rejecting you? What does the person or entity mean relative to your existence? Is this entity blocking your energy, self-confidence, and achievements? Are you so vulnerably perched that other people's opinions can topple your constellation?

When you can have a good laugh over the significance you had once placed on the answers to these questions, you will be able to respond to rejection in the same manner in which you respond to any other form of junk mail.

·7·
The Mysterious World of Grants: Fact and Fiction

He who hesitates watches someone else get the grant he might have gotten.
—JANE C. HARTWIG
Former Deputy Director,
Alicia Patterson Foundation

Who gets grants and why? The *real* answers to these questions can be provided by jurors who select grant recipients. All other answers are speculative and have more to do with hearsay than reality. When I asked members of various grants panels about their selection criteria, their answers were simple and direct: they liked the artist's work or they liked the project under consideration and thought that the artist was capable of undertaking the work. Probing further, the answers were predictably numerous, varied, and subjective, and boiled down to "taste buds."

Artists who are apprehensive and skeptical about applying for grants have many misconceptions about who receives them. Skeptical artists deem themselves ineligible for various reasons, such as being too old or young, lacking sufficient or impressive exhibition or performance credits, or lacking the *right* academic background. They believe that the kind of work they are doing isn't considered "in," or they lack the *right* connections, which implies that juries are rigged!

It is perfectly conceivable and probable that some artists have been denied grants by some foundations because of some or all of the above-mentioned factors. However,

on the basis of my own experiences as a grant recipient and those of my clients (the majority of whom would not measure up to the tough profile that many artists conceive as being the perfect "grant-winning specimen"), I am convinced that, for the most part, grant selection is a democratic process—meaning that everyone has a *real* chance. Steve Penny, author of *How to Get Grants in Films* (see "Grants" in the Appendix) writes:

> I was able to get my start in filmmaking with a grant to produce an ethnographic documentary on *The Cave Paintings of the Chumash Indians*. The grant was awarded despite the fact I had no previous background in photography or anthropology. I received grants to travel around the world and make films, not because I have any extraordinary qualifications or contacts, but rather from a careful study and practice of grantsmanship.[37]

Many artists believe that because they have applied for the same grant year after year without success, it is a waste to continue to apply. Images are conjured up of a jury sitting around a table moaning, "Oh no, not him again!" Or conversely, there are artists who believe that one must apply for the same grant at least three or four times before it will be awarded: "It's her fourth application, let's give her a break!" But contrary to the notion that jurists remember who applied for a grant each year, most panels change their members each time a jury convenes. Each time you apply you have a fresh chance.

Since grant selection in the arts is based on taste, and, like taste buds, the grants world is mysterious, whimsical, and fickle, you should not depend on or view grants as the only means to provide the opportunity to do what you really want. Grants should be looked upon as "cream" to help alleviate financial pressures for a temporary amount of time, provide time and new opportunities to develop your career, and add another entry to your list of endorsements.

Projects and ideas should not be tossed aside or thwarted if funding agencies or foundations reject your application(s). Remember, the selection criteria is subjective and *ultimately you must be the judge* of whether your work and ideas have merit. A grant is not the deciding factor.

Also remember that juries are composed of human beings, and humans can't always predict a "winner." In fact, we have quite a track record for not recognizing talent (until someone dies), while putting some rather scandalous people on a pedestal.

The grants world might seem mysterious, but hundreds of artists each year who took the time and energy to investigate grant possibilities and complete well-thought-out applications are reaping the benefits.

Big Grants and Little Grants

If Your Mother Is an Eskimo, Have I Got a Grant for You! Grants come in many different shapes, sizes, and forms. Although grants and fellowships sponsored by the National Endowment for the Arts, the National Endowment for the Humanities, and state arts councils are the most well-known in the performing and visual arts fields, there are many other grants available. Because they are less known, they are often less competitive in terms of the numbers of people applying.

There are grants for visual and performing artists with broad-based purposes and specific project grants for well-defined purposes. For example, there are grants for artists who are women, artists who are mothers, artists with a particular ethnic or religious background; grants for artists born in certain regions, states, and cities; grants for artists involved with conceptual art or traditional art; grants for travel; grants for formal study; grants for in-

dependent study; grants for apprenticeship; and grants for teaching.

From year to year grant agencies and foundations open and fold, cut budgets, increase budgets, change their funding interests and priorities, emphasize one arts discipline over another or one socioeconomic group over another. It is important to keep abreast of these changes. A grant that is not applicable to your current situation and interests could be suitable in the future.

Even when budgets are being cut, don't hesitate to submit grant applications. A case in point: in 1982, while federal arts budgets were being slashed, I received a large matching grant from the National Endowment for the Arts. I was not optimistic that I would receive a grant when I submitted the application. Not only was I surprised that I received the grant, I was also surprised that I was awarded every penny that I requested. However, it was pointed out to me by a person familiar with the inner workings of the NEA that when government arts funding is cut, people are reluctant to submit grant applications. Thus, much of the normal competition is reduced. In many instances, people have a better chance of receiving a grant when the financial climate is restrained.

The section "Grants" in the Appendix lists some resources where you can learn more about grants in the visual and performing arts.

ART COLONIES AND ARTIST-IN-RESIDENCE PROGRAMS

Acceptance in art colonies, also known as retreats or artist-in-residence programs, is a form of a grant, since the sponsoring organization subsidizes the artists whom they select.

These retreats are scattered throughout the United States and the world. They offer artists an opportunity to work

on a project for a specific amount of time, free from life's daily burdens, responsibilities, and distractions.

Subsidization can be as comprehensive as transportation expenses, room and board, and a monthly stipend. Or it can be limited to partial subsidization of room and board, with the artist required to pay a small fee.

Some colonies offer luxurious creature comforts, such as the American Academy in Rome and the Bellagio Study Center in Italy, sponsored by the Rockefeller Foundation. Other colonies offer a summer-camp ambience and are based on a communal structure.

There are colonies that specialize in one particular arts discipline as well as those that include visual and performing artists and writers.

Artist-in-residence programs can include teaching opportunities (described in the next chapter) as well as international exchanges. For example, Partners of the Americas sponsors an exchange program that involves visual and performing artists in the United States, Latin America, and Caribbean countries. The British American Arts Association organizes exchange programs between artists in Great Britain and the United States.

Additional information and resources about domestic and international art colonies, artist-in-residence programs, and exchange programs are listed in the Appendix under "Art Colonies, Artist-in-Residence and Exchange Programs."

MORE OPPORTUNITIES

There are more grants available to nonprofit arts organizations than to individual artists, and the dollar value of the grants available is substantially higher. For this reason, in the early 1970s I turned myself into a nonprofit, tax-exempt organization. The tax-exempt status also al-

lowed private individuals to receive a tax break on any contributions and donations to my various projects.

Although there are many advantages to being a nonprofit, tax-exempt organization, there are also disadvantages. For example, while my nonprofit organization was in operation I found myself spending a disproportionate amount of time completing forms and various reports that were required by federal and state agencies. Another drawback was having to contend with a board of directors, which diminished, to a certain extent, the autonomy that I had enjoyed while working on my own. You should evaluate your situation carefully before taking any steps to form a nonprofit organization. For further information about forming this kind of organization see "Nonprofit Organizations" in the Appendix.

If you personally do not wish to go nonprofit, there is an option available that would allow you to bypass the tax-exemption route: use the services of an *umbrella organization*. Umbrella organizations are nonprofit, tax-exempt groups that let you apply for a grant under their auspices. If a grant is awarded, the umbrella organization receives the award and in turn pays you.

Umbrella services can vary from a minimum of signing a grant application to bookkeeping, managerial advice, preparation of annual, federal, and state reports, assistance with publicity and promotion, and fund raising. In return for these services, a percentage of any grant that is awarded to an artist or a group of artists goes to the umbrella organization.

Umbrella organizations do not take all artists under their wings. Their criteria are based on the nature of the project and the impact it will have on the community. Umbrella groups rely on grants to pay their overhead and salaries, and their ability to receive grants depends largely on the success of the projects they sponsor.

The best way to learn about umbrella organizations in your area is to contact your local state arts council.

Increasing Your Chances of Being Funded

PREAPPLICATION RESEARCH

Before completing a grant application learn as much as possible about the funding organization. Your homework should include eligibility requirements, funding priorities, the long-term goals of the organization, and the maximum and minimum amount of the grant. Jane C. Hartwig, former deputy director of the Alicia Patterson Foundation, emphasizes the importance of homework: "The fact that you have done your homework, even at the earliest stage, is impressive, and appreciated by the foundation. It will also save you time, money, and possibly grief."[38]

When you receive your application instructions and the background information about the agency or foundation, the kind of language used will give you a strong indication of the types of art and arts projects that are funded. For example, a foundation that describes the purpose of its grants as "to foster a high standard in the study of form, color, drawing, painting, design, and technique as expressed in modes showing a patent affinity with the classical tradition of Western culture"[39] makes it very clear what they are looking for. If your work or project involves anything other than "the classical tradition of Western culture," it is a waste of time to apply to this foundation.

SUBMITTING VISUAL MATERIALS

Grant applications in visual arts usually require that slides or photographs of the artist's work accompany a written application. Although some funding agencies request to see the actual work once an artist passes a semifinal stage,

most organizations make their final selections on the basis of slides or photographs.

Too often artists place great importance on a written application and give too little attention to the photographic material. Both are important for completely different reasons. Here are some guidelines to follow in submitting visual materials. In addition, review the section "Slide/Photo Presentations" in Chapter 1.

(1) All photographic material should be of *top quality*: clear and crisp, with good lighting and tone.

(2) Submit photographs of your most *recent* work. Funding agencies do not want to see a retrospective of your last ten years. They want a strong, clear indication of your current interests and directions.

(3) Select photographs or slides of the *best* of your recent work. *You decide what is best.* If you are indecisive about what to submit, consult with someone whose taste you respect.

(4) Even if the funding agency does not require photographic materials to be labeled, *label* each and every slide or photograph with the following information: your name, title, medium, date of the work, dimensions, and include a directional indication showing the top of the work. This information could make the difference between your work being rejected or entering the next stage of judging. Photographs or slides should seduce the judges, but if they are confused and can't "read" what is going on, they will not take time to look up your written application in hopes of clarification.

COMPLETING APPLICATIONS

The first time one encounters a grant application the initial reaction is often like trying to decipher Egyptian hieroglyphics. Mastering grant applications *is* like learning a new language, and the more experience you have the easier it becomes.

In addition to carefully following instructions, the best posture to take when filling out an application is to put yourself in the shoes of a jurist. In other words, you want to read applications that are legible, clear, and that come quickly to the point. You do not want to have to reread an application for clarity. Applications should hold the judges' attention.

I am often called upon to review *unsuccessful* grant applications. These applications tend to have in common one or all of the following mistakes:

(1) They reflect a negative tone, implying that the artist has a chip on his or her shoulder (e.g., "The world owes me a grant").
(2) The description of the grant purpose and/or project talks over the heads of the readers, rambles on with artsy language, and goes off on irrelevant tangents.
(3) Funds are requested for inappropriate or "off-the-wall" purposes, basically insulting the intelligence of the judges.

Judging Procedures

Most funding agencies use the first round of judging to sort through applications to make sure that artists have complied with all of the instructions, rules, and regulations. Consider this the "negative" stage of judging, as the agency is on the lookout for applicants who do not follow instructions. The purpose of this hunt has no deeper significance than making the judges' work easier by reducing the number of applications to be considered.

The next round of judging is based on viewing slides and photographs. For example, the Artist Fellowship selection in the Visual Arts Division of the National Endowment for the Arts works as follows: four to five panelists view ten slides of one's artist's work. The slides are pro-

jected on a screen, five at a time. Each artist is rated on the basis of a point system, and artists who receive the highest rating go on to the next judging round. The same ten slides are shown again, and the artist is rated again. The same process continues until the panel has narrowed down the selection of artists for the final stages of judging. At this point the written application is reviewed.

"SAY THE SECRET WORD AND WIN ONE HUNDRED DOLLARS"

Probably as a result of the many tests one is subjected to in school, artists approach a grant application as an aptitude or IQ test. It is felt that ultimately the application is trying to trick you with double meanings. The fact is that there are definitely "wrong" answers, such as those described from the unsuccessful grant applications, but there is no one "right" answer.

For example, the National Endowment for the Arts fellowship applications request information on *educational background* and *salary*. Those artists who believe their formal education is inadequate, in terms of establishment credentials, often believe that they will have virtually no chance of being funded. I have also heard artists ponder over the question of what to state for salary, thinking that if they put their real salary, it will be considered too high ("She's making a bundle and doesn't deserve a grant") or too low ("If he's making so little, he couldn't possibly be talented"). The truth of the matter is that during the judging process the NEA does not even look at educational background or salary information. The information is used *only* for *statistical* purposes, providing taxpayers with a profile of federal grant recipients.

Although there are grants available that are specifically designed to assist impoverished or low-income artists, this requirement is specified in a foundation's statement

of purpose. If it is not stated, one can safely assume that the grant is awarded on the basis of merit and not financial need.

Although there are grants that require specific academic proficiency (degrees) and academic affiliation (teaching at college or university level), these eligibility factors are also pointed out in a funding agency's statement of purpose or grant guidelines. Because of the misconceptions about the Guggenheim Fellowship, it is a prime example of a grant for which many artists hesitate to apply. It is rumored that to be a Guggenheim Fellow one must be a full professor at an Ivy League college, implying that the Guggenheim Foundation believes that the most talented artists teach in glamorous colleges and universities. This is not only absurd, it is also untrue. The fact of the matter is that in 1986 Guggenheim Fellowships to visual and performing artists went to twelve photographers, painters, and sculptors without academic affiliation and nine with; seven filmmakers and video artists without academic affiliation and three with; two choreographers without academic affiliation and none with; and twenty-three writers, poets, and playwrights without academic affiliation and ten with.

Another part of the "secret word" syndrome is how much money to ask for. Arriving at a funding-request figure is not like a jelly bean–counting contest, where you have to guess down to the exact penny how much you think the foundation will give you.

Some foundations give a set amount of money (e.g., twenty grants of $5,000 each). Other foundations state a maximum amount, but say that smaller grants will also be given, the amount of which will be left to the discretion of the jury. For example, the National Endowment for the Arts offers fellowships of $25,000 each, with a limited number of $5,000 fellowships for emerging artists. Many artists believe that they have a better chance of receiving an NEA fellowship if they request a lower

amount of money. However, the NEA clearly states in its grant guidelines: "All applicants should apply for the major fellowship amount of $25,000." (You might think you are in the process of emerging, but a jury might believe that you have already arrived!)

There are also foundations that offer project grants. They specify the maximum amount given and ask you to provide a budget and/or statement of your needs.

If you are required to provide a budget, it should be logical and realistic. Spend time investigating real project costs, item by item. If you are awarded a grant and your budget isn't accurate, you could end up in the frustrating position of having to dig into your own pocket to complete the project. Also, a realistic budget makes a jury feel more secure that you know what you are doing and that the project has a real chance of being implemented and completed.

Do not be shy about allocating money in the budget for *your time* ("artist's fee"), and don't undervalue your time. Many applications I have reviewed request funds only for materials and do not include compensation for the artist's time or studio expenses (rent, electricity, etc.). Or, if an artist fee is provided, it is equivalent to a minimum-wage scale. Undervalued artists' fees can imply to a jury that you do not believe in your own worth, so why should they give you money?

LETTERS OF RECOMMENDATION

When foundations request that an applicant include a letter or letters of recommendation, it means that they are asking for testimony from other people that your work is good and/or that your project has merits and is relevant and important. I often encounter blank expressions when I ask applicants whom they are going to use as a reference. They believe there is not one person available to help.

Of course, it is impressive if you are recomended by an art-world superstar. However, if such a person is not part of your network, do not let this become a stumbling block. Jane C. Hartwig puts it this way:

> You certainly shouldn't shy away from using someone well known in your field if that person happens to know you and your work and has indicated a willingness to write a letter in your behalf. Just don't think that you haven't a chance if you don't know any luminaries. Happily, it doesn't matter.[40]

In summary, if you were on a grant panel, what would impress you more? An insipid but well-meaning letter of recommendation from a celebrity, or a perceptive and analytical letter from someone you have never heard of?

There is a range of possibilities for obtaining letters of recommendation: a critic who has given you a good review; the director or curator of a museum where your work has been shown; the director of a gallery where your work has been shown; a former teacher; another artist; an art historian; a collector of your work; or the director of an arts organization.

Remember, the worst thing that can happen is that the person you ask to write the recommendation will say no. Although this happens, it doesn't happen that often, because most everyone has been in the position of asking for help.

An Untraditional Grantsmanship Route

The traditional way to apply for grants is to rely on a foundation to announce the availability of a grant and submit an application. However, there is an untraditional route, which I have personally used with very successful results.

CORPORATE DETECTIVE WORK

I obtained corporate sponsors for many exhibitions and projects by taking the initiative to contact companies, regardless of whether they were in the "grants business." I first located corporations who either provided services or manufactured goods and materials that had some relationship to my project or exhibition. My detective work began at the library by using *Standard & Poor's Rating Guide*, a massive directory that lists major American corporations, cross-referenced according to product and/or service.

In one instance, I was planning an exhibition of sculpture in which aluminum would be used extensively. Through *Standard & Poor's* I came up with a list of major aluminum companies, their addresses, the names of public- or corporate-relations directors, as well as the name of each company's key officers.

Letters were sent to each of the public- or corporate-relations directors, with copies to each key officer, indicating on the original letter that company officers also received the letter.

The letter detailed the purpose of the exhibition, description, where it was being held, and a budget. I also included a sentence or two about what the company would receive in return for their sponsorship; namely public-relations benefits. *Within six weeks* I landed a sponsor.

VALUE OF CARBON COPIES

Sending copies of the sponsorship request to key corporate officers is very important. It increases the chances that the letter will really be given "careful consideration" and it decreases the chances that a sponsorship decision can be blocked by one person. For example, if only the

public-relations director receives a letter and that person, for one reason or another, is "unmoved," the request dies a quick death. By submitting the request to many officers, the chances are increased that you will find an ally with clout!

Yes, You Can Fight City Hall

For four consecutive years I applied for a grant from a state arts council for three different projects. Each year I was rejected. After the fourth rejection, I launched my own investigation and learned that one staff member was blocking my application, but for reasons that were so petty I could attribute them only to a "personality conflict." Venting my frustration, I wrote to the director of the arts council, detailing the four-year history of grant applications, documenting all the human hours spent on applications, answering questions, meetings, appointments, interviews, letters of recommendation, more letters of recommendation. But most important, I reiterated the merits of the project that I wanted funded. I also named the staff member who had been giving me such a hard time and sent a copy of my diatribe to that person. About three weeks later I received a letter from the arts council stating that they had reversed their decision— the project would be funded.

· 8 ·
Generating Income: Alternatives to Driving a Cab

All artists seek to support themselves financially through their creations. Yet artists are easily sidetracked from this goal, and plunge into non-art-related situations without considering all the alternatives available, alternatives that would allow them to *use their careers to generate income*, independent of the traditional art market. This chapter discusses some of the options as well as the attributes and drawbacks of the conventional jobs that artists often take.

Assets and Drawbacks of Conventional Jobs

To solve the problem of how to support yourself as an artist you must take into account your financial and emotional needs and your physical capabilities. Whether the options suggested in this chapter are appealing or you prefer traditional forms of employment that offer more financial security depends on your personality, temperament, and energy level. What works for one artist doesn't necessarily work for another. But the *common goal* is to

generate income that simultaneously allows you to maintain a good standard of creature comforts, a good state of mind and health, energy for your own projects, and energy to develop your career. Each of these criteria is equally important. One should not be sacrificed or compromised for another.

However, in the name of art and the "myth of the artist," compromises and sacrifices are constantly made. Contrary to the teachings of the myth, you are entitled to what you want, and there are ways to get it.

Before jumping into employment, assess carefully and *honestly* what you are looking for and why. Does the job provide a *real means to an end*, or is the job likely to annihilate your end? For example, two of my clients took jobs with arts service organizations. Both jobs provided the artists with sufficient income as well as opportunities to meet people related to their profession and expand contacts and networks. One job involved low-pressure, routine duties. Although the artist was not mentally stimulated, because her responsibilities were minimal, she had energy to sculpt and develop her career. The other job was full of responsibilities. It was demanding and stimulating. Although the artist found the work fulfilling, at the end of the day she was drained and did not have the energy for her artwork.

One of the best tools around to help you assess what you are looking for and what you would be good at is a publication called *What Color Is Your Parachute? A Practical Manual for Job Hunters and Career Changers* by Richard Nelson Bolles (see "Employment Opportunities" in the Appendix). Although it is not specifically addressed to artists, artists will derive a great deal of valuable information and ideas from the book. It deals with helping you discover latent skills and talents, and it also concentrates on how to expand your concept of what you can do to earn a living.

If you are inclined to want to work within the arts, there are some good resources available. The Union of Independent Colleges of Art publishes *Career Resources List for Visual Artists,* which lists by discipline (painting, sculpture, crafts, etc.) various jobs and positions that are available. The listings are available free of charge. The *National Arts Jobbank* is a bimonthly newsletter that lists employment opportunities in the visual and performing arts, literature, education, and art administration. *The College Art Association's Listing of Positions* contains a listing of arts-related jobs, mainly in museums and colleges and universities. *Artsearch,* published by the Theatre Communications Group, is a national employment-service bulletin for the performing arts. It includes art and arts-related positions in education, production, and management. The Center for Arts Information publishes *Jobs in the Arts and Arts Administration,* a guide to placement and referral services, career counseling, and publications that feature arts-employment listings. In addition, Opportunity Resources for the Arts, Inc., is a national organization that serves as a placement service for administrative positions in museums, art centers, art councils, theater, opera and ballet companies, symphonies, et cetera. For further information about these resources, see "Employment Opportunities" in the Appendix.

TEACHING: A BOON OR A TROJAN HORSE?

Teaching is attractive to artists for several reasons: it offers financial security as well as the fringe benefits of health insurance, life insurance, sick leave, vacation pay, and long vacations. In addition, it is a highly respected occupation.

Because of these attractions, the competition to teach is horrendous, so horrendous that, unless one is a super-

star, getting a job usually necessitates returning to school for more degrees. On the other hand, even if your qualifications are superlative, there is no job guarantee. There are more qualified artists than teaching positions available in colleges and universities and within school systems.

The scarcity of jobs is not the only drawback. Being an artist and teacher lends itself to wearing two hats. If teaching consisted only of lectures, critiques, and advising students, it would be relatively simple. However, teaching means a lot more. It means extracurricular involvement with faculty politics and yielding to the special demands and priorities of academia. Theoretically, these roles should be compatible and supportive, but often they are not.

Artists who teach *and* want to develop their careers must contend simultaneously with the occupational hazards of both professions. The dilemma is particularly complex because many of the demands and priorities of the art world and academic world are in conflict. Often, artists involved in the academic world face peer pressure based on how much they know about the past rather than what they are doing in the present. Sometimes artists are forced to change their methods of teaching and/or style of work to conform with current academic trends and ideology. Getting tenure often becomes the most important goal in life. Academia also puts demands on teachers to publish articles, essays, and books about art history and art criticism. An artist may have little time for his personal work.

On the other hand, some teaching opportunities are available that allow artists autonomy and flexibility. These opportunities exist both within and outside academic compounds. Some of these opportunities are described in the following section.

Using Your Career to Generate Income

ARTIST-IN-RESIDENCE PROGRAMS

There are various forms of artist-in-residence programs. Some provide artists with opportunities to live in a new surrounding so that they can work on projects and be free from life's daily worries and distractions. These are described in "Art Colonies, Artist-in-Residence and Exchange Programs" in the Appendix. In addition, there are artist-in-residence programs that pay artists to teach on a temporary, semitemporary, full-time, or part-time basis in school systems and communities throughout the United States.

Included in the national programs is Artists-in-Schools, which places visual and performing artists and writers in educational settings to work and demonstrate artistic disciplines. Residencies are available for photographers, sculptors, architects, craftspersons, printmakers, dancers, filmmakers, video artists, musicians, poets, theater artists, and writers.

Affiliate Artists, Inc., places performing artists in eight-week residencies. The program is available to actors, dancers, instrumentalists, and singers. Artists receive a fee that covers salary, travel costs, and administrative expenses.

Independent Curators, Inc., arranges long-term residencies for visual artists, choreographers, dancers, and musicians.

The Federal Bureau of Prisons, through its Artist-in-Residence Program, provides full- or part-time employment for visual and performing artists in prisons throughout the United States.

The addresses of the above organizations are listed under "Employment Opportunities" in the Appendix. In addition, there are many artist-in-residence programs on local

levels. Further information about these programs can be obtained by contacting local and state arts councils.

PUBLIC APPEARANCES AND WORKSHOPS

Lectures, lecture/slide demonstrations, and workshops are excellent means of generating income. They also offer exposure and serve as good public-relations vehicles.

Colleges and universities, civic, cultural, and educational organizations, as well as social-service agencies frequently hire artists for "guest" appearances.

When I suggest public appearances to clients I am often confronted with a blank stare, indicating that they are wondering what they could possibly lecture about or demonstrate. Granted, you might not be able to obtain a speaking engagement on the basis of placing a canvas on an easel and inviting people to watch you paint (although you never know), but lectures do not have to be based on your work. Art history, art criticism, criticism of art criticism, arts legislation, and all points of view related to art are good material. Subjects and themes of arts-related workshops are unlimited.

Substantial income from public appearances and workshops can be derived if you *repeat your performance* several times. This is discussed later in the section "Hitting the Road."

The next section describes how to go about making it known that your services are available. In addition, there are many organizations that arrange public appearances and workshops for artists. Information about the organizations in your area can be obtained from your local or state arts council. National organizations include Independent Curators, Inc., which also arranges long-term residencies, and Hospital Audiences, Inc., which brings visual and performing artists to individuals confined in

institutions such as mental-health, senior-citizen, drug-rehabilitation, and correctional centers. Artists selected for the Hospital Audiences program are paid a fee each time they participate. See "Employment Opportunities" in the Appendix.

Organizing Artist-in-Residence Positions, Workshops, and Public Appearances

The best way to approach an organization or institution about sponsoring an artist-in-residence position, public appearance, or workshop is to provide a concrete proposal that describes the purpose of your idea or program, why it is relevant, and what the audience will gain. If you are applying for an artist-in-residence position, include a proposal, even if the application does not require it. A proposal for a lecture workshop should not be limited to a title. It should elaborate on the contents of your presentation, including the purpose, relevance, and benefit to the audience.

The value of preparing a proposal in advance is that you avoid having to rely on the institution or organization to figure out a way to use your talents. This could take months.

The other value of preparing a proposal is that it can be used to generate residencies, public appearances, and workshops independent of organizations and institutions that sponsor such programs. In other words, it is not necessary to go through Artists-in-Schools, Independent Curators, or Hospital Audiences to get work. You can initiate contacts yourself.

Send proposals to schools, colleges, universities, social-service agencies, and educational and cultural organizations. Corporations are also receptive to sponsoring lectures and workshops, and many organize educational and cultural programs specifically for their employees.

Hitting the Road

Although I conduct workshops and lectures in my home city, others involve a great deal of traveling. Once I receive an out-of-town invitation I use the opportunity to create more opportunities by contacting other educational or cultural institutions in the same area. What started out as a one-shot engagement ends up as a lecture tour. This generates more revenue and exposure for me, and since the institutions involved split my travel expenses (apart from the fees I am paid), they all save money.

GENERATING INCOME THROUGH THE PRINTED IMAGE

Mail art, book art, rubber-stamp art, Xerox art, and postcard art are new art forms created by artists exploring the tools and resources of mass communication and the electronic age. Not only do these new art forms respond to the aesthetic sensibilities of mass communication, they *are* mass communication and are mass-produced. Thus, they are art forms with nonexclusive price tags and have the potential to broaden the art-buying market.

A market and marketing vehicles have already begun to develop for these art forms. This can be attributed to the efforts of Printed Matter, in New York City (see "Artists' Books" in the Appendix), which was founded in 1976. This shop/gallery and mail-order service exhibits and sells a vast range of artists' books and other types of artist-created printed materials. In some instances Printed Matter serves as publisher. It also takes work on consignment.

If involvement in esoteric art is not in your realm of interests, traditional forms of printed materials also offer artists many ways to generate income (and exposure). These include signed, unsigned, limited, and unlimited editions of prints, posters, lithographs, et cetera.

There is already a large demand for works on paper, and sales do not depend on commercial galleries. You can do your own marketing. I have sold numerous prints, posters, and the like through my studio, just on the basis of writing a press release. In one instance I was involved with a silk-screen series consisting of five prints based on one *theme*. Press releases announcing the series and availability details were sent to arts-related publications and museum shops. Except for the prints that I retained for myself, the entire series sold. Marketing involved neither paid advertising nor a middleperson.

The Print World Directory is an excellent source for locating print distributors. It contains the names and addresses of print publishers. Usually a distributor will take works on a consignment basis, but if your work sells well, it is possible that the distributor will commission you for specific projects and pay the printing costs. For further information about the *Directory* see the Appendix section "General Arts References."

Don't forget that there are various potential markets for artists' work. If you limit yourself to one-of-a-kind objects, your market is one-of-a-kind buyers, those who consider exclusivity and scarcity important and are able and willing to pay for it. But there are many others who appreciate and want to buy art and are not concerned with these issues. They are not part of the audience a commercial gallery seeks, but an artist's career should not depend solely on commercial galleries or their customers.

Minimizing Expenses

I was able to afford an investment in the silk-screen series described above, as well as in other print projects that I

initiated, by minimizing my overhead expenses. There are many ways to keep expenses low in order to afford the necessary initial financial investment to launch projects. Some of these opportunities are described below.

BARTERING

Bartering has been in existence for thousands of years. Artists can trade their artwork and special skills for employment- and career-related supplies, materials, and equipment. You can save money on various daily living expenses so that more funds can be allocated for your career.

Some of my clients have bartered with doctors, dentists, restaurants, food stores, plumbers, carpenters, and electricians. I have arranged barters with printers to pay for the overhead expenses involved with various poster and print series.

The bartering phenomenon has expanded into big business, and barter organizations and clubs exist throughout the United States. The names of barter organizations can be found in the Yellow Pages Business-to-Business directory under "Barter and Trade Exchange." For additional information about bartering, consult *The Barter Network Handbook* (see "Bartering" in the Appendix).

APPRENTICES

If you need manpower assistance you can save money by using the services of an apprentice. Apprenticeship programs provide artists with students who want studio or work experience. Some apprenticeship programs are structured as a barter: free assistance in return for learning and developing new skills; other programs require an artist to pay an apprentice a reasonable hourly wage.

Local and state arts councils can provide information on apprenticeship programs. College and university art departments are also good sources. In addition, the Great Lakes College Association sponsors a student-intern apprenticeship program, which makes available apprentices in the visual arts, theater, writing, music, dance, and media. In the visual arts, apprentices are available in painting, sculpture, photography, crafts, all areas of design and commercial art, as well as architecture. In the theater field, apprentices work with producers and directors and with set, costume, and lighting-design personnel. In music, dance, and media, apprentices are available in composition, choreography, production, management, recording, criticism, animation, art, lighting, and editing. See "Apprentices and Interns" in the Appendix for the addresses of these organizations.

SURPLUS-MATERIAL PROGRAMS

You can save money on equipment, supplies, and materials by using surplus-material programs. These programs are located throughout the United States and are administered by various arts agencies. Their main source of supply is the General Services Administration, which donates to public agencies and nonprofit organizations a variety of materials, machine tools, office machines, supplies, furniture, hardware, construction equipment, et cetera. In turn, many of the agencies make the supplies and equipment available to artists. A surplus-property agency exists in every state. Contact your local arts agency for further information, and see "Surplus-Material Programs" in the Appendix.

APPENDIX
OF RESOURCES

The following list of contacts and resources includes the addresses of organizations and agencies and the details of publications cited in this book. It also includes other national resources pertaining to specific topics. This list is a beginning and by no means covers the infinite amount of resources and information available to artists. But it is a good starting point from which to develop a library of materials and contacts to launch or relaunch and sustain your career.

Accounting/Bookkeeping

PUBLICATIONS

The Art of Deduction: Income Taxation for Performing, Visual and Literary Artists. Bay Area Lawyers for the Arts, Fort Mason Center, Building C, Room 255, San Francisco, California 94123, revised 1982.

The Art of Filing: A Tax Workbook for Visual, Performing, Literary Artists and Other Self-Employed Professionals by Carla Messman. Resources and Counseling/United Arts, 411 Landmark Center, 75 West Fifth Street, St. Paul, Minnesota 55102, revised annually.

Bookkeeping for Artists. Chicago Artists' Coalition, 5 West Grand Avenue, Chicago, Illinois 60610, revised 1985.

Business Forms and Contracts (in Plain English) for Craftspeople by L. D. DuBoff. Madrona Publishers, P.O. Box 22667, Seattle, Washington 98122, 1986. Includes consignment agreements, tax records and deductions, copyright, collection letters, and commission contracts.

Fear of Filing: A Beginner's Guide to Tax Preparation and Record-keeping for Artists, Performers, Writers and Freelance Professionals by Theodore W. Striggles and Barbara Sieck Taylor. Volunteer Lawyers for the Arts, Third Floor, 1285 Avenue of the Americas, New York, New York 10019, revised 1985.

"How to Pick a Tax Accountant," *Business Week*, November 9, 1981. Provides excellent tips on what to look for in an accountant.

The Individual Artist: Recordkeeping, Methods of Accounting, Income and Itemized Deductions for Federal Income Tax Purposes by Herrick K. Lidstone and Leonard R. Olsen. Volunteer Lawyers for the Arts, 1285 Avenue of the Americas, New York, New York 10019, 1976.

Legal Guide for the Visual Artist by Tad Crawford. New York: Madison Square Press, revised 1986. See "Income Taxation," "Income Taxation II," "The Hobby Loss Challenge," "The Artist's Estate," and "The Artist as Collector."

A Practical Business and Tax Guide for the Craftsperson by Fred Bair and James Norris. Publishing Horizons, 2950 North High Street, P.O. Box 02190, Columbus, Ohio 43202-9990, revised 1986.

The Professional Artist's Manual by Richard Hyman. New York: Van Nostrand Reinhold, 1980. See "Bookkeeping."

A Tax Guide for Artists and Arts Organizations edited by Herrick K. Lidstone. Lexington Books, D. C. Heath & Co., 125 Spring Street, Lexington, Massachusetts 02173, 1979.

The Tax Reliever: A Guide for the Artist by Richard Helleloid. Drum Books, P.O. Box 16251, St. Paul, Minnesota 55116, 1979. Includes information and suggestions on good bookkeeping, use of major business assets, business deductions, accounting principles, and an overview of basic tax matters.

Taxation Information for Canadian Visual Artists. Canadian Artists' Representation Ontario (CARO), 345-67 Mowat Avenue, Toronto, Ontario, Canada M6K 3E3, 1980.

ORGANIZATIONS

The Artists Foundation, Inc., 110 Broad Street, Boston, Massachusetts 02110. Offers accounting advice for artists.

Foundation for the Community of Artists, 280 Broadway, New York, New York 10007. Offers financial services to artists, including tax

preparation, pension planning, general advice on financial management, and bookkeeping systems.

Alternative Exhibition/Performance Opportunities, Places, and Spaces

PUBLICATIONS

Artists Guide to New England Galleries: An Insider's Resource Book. The Artists Foundation, Inc., 110 Broad Street, Boston, Massachusetts 02110, 1986. Lists over 200 spaces that exhibit contemporary work, including nonprofit galleries and arts organizations.

The Directory of Artists' Organizations. National Association of Artists' Organizations (NAAO), 1007 D Street, NE, Washington, D.C. 20002, revised 1987. Lists over 1,000 organizations, in the visual, performing, and literary arts, and describes programs, policies, and services.

Directory of Sources for International Traveling Exhibitions. Washington, D.C.: International Council of Museums, 1987. Available from Humanities Exchange, P.O. Box 1608, Largo, Florida 34294. Lists over 200 organizations in thirty-five countries which organize traveling exhibitions. Entries include name, address, contact person, and telephone number for each agency.

The Emerging Arts: Management, Survival and Growth by Joan Jeffri. New York: Praeger, 1980. Good background information on the alternative-space movement. See "Off Off Broadway Theater: The Cost of Growing Up" and "Alternative Movements in the Visual Arts."

A Guide to Exhibition Spaces in Chicago and Illinois. Chicago Artists' Coalition, 5 West Grand Avenue, Chicago, Illinois 60610, 1985. Lists 160 exhibition opportunities.

New York Fine Artists' Source Book by the New York City Department of Cultural Affairs. Reading, Massachusetts: Addison-Wesley, 1983. See Part II, "Nontraditional Exhibition Spaces."

The Photographer's Complete Guide to Exhibition Spaces edited by Peter H. Falk. Photographic Arts Center, 127 East 59th Street, New York, New York 10022, 1985.

Places: A Directory of Public Places for Private Events and Private Places for Public Functions. Tenth House Enterprises, Caller Box 810, Gracie Station, New York, New York 10028, 1984. A guide to exhibition, performance, lecture, and special-events facilities.

Public Hangings. The City Gallery, New York City Department of Cultural Affairs, 2 Columbus Circle, New York, New York 10019, 1985. Lists over seventy alternative spaces in New York City.

Space Search. Alliance for the Arts, Room 1701, 330 West 42nd Street, New York, New York 10036, 1984. Directory of all cultural facilities in the five boroughs of Manhattan. Includes performing arts, visual arts, and media arts facilities. Available as a complete directory or by borough and discipline.

PROGRAMS AND ORGANIZATIONS

Living Buildings Program, Public Buildings Service, General Services Administration, Washington, D.C. 20405.

National Association of Artists' Organizations (NAAO), 1007 D Street, NE, Washington, D.C. 20002. Membership organization open to individual artists, organizations, and alternative spaces. Dedicated to the creation and presentation of contemporary visual and performing arts in all media. The only service organization providing coordinated resources and programs for organizations in all disciplines.

Apprentices and Interns

PUBLICATIONS

The Fourth Annual Internships in Federal Government. The Graduate Group, 86 Norwood Road, West Hartford, Connecticut 06117, 1987.

The Fourth Annual Internships in State Government. The Graduate Group, 86 Norwood Road, West Hartford, Connecticut 06117, 1987.

National Directory of Arts Internships by Warren Christensen. California Institute of the Arts, 1986. Lists over 350 internship opportunities nationwide in dance, theater, music, art, design, film, and video. Describes positions available, eligibility requirements, and application procedures. Available from the American Council for the Arts, 1285 Avenue of the Americas, New York, New York 10019.

New Internships for 1987. The Graduate Group, 86 Norwood Road, West Hartford, Connecticut 06117, 1987.

The Second Annual Internships and Job Opportunities in New York City and Washington, D.C. The Graduate Group, 86 Norwood Road, West Hartford, Connecticut 06117, 1987.

The Third Annual Internships Leading to Careers. The Graduate Group, 86 Norwood Road, West Hartford, Connecticut 06117, 1987.

PROGRAMS AND ORGANIZATIONS

Arts Apprenticeship Program, New York City Department of Cultural Affairs, 2 Columbus Circle, New York, New York 10019.

Great Lakes College Association, Ohio Wesleyan University, Delaware, Ohio 43105.

Great Lakes College Association Program in New York, 308 West 48th Street, New York, New York 10036.

Art Colonies, Artist-in-Residence, and Exchange Programs

PUBLICATIONS

"Aiming at the Source: America's Artist Colonies" by Brook Hersey, *American Artist*, November 1983.

Artist Colonies. Center for Arts Information, 1285 Avenue of the Americas, New York, New York 10019, 1986. Provides addresses, contact names, application deadlines, etc., for residency programs in various arts disciplines.

Boston Visual Artists Union Guide to Art Colonies. Boston Visual Artists Union, 700 Beacon Street, Boston, Massachusetts 02115, 1982.

"Help for Artists: Colonies, Retreats and Study Centers," *Women Artist News*, Summer 1984.

International Cultural Exchange. Center for Arts Information, 1285 Avenue of the Americas, New York, New York 10019, 1986. A guide to organizations that facilitate or fund international exchange programs.

Money Business: Grants and Awards for Creative Artists. The Artists Foundation, Inc., 110 Broad Street, Boston, Massachusetts 02110, revised 1981. See "Retreats."

Money for Artists: A Guide to Grants and Awards for Individual Artists edited by Rebecca Lewis and Rita K. Roosevelt. New York: Center for Arts Information, 1987. Available from the American Council for the Arts, 1285 Avenue of the Americas, New York, New York 10019. See "Artist-in-Residence Programs."

ORGANIZATIONS

Affiliate Artists, Inc., 37 West 65th Street, New York, New York 10023. Regional office: 1401 Peachtree Street, Atlanta, Georgia 30309.

American Academy in Rome, 41 East 65th Street, New York, New York 10021.

Artist-in-Residence Program, Education Division, Federal Bureau of Prisons, 320 First Street, NW, Washington, D.C. 20534.

Artists-in-Education Program, Office for Partnership, National Endowment for the Arts, 1100 Pennsylvania Avenue, NW, Washington, D.C. 20506.

Arts International, 1400 K. Street, NW, Suite 605, Washington, D.C. 20005. Service organization that assists individuals and organizations in funding or developing international arts-exchange programs.

Bellagio Study Center, Rockefeller Foundation, 1133 Avenue of the Americas, New York, New York 10036.

British American Arts Association, 49 Wellington Street, London WC2E 7BN, England. Assists artists and arts organizations with performing and exhibition programs and programming ideas.

German Academic Exchange Service, Deutscher Akademischer Austauschdienst (DAAD), 535 Fifth Avenue, Suite 1107, New York, New York 10017. Selects fifteen to twenty young sculptors, painters, writers, composers, and filmmakers to spend twelve months in Berlin as artists-in-residence.

Hospital Audiences, Inc., 1540 Broadway, New York, New York 10036.

Independent Curators, Inc., 799 Broadway, New York, New York 10003.

International Sculptor Exchange, c/o Jorg Plickat, Bildheuer/BBK, Wassermühle 2301 Steinfurt, Mielkendorf, West Germany. Arranges international exchanges of young professional sculptors and, occasionally, other artists, involving reciprocal exchange of studio and living space.

Partners of the Americas, 1424 K Street, NW, Washington, D.C. 20005.

Two Continents Arts Exchange, 924 West End Avenue, New York, New York 10025. An independent agency that provides services to performing and visual artists, including arranging tours and bookings, providing referrals, and promoting the exchange of information.

Also see "Employment Opportunities."

Artists' Books

ORGANIZATIONS

Artists Book Works, 1422 West Irving Park Road, Chicago, Illinois 60613. A nonprofit organization that promotes the art of handmade books through exhibitions, workshops, and a slide registry of artists working in the book arts.

DISTRIBUTORS

Art in Form, P.O. Box 2567, Seattle, Washington 98111. Distributes artists' books in the Northwest.

Artworks, 170 South LaBrea, Los Angeles, California 90036. Distributes 600 artists' books.

Astro Artz, 240 South Broadway, 5th Floor, Los Angeles, California 90012.

Bookspace, 703 South Dearborn, Chicago, Illinois 60605. Distributes 1,600 artists' books; prints local artists' works.

The Center for Visual Arts, 1333 Broadway, Oakland, California 94612. Distributes artists' books; sells bookworks, publications of local alternative presses, and unique artist creations.

Media, 360 North 9th Street, San Francisco, California 94103.

Printed Matter, 7 Lispenard Street, New York, New York 10013. Exhibits and sells artists' books. Also operates a mail-order business.

Arts Legislation

PUBLICATIONS

ACA Update. American Council for the Arts, 1285 Avenue of the Americas, New York, New York 10019.

Coalition of Women's Art Organizations News. 123 East Beutel Road, Port Washington, Wisconsin 53074. Contains news of action needed to support or reject arts legislation on the state and national levels. Published monthly.

ORGANIZATIONS

American Council for the Arts, 1285 Avenue of the Americas, New York, New York 10019. National organization that provides infor-

mation on legislative issues and governmental policy affecting the arts.

Coalition of Women's Art Organizations, Washington Women's Art Center, 1821 Q Street, NW, Washington, D.C. 20009. A cooperative lobby dedicated to the achievement of equality for women in the arts.

National Artists Equity Association, Inc., P.O. Box 28068, Central Station, Washington, D.C. 20038. National organization with state chapters. Operates at federal, state, and local levels on legislative issues affecting economic and social change for artists.

Arts Service Organizations

PUBLICATIONS

Craft Artist Membership Organizations (NEA Research Division Report #13). Publishing Center for Cultural Resources, 625 Broadway, New York, New York 10012, 1981. Provides information on 1,200 American craft organizations, including national and regional groups, size, location, and media.

The Directory of Artists' Organizations. National Association of Artists' Organizations (NAAO), 1007 D Street, NE, Washington, D.C. 20002, revised 1987. Includes over 1,000 arts organizations throughout the U.S. that sponsor the production and presentation of artists' work in all disciplines or provide artists' services.

Directory of Hispanic Artists and Organizations. Association of Hispanic Artists, 200 East 87th Street, New York, New York 10028. Lists artists and organizations involved with dance, literature, media, music, theater, and visual arts. Published bimonthly.

Directory of Minority Arts Organizations edited by Carol Ann Huston. Division of Civil Rights, National Endowment for the Arts, 1100 Pennsylvania Avenue, NW, Washington, D.C. 20506, 1982. Lists 400 art centers, galleries, performing groups, presenting groups, and local and national arts service organizations that have leadership and constituency that is predominantly Asian-American, black, Hispanic, Native American, or multiracial.

The Directory of Visual Arts Organizations in New Jersey. 720 Lawrence Avenue, Westfield, New Jersey 07090, 1986. Lists regional and county arts councils, cultural and heritage commissions, and museums.

Film Service Profiles. Center for Arts Information, 1285 Avenue of the Americas, New York, New York 10019, 1980. Describes fifty-two

national and local organizations and funding agencies that offer services to independent filmmakers and film users.

Guide to Women's Art Organizations: Groups/Activities/Networks/Publications edited by Cynthia Navaretta. Midmarch Associates, Women Artist News, P.O. Box 3304, Grand Central Station, New York, New York 10017, revised 1982. Lists women's organizations involved in painting, sculpture, drawing, photography, architecture, design, film and video, dance, music, theater, and writing.

The New York Fine Artist's Source Book by the New York City Department of Cultural Affairs. Reading, Massachusetts: Addison-Wesley, 1983. See Part I, "Artists' Organizations."

Video Service Profiles. Center for Arts Information, 1285 Avenue of the Americas, New York, New York 10019, 1983. Includes descriptions of nonprofit organizations and government agencies that offer funds, exposure, training, equipment, exhibition possibilities, or other forms of assistance to video artists.

ORGANIZATIONS

American Council for the Arts, 1285 Avenue of the Americas, New York, New York 10019. National organization whose programs address underlying problems and key policy issues regarding the arts. Publishes *Vantage Point* as well as good reference materials.

American Craft Council, 40 West 53rd Street, New York, New York 10019. National organization that sponsors exhibitions, seminars and workshops, and international exchange and communication programs. Publishes *American Craft.*

American Society of Artists, Inc., 1297 Merchandise Mart Plaza, Chicago, Illinois 60654. National membership organization.

Artists Alliance, Inc., P.O. Box 75184, Tampa, Florida 33605. Florida's Center for Contemporary Art. Primarily represents emerging artists in Florida. Services include a slide registry, legal referrals, studio space, and networking information.

Artists for Economic Action, 2557 Roscomare Road, Los Angeles, California 90077. Dedicated to improving the financial position of artists.

The Artists Foundation, Inc., 110 Broad Street, Boston, Massachusetts 02110. Serves New England artists in all disciplines. Provides health insurance, discounts on legal and accounting assistance; fellowships,

an artists' registry, and public art program; publishes books and pamphlets.

Artists Services/United Arts Council, 429 Landmark Center, 75 West Fifth Street, St. Paul, Minnesota 55102. Provides business-related information, advice, and technical assistance for artists of all disciplines. Offers individual consultations and workshops, career counseling, marketing, and contract and copyright advice.

Arts Extension Service, Division of Continuing Education, University of Massachusetts, Amherst, Massachusetts 01300. Serves as a catalyst for better management of the arts in communities through continuing education for artists and arts organizations. Sponsors programs in arts management, business development, fund raising, advocacy leadership, and marketing. Publishes and distributes books, guides, and pamphlets. Also sponsors festivals, Percent for Art programs, and internships.

Arts for Greater Rochester, Suite 500, 328 East Main Street, Rochester, New York 14604. A coalition of arts organizations, artists, businesses, and county government. Provides support services to individual artists, including promotion, consultations, management workshops, volunteer legal assistance, group health insurance, and a registry.

Arts Resource and Information Center, Minneapolis Institute of Arts, 2400 Third Avenue South, Minneapolis, Minnesota 55400. A clearinghouse for information on visual, literary, and performing arts in Minnesota. Houses a cross-disciplinary library on arts organizations, speakers, museum objects, etc. Sponsors conferences and workshops. Provides an employment referral and artists' registry.

Association for Resources and Technical Services (ARTS), Suite 211, 1341 G Street, NW, Washington, D.C. 20005. Provides information, resources, and technical assistance to Hispanic artists, art service, and presenting organizations.

Association of Hispanic Arts, Inc., 200 East 87th Street, New York, New York 10028. Offers individual technical assistance, legal and administrative referral service, workshops and conferences on skills development and funding. Publishes *AHA Newsletter*.

Association of National Non-Profit Artists' Centres, 217 Richmond Street West, Toronto, Ontario, Canada M5V 1W2. Represents artist-run centers throughout Canada.

ATLATL, 402 West Roosevelt, Phoenix, Arizona 85003. A national nonprofit organization dedicated to the preservation, promotion, growth, and development of contemporary and traditional Native American arts. Provides a Native American Resource and Distribution Clearing-

house. Offers employment referrals, reference and referral information, and publishes *Native Arts Update*.

Boston Visual Artists Union, 700 Beacon Street, Boston, Massachusetts 02115. Service organization that supports artists' work through exhibitions, a slide registry, resource center, newsletter, and special programs.

Canadian Artists' Representation Ontario (CARO), 345-67 Mowat Avenue, Toronto, Ontario, Canada M6K 3E3. Association of professional visual artists in Ontario working to improve the financial and professional status of artists.

Canadian Crafts Council, 46 Elgin Street, Ottawa, Ontario, Canada K1P 5K6. Provides information and services to artists.

Canadian Women's Art Caucus, c/o Department of Fine Arts, University of British Columbia, 403-6333 Memorial Road, Vancouver, British Columbia, Canada V6T 1W5. Formed to bring together women artists, art historians, and women in museums in Canada to overcome geographical isolation and deal with issues common to women in the arts.

Center for Arts Information, 1285 Avenue of the Americas, New York, New York 10019. Serves as a clearinghouse for the arts in New York State, but also publishes excellent reference materials, directories, and guides that are relevant to visual and performing artists throughout the United States.

Chicago Artists' Coalition, 5 West Grand Avenue, Chicago, Illinois 60610. An artist-run service organization for visual artists that offers members a monthly newsletter, slide registry, lectures, job referral services, and workshops. Publishes *CAC Newsletter*.

Chicano Humanities and Arts Council, Inc., P.O. Box 2512, Denver, Colorado 80201. Provides technical assistance on proposals and promotion, and offers workshops on the business of art and marketing techniques.

Cultural Alliance of Greater Washington, 633 E Street, NW, Washington, D.C. 20004. Membership organization that sponsors workshops and seminars. Provides health insurance for members. Publishes *Art Washington Newsletter*.

Deaf Artists of America, Inc., P.O. Box 2332, Westfield, New Jersey 07091. National organization that helps support hearing-impaired visual and performing artists. Provides financial support, business advice, health insurance, and employment referral.

Disabled Artists Network, P.O. Box 20781, New York, New York 10025.

Foundation for the Community of Artists, 280 Broadway, New York, New York 10007. National organization that offers a broad range of services to visual and performing artists and writers, including group health plans, seminars, and workshops, etc. Publishes *Art and Artists.*

International Sculpture Center, 1050 Potomac Street, NW, P.O. Box 19709, Washington, D.C. 20007. Nonprofit service organization for professional sculptors. Offers health and studio insurance and a data bank, and organizes international and national exhibitions. Publishes *International Sculpture.*

Midmarch Associates, P.O. Box 3304, Grand Central Station, New York, New York 10163. Women's art service organization that plans and coordinates exhibitions, conferences, festivals, and symposiums. Maintains internship programs and serves as an information clearinghouse and resource center for artists, providing information on grants, schools, and technical consultations.

Museum Reference Center, Smithsonian Institution Libraries, Office of Museum Programs, Arts and Industries Building, Room 2235, 900 Jefferson Drive, SW, Washington, D.C. 20560. Provides technical assistance, workshops and conferences, and information on museums and visual arts. Sponsors an internship program and publishes book lists and guides.

National Artists Equity Association, Inc., P.O. Box 28068, Central Station, NW, Washington, D.C. 20038. National organization for visual artists with local chapters throughout the United States. Benefits include group medical insurance, studio and work insurance, promotion of arts-related legislation, debt collection, model contracts, and publications.

National Association of Artists' Organizations (NAAO), 1007 D Street, NE, Washington, D.C. 20002. Comprised of organizations and individuals that sponsor the production and presentation of contemporary artists' work (live, exhibited, or published), and/or provide artists' services. Member organizations maintain a commitment and responsibility to contemporary arts, ideas, and forms, and operate on a not-for-profit basis. Artists hold a central role in running these organizations.

National Center on Arts and the Aging, National Council on the Aging, 600 Maryland Avenue, SW, West Wing 100, Washington, D.C. 20024. Serves as a clearinghouse on public and private arts and aging

agencies. Provides reference and referrals, conferences, workshops, and technical assistance. Organizes exhibitions and maintains an artists' registry. Publishes *Collage* and books on arts and the aging.

The New England Foundation for the Arts, 678 Massachusetts Avenue, Cambridge, Massachusetts 02139.

New Organization for the Visual Arts (N.O.V.A.), One Playhouse Square, 1375 Euclid Avenue, Cleveland, Ohio, 44115. Artists' membership organization. Provides an art marketing program to corporations, exhibits, lectures, and workshops.

Ontario Crafts Council, 346 Dundas Street West, Toronto, Ontario, Canada M5T 1G5. Provides information and assistance to artists through seminars, conferences, publications, and exhibitions.

Opportunities for the Arts, P.O. Box 2572, Columbus, Ohio 43216. A membership organization serving visual artists in Ohio. Provides art-shipping services on a sliding fee scale and organizes exhibitions. Publishes *Dialogue.*

Photographic Resource Center, 1019 Commonwealth Avenue, Boston, Massachusetts 02115. Service organization that assists individuals and organizations. Provides a monthly newsletter, lectures, workshops, research materials, a job bank, and an insurance program. Also offers grants to artists and writers.

Pro Arts, 1920 Union Street, Oakland, California 94607. Nonprofit membership organization serving artists of all disciplines in the Bay Area. Offers a Technical Assistance Program, free individual consultations, service library, seminars, workshops, artist-in-residence program, and exhibitions.

Texas Fine Arts Association, 3809 West 35th Street, P.O. Box 5023, Austin, Texas 78763. Membership organization for Texas artists. Provides statewide and national art exhibits. Provides information and referrals. Publishes *News.*

Third World Coalition of Minority Artists, 4911 Ames Avenue, Omaha, Nebraska 68104. Advocates Third World art forms, and sponsors workshops, conferences, and festivals. Provides employment-referral services for individual artists. Serves African Americans, Native Americans, Chicanos, and Asians.

Visual Arts Ontario, 439 Wellington Street West, Toronto, Ontario, Canada, M5V 1E7. Resource center of current art books, reports, periodicals, and catalogs; sponsors artists' business seminars. Services also include group insurance plans; an artists' registry, color xerography center, international art programs, and art placement programs.

Western States Arts Foundation, Suite 200, 207 Shelby Street, Santa Fe, New Mexico 87501. A regional alliance of state art agencies, including Alaska, Arizona, Colorado, Hawaii, Idaho, Montana, Nevada, New Mexico, Oregon, Utah, Washington, and Wyoming. Offers publications of interest to artists.

Women in the Arts Foundation, Inc., 325 Spring Street, New York, New York 10013. National membership organization founded to overcome discrimination against women in the arts. Sponsors educational programs and exhibitions, and negotiates with museums, galleries, and collections. Runs a slide registry and publishes a newsletter.

Women's Art Registry of Minnesota, 414 First Avenue North, Minneapolis, Minnesota 55401. Membership organization serving women visual artists in Minnesota. Maintains a slide registry and administers a mentor program which matches emerging women artists with more established women artists for a period of one year.

Women's Caucus for Art, Moore College of Art, 20th and Parkway, Philadelphia, Pennsylvania 19103. National organization with regional chapters throughout the United States. Represents the professional and economic concerns of women artists, art historians, educators, writers, and museum professionals. Sponsors conferences and exhibitions and publishes a newsletter.

Bartering

PUBLICATIONS

The Barter Network Handbook by David Tobin and Henry Ware. Volunteer Readership, 111 North 19th Street, Arlington, Virginia 22209, 1983.

Career Management, Business, and Marketing

PUBLICATIONS

Are You Ready to Market Your Work? edited by Norma A. Fox. Boston Visual Artists Union, 700 Beacon Street, Boston, Massachusetts 02115, 1979.

Art Business News. 60 Ridgeway Plaza, Stamford, Connecticut 06905. Published monthly; semimonthly in September.

Art Career Guide by Donald Holden. New York: Watson-Guptill, 1983.

The Art Marketing Letter. Custom Publishing Services, 85 Beach Street, Westerly, Rhode Island 02891. Includes information on marketing, promotion, and art business news. Published bimonthly.

Artists' Resource Book. Chicago Artists' Coalition, 5 West Grand, Chicago, Illinois 60610, 1985. Provides information on exhibiting, marketing, materials, and space.

The Artists' Survival Manual: A Complete Guide to Marketing Your Work by Toby Judith Klayman and Cobbett Steinberg. New York: Charles Scribner's Sons, 1984.

Arts and Crafts Market by Lynne Lapin and Betsy Wones. Cincinnati, Ohio: Writer's Digest. Revised annually.

Business and Law References: An Annotated Bibliography for Visual Artists by Lisa Helfand and Cyndra MacDowall. Canadian Artists' Representation Ontario (CARO), 345-67 Mowat Avenue, Toronto, Ontario, Canada M6K 3E3, 1984. Bibliography of references, including arts administration, cultural policy, general business, general reference, health hazards, law, studio and housing, and taxes.

The Business of Art edited by Lee Evan Caplin. Englewood Cliffs, New Jersey: Prentice-Hall, 1983. Collection of business techniques that make art profitable for artists. Written by artists, attorneys, accountants, business experts, and gallery dealers.

Computers and Crafts: A Practical Guide by Marc Goldring. National Crafts Planning Board, 1984. Available from the American Council for the Arts, 1285 Avenue of the Americas, New York, New York 10019.

The Crafts Business Encyclopedia by Michael Scott. New York: Harcourt Brace Jovanovich, 1977. Covers marketing, management, and money.

Crafts Business Management. American Craft Enterprises, Inc., P.O. Box 10, New Paltz, New York 12561. For craft producers and retailers. Contains articles on purchase-order contracts, product liability, pricing, and incorporation. Published monthly.

The Craftsletter. P.O. Box 747, Pine Lakes, Georgia 30072. Provides step-by-step marketing techniques. Published ten times a year.

The Crafts Report: The News Monthly of Marketing, Management and Money for Crafts Professionals. 3632 Ashworth North, Seattle, Washington 98103. Published eleven times a year.

The Emerging Arts: Management, Survival and Growth by Joan Jeffri. New York: Praeger, 1980. Analyzes small companies in theater, dance,

and the visual arts in the United States from a managerial point of view. Traces the history, development, and growth of representative groups and companies in these fields, draws comparisons, and suggests new avenues for their survival.

Entrepreneurial Mothers by Phyllis Gillis. Rawson Associates, 597 Fifth Avenue, New York, New York 10003, 1983. For independent businesswomen, such as artists, with children.

The Facts of Art: A Practical Guide for the Visual Artist by Linda Mollenhauer and edited by Gail J. Habs. Visual Arts Ontario, 439 Wellington Street West, Toronto, Ontario, Canada M5V 1E7, 1982.

The Guide to Professional Practice in the Visual Arts by Hamish Buchanan et al. Canadian Artists' Representation Ontario (CARO), 345-67 Mowat Avenue, Toronto, Ontario, Canada M6K 3E3, 1987.

"Managing the Business of Art," *Women Artist News*, November 1980.

The Media Resource Guide: How to Tell Your Story edited by Chuck Rossie. Foundation for American Communications, 1983. Available from the American Council for the Arts, 1285 Avenue of the Americas, New York, New York 10019.

Photographing Your Craftwork: A Hands-on Guide for Craftspeople. Madrona Publishers, P.O. Box 22667, Seattle, Washington 98122, 1986.

Profitable Crafts Marketing. A Complete Guide to Successful Selling by Brian T. Jefferson. Madrona Publishers, P.O. Box 22667, Seattle, Washington 98122, 1986.

Promoting and Selling Your Art by Carole Katchen. New York: Watson-Guptill, 1978.

Resources for Artists and Writers: An Annotated Bibliography compiled by Tonda Gorton and Lin Lepore. Published by the Western States Arts Foundation, Santa Fe, New Mexico, 1982. Available from the Arizona Commission on the Arts, Arts Services Program, 417 West Roosevelt Avenue, Phoenix, Arizona 85003. Includes information on marketing, copyright, contracts, legal matters, taxes, grants and awards, health hazards, newsletters and magazines, organizations, and directories.

The Road Show: A Handbook for Successful Booking and Touring in the Performing Arts by Rena Shagan. American Council for the Arts, 1285 Avenue of the Americas, New York, New York 10019, 1985. A complete manual for planning and executing out-of-town engagements for soloists and companies in all the performing arts.

Supporting Yourself as an Artist: A Practical Guide by Deborah A. Hoover. New York: Oxford University Press, 1985.

The Unabashed Self-Promoter's Guide by Dr. Jeffrey Lant. Jeffrey Lant Associates, 50 Follen Street, Suite 507, Cambridge, Massachusetts 02138, 1983. Describes how to explore and exploit the media to promote a product or service.

The Visual Artist's Manual: A Practical Guide to Your Career by Susan A. Grode and David Paul Steiner. Los Angeles: Core Graphics, 1981.

ORGANIZATIONS

Caroll Michels, Artists' Consultant, 491 Broadway, New York, New York 10012.

National Network for Artist Placement and Career Development, California Institute for the Arts, 2400 McBean Parkway, Valencia, California 91355. Nonprofit organization dedicated to bringing career counseling, employment services, and survival skills to artists and students.

Also see "Periodicals."

Competitions

PUBLICATIONS

How to Enter and Win Fiction Writing Contests by Alan Gadney. New York: Facts on File Publications, 1981. Includes over 1,500 opportunities to enter fiction-writing contests, including poems, short stories, novels, plays, and screenplays. Also lists scholarships and grants.

How to Enter and Win Fine Arts and Sculpture Contests by Alan Gadney. New York: Facts on File Publications, 1982. Includes over 2,000 opportunities to enter contests, competitions, juried shows, fellowships, art fairs, and artist-in-residence programs. Includes hints on how to win, technical requirements, and deadlines.

How to Enter and Win Video/Audio Contests by Alan Gadney. New York: Facts on File Publications, 1981. Includes fellowships, grants, and broadcast opportunities.

Also see "Juried Exhibitions."

Cooperative Galleries

PUBLICATIONS

The Artist in the Marketplace by Patricia Frischer and James Adams. New York: M. Evans, 1980. See "Cooperative Galleries" chapter. Provides information on how to organize a co-op, including dos and don'ts.

The Artist's Guide to the Art Market by Betty Chamberlain. New York: Watson-Guptill, revised 1983. See the chapter "Cooperatives." Provides information on establishing a co-op, including space considerations, membership fees, commissions, pricing, insurance, and publicity.

The Emerging Arts: Management, Survival and Growth by Joan Jeffri. New York: Praeger, 1980. See "Cooperative Galleries" chapter.

ORGANIZATIONS

Association of Artist-Run Galleries (AARG), 164 Mercer Street, New York, New York 10012. Serves the United States and Canada. Pools information and resources to upgrade the professional standards of cooperative galleries and reduce costs for artists and galleries. Services include resource coordination; provides information on rent, dues, real estate, boards of directors, and mailing lists; assists artists in setting up cooperative galleries by providing information on all facets of gallery organization; arranges for the exchange of exhibitions among cooperative galleries; and maintains a slide registry.

Corporate Art

PUBLICATIONS

Art in America Annual Guide to Galleries, Museums and Artists. Published annually. See "Corporate Consultants" in index.

"Art, Inc.: The Photograph in the Gray Flannel Suit" by Mary Anne Staniszewski, *Manhattan, Inc.,* May 1986.

The Corporate Art Advisors Directory. 35 Newbury Street, Boston, Massachusetts 02116, 1987. Lists the names, addresses, phone numbers, and areas of expertise or specialization of corporate art advisors nationwide.

"Corporate Collecting Is Different" by Bruce Wolmer, *ARTnews,* May 1981.

"Corporate Interest in Collecting Art Growing," *Arts Management*, Summer 1985.

Directory of Corporate Art Collections. Published by *ARTnews* and International Art Alliance, revised 1986. Available from the American Council for the Arts, 1285 Avenue of the Americas, New York, New York 10019. Lists over 490 corporate art collections throughout the U.S. and Canada, and includes addresses, key personnel, and description of interest.

The Guild. Kraus Sikes, Inc., 150 West 25th Street, New York, New York 10001, published annually. A resource directory for architects and interior designers. Contains the names, addresses, phone numbers, photographs, and biographical information of American craft artists. Distributed free of charge to attendees of the American Society of Interior Designers and American Institute of Architects national conferences.

"Making a Business out of Art for the Office" by Paula Span, *The Wall Street Journal*, 11 July 1985.

"More Corporations Becoming Working Museums" by Thomas J. Lueck, *The New York Times*, 15 September 1985.

Partners: A Practical Guide to Corporate Support of the Arts edited by Patricia C. Jones. Alliance for the Arts, 330 West 42nd Street, New York, New York 10036, 1982.

"What Big Business Sees in Fine Art" by Grace Glueck, *The New York Times*, 26 May 1985.

ORGANIZATIONS

American Institute of Architects, 1735 New York Avenue, NW, Washington, D.C. 20006.

American Society of Interior Designers, 1430 Broadway, New York, New York 10018.

Association of Professional Art Advisors, P.O. Box 2485, New York, New York 10163.

Business Committee for the Arts, 1775 Broadway, New York, New York 10019. National organization that stimulates corporate concerns for support of and involvement in the arts. Publishes *BCA News*, a monthly newsletter for arts organizations that presents examples of what business is doing for the arts nationally.

Also see "Interior Design and Architecture."

Employment Opportunities

PUBLICATIONS

Artsearch. Theatre Communications Group, 355 Lexington Avenue, New York, New York 10017. Published biweekly, this is a national employment-service bulletin for the performing arts that lists jobs in arts and arts-related education, production, and management.

The College Art Association's Listing of Positions. College Art Association, 149 Madison Avenue, New York, New York 10016. Published five times a year, this is a listing of art jobs, mainly in colleges and museums, in the United States and Canada.

Jobs in Art and Media Management: What They Are and How to Get One by Stephen Langley and James Abruzzo. New York: Drama Book Publishers, 1986.

Jobs in the Arts and Arts Administration: A Guide to Placement/ Referral Services, Career Counseling, and Employment by Henry S. Hample. Center for Arts Information, 1285 Avenue of the Americas, New York, New York 10019, revised 1984. A general overview of resources available for finding permanent employment in the arts. Lists newsletters and other periodicals with employment listings, and organizations that offer career counseling, job placement, or job referrals.

National Arts Jobbank. 207 Shelby Street, Santa Fe, New Mexico 87501. Bimonthly newsletter listing available employment in visual and performing arts, literature, education, and arts administration.

What Color Is Your Parachute? A Practical Manual for Job Hunters and Career Changers by Richard Nelson Bolles. Ten Speed Press, P.O. Box 7123, Berkeley, California 94707, revised 1986.

ORGANIZATIONS

Affiliate Artists, Inc., 37 West 65th Street, New York, New York 10023. Regional office: 1401 Peachtree Street, Atlanta, Georgia 30309.

Artist-in-Residence Program, Education Division, Federal Bureau of Prisons, 320 First Street, NW, Washington, D.C. 20534.

Artists-in-Education Programs, Office for Partnership, National Endowment for the Arts, 1100 Pennsylvania Avenue, NW, Washington, D.C. 20506.

Artists Work. Chicago Artists' Coalition, 5 West Grand Avenue, Chicago, Illinois 60610. An employment service offered free of charge to Chicago Artists' Coalition members.

Hospital Audiences, Inc., 1540 Broadway, New York, New York 10036.

Independent Curators, Inc., 799 Broadway, New York, New York 10003.

National Network for Artist Placement and Career Development, California Institute for the Arts, 2400 McBean Parkway, Valencia, California 91355. Nonprofit organization dedicated to bringing career counseling, employment services, and survival skills to artists and art students.

Opportunity Resources for the Arts, Inc., 1457 Broadway, New York, New York 10036. National organization that provides placement services for administrative positions in museums, art centers, art councils, theater, opera and ballet companies, symphony orchestras, etc.

Also see "Art Colonies, Artist-in-Residence and Exchange Programs."

Exhibition Planning

PUBLICATIONS

The Artist's Guide to Getting and Having a Successful Exhibition by Robert S. Persky. New York: The Consultant Press, 1985. Available from the Photographic Arts Center, 127 East 59th Street, New York, New York 10022.

Artist's Guide to Producing a Solo Show in New York by Gil Kerlin. Light Brown Press, 39 Forest Avenue, Hastings, New York 10706, 1986. Includes information on developing a mailing list, finding a photographer, advertising, planning an opening, creating a poster and invitation, and managing sales.

Bibliography: Organizing Traveling Exhibitions. Washington, D.C.: International Council of Museums, 1987. Available from Humanities Exchange, P.O. Box 1608, Largo, Florida 34294.

CARFAC Recommended Minimum Exhibition Fee Schedule. Canadian Artists' Representation Ontario (CARO), 345-67 Mowat Avenue, Toronto, Canada, M6K 3E3, 1982.

Good Show! A Practical Guide for Temporary Exhibitions by Lothar P. Wittenborg. Smithsonian Institution Traveling Exhibition Service, Washington, D.C. 20506, 1981. Excellent how-to manual for developing temporary exhibitions.

Open Studio Event: An Artist's Planning Guide. The Artists Foundation, Inc., 110 Broad Street, Boston, Massachusetts 02110, 1980. Practical guide for planning and implementing an open studio event, including tips on organizing, creating a time line, publicity, and publications.

The Photographer's Guide to Getting and Having a Successful Exhibition by Robert S. Persky. Photographic Arts Center, 127 East 59th Street, New York, New York 10022, 1987.

Gallery Relations

PUBLICATIONS

CARO-OAAG Artist–Public Gallery Exhibition Agreement. Canadian Artists' Representation Ontario (CARO), 345-67 Mowat Avenue, Toronto, Ontario Canada M6K 3E3, 1978. Includes commentary for artists negotiating with galleries.

Some Facts About Artists' Relations with Their Dealers in Ontario by Dr. Peter Denny and Deborah Meldazy. Canadian Artists' Representation Ontario (CARO), 345-67 Mowat Avenue, Toronto, Ontario, Canada M6K 3E3, 1976.

General Arts References

PUBLICATIONS

American Art Directory. New York: R.R. Bowker, triannual. Directory of arts organizations, art schools, museums, magazines, and scholarships and fellowships.

Art in America Annual Guide to Galleries, Museums and Artists edited by Elizabeth C. Baker. Brant Art Publications, 980 Madison Avenue, New York, New York 10021. Alphabetical listing of American museums, galleries, and alternative spaces, arranged by state and city. Includes addresses, phone numbers, business hours, names of key staff members, and a short description of type of art shown. Published annually.

Art Now/U.S.A.: The National Art Museum and Gallery Guide. Art Now, Inc., 144 North 14th Street, Kenilworth, New Jersey 07033. A national publication with up-to-date information on exhibitions in over 900 galleries and museums. Special geographic editions are also available for the following geographic areas: New York City, Boston,

Philadelphia, Chicago, the Southwest, the Southeast, and California. Published monthly.

Cultural Directory II. Smithsonian Institution Press, 1111 North Capitol Street, Washington, D.C. 20560, 1980. Guide to federal funds and services for the arts and humanities.

The Encyclopedia of Associations. Gale Research Company, Book Tower, Detroit, Michigan 48226. Revised periodically. Indexed by title and subject. Each entry includes address, purpose, programs, and publications.

International Resources for Canadian Artists by Alan Bates, edited by Gail J. Habs. Visual Arts Ontario, 439 Wellington Street West, Toronto, Ontario, Canada, M5V 1E7, 1983. Lists world museums, public galleries, and alternative spaces; international exhibition opportunities; art schools and workshops; international grants, scholarships, fellowships, and internships; and international art magazines and periodicals.

New York Fine Artist's Source Book by the New York City Department of Cultural Affairs. Reading, Massachusetts: Addison-Wesley, 1983. A comprehensive manual describing a full range of professional art services available in New York City, including artists' organizations, nontraditional exhibition spaces, and special opportunities for artists.

The Photographic Collectors' Resource Directory. Photographic Arts Center, 127 East 59th Street, New York, New York 10022, revised 1985. Over 1,000 listings of galleries, museums, dealers, and workshops in the U.S., Canada, and Europe.

The Poor Dancer's Almanac. Dance Theatre Workshop, 219 West 19th Street, New York, New York 10011, 1983. Survival manual for choreographers, dancers, and dance companies.

The Print World Directory. Printworld, Inc., P.O. Box 785, Bala Cynwyd, Pennsylvania 19004. Published annually.

We Will Not Be Disappeared! Directory of Arts Activism edited by Susan R. McCarn. Cultural Correspondence, 505 West End Avenue, #15C, New York, New York 10024, 1984. Published in cooperation with Lake View Press. A networking directory for groups and individuals to share information, ideas, and resources.

Who Does What. Canadian Conference of the Arts, 126 York Street, Suite 400, Ottawa, Ontario, Canada K1N 5T5, 1985–1986. A guide to over 100 national Canadian associations, service organizations, and unions operating in most areas of the arts.

World Crafts Council Directory/Europe. World Crafts Council, Secretariat, P.O. Box 2045, DK1012, Copenhagen K, Denmark. Covers twenty-five countries with information on and addresses of government agencies concerned with crafts, and institutions, schools, galleries, crafts events, trade fairs, and publications. Published annually.

Writer's Market. Writer's Digest Books, 9933 Alliance Road, Cincinnati, Ohio 45242. Published annually.

Grants

PUBLICATIONS

The Art of Winning Corporate Grants by Howard Hillman with Marjorie Chamberlain. New York: Vanguard Press, 1980.

Artsmoney by Joan Jeffri. New York: Neal-Schuman, 1983. A fundraising handbook and catalog of ideas for artists and art groups.

Developing Skills in Proposal Writing by Mary Hall. Continuing Education Publications, Portland State University, Community Services, P.O. Box 1491, Portland, Oregon 97207, second edition 1977. Manual on developing information for a project and writing a strong proposal.

The Directory of New York State Foundations. Logo Associates, 7 Park Street, Attleboro, Massachusetts 02703, 1986.

Directory of Private Funding. Association of Hispanic Arts, Inc., 200 East 87th Street, New York, New York 10028, revised 1985. Identifies foundations, corporations, and public arts funding opportunities for organizations and individual artists.

"Emergency Funds," *Women Artist News*, Fall 1984.

For Us Women Newsletter: The Newsletter of Funding Resources for Women's Self-Development edited and published by Shakurra Amatualla. For Us Publications, P.O. Box 33147, Farragut Station, Washington, D.C. 20033. Published bimonthly.

Foundation Fundamentals: A Guide for Grant Seekers by Carol Kurzig. The Foundation Center, 79 Fifth Avenue, New York, New York 10003, 1980.

Foundation Grants to Individuals. The Foundation Center, 79 Fifth Avenue, New York, New York 10003, third edition 1981. Lists schol-

arships, education loans, fellowships, residencies, internships, awards, and prizes available to individuals from private foundations. Also includes information on how to approach foundations.

Get Your Money, Honey! A Student's Guide to Staying Alive by Shakurra Amatulla. For Us Publications, P.O. Box 33147, Farragut Station, Washington, D.C. 20033, 1983. Funding resources to start or return to school, and unique ways to stay economically afloat. Includes information and ideas for raising money in all types of circumstances; overcoming fears of proposal writing; and finding the right grant.

Grant Proposals That Have Succeeded by Virginia White. New York: Plenum Press, 1983.

Grant Seekers' Guide edited by Jill R. Shellow. Mount Kisco, New York: Moyer Bell Limited, revised 1985.

Grants and Awards Available to American Writers. PEN American Center, 568 Broadway, New York, New York 10012. Lists nearly 500 American and international grant programs for writers. Includes deadlines, guidelines, and summaries of application procedures. Fourteenth edition 1987.

Grants for Arts and Cultural Programs. The Foundation Center, 79 Fifth Avenue, New York, New York 10003, 1986. Lists nearly 5,000 grants for arts and cultural programs by independent, corporate, and community foundations.

Grants for the Arts by Virginia P. White. New York: Plenum Press, 1980. Covers state by state where to go to get information on grants for visual, performing, and literary arts. Includes publications, periodicals, foundations, and corporate directories and government programs. Provides information on how to write a proposal for a project, and what to do if you are turned down.

Grants Magazine. Journal of Sponsored Research and Other Programs. Plenum Press, 233 Spring Street, New York, New York 10012. Published four times a year.

The Grass Roots Fund Raising Book: How to Raise Money in Your Community by Joan Flanagan. Swallow Press, subdivision of Ohio University Press, 811 West Junior Terrace, Chicago, Illinois 60613, 1977.

Guide to the National Endowment for the Arts. National Endowment for the Arts, 1100 Pennsylvania Avenue, NW, Washington, D.C. 20506. Published annually.

How the Rich Get Richer and the Poor Write Proposals by Nancy Mitiguy. Citizens Involvement Training Project, University of Massachusetts, 138 Hasbrouch, Amherst, Massachusetts 01003, 1978. Introductory workbook on planning and writing proposals and approaching funding sources. Available from Citizens Involvement Training Project.

How to Get Grants in Films by Steve Penny. Film Grants Research, P.O. Box 1138, Santa Barbara, California 93102, 1978. A guide to media grants on film, video, audiovisual projects, and scholarships.

The Individual's Guide to Grants by Judith Margolin. New York: Plenum Press, 1983.

Money Business: Grants and Awards for Creative Artists. The Artists Foundation, Inc., 110 Broad Street, Boston, Massachusetts 02110, revised 1981. Lists hundreds of organizations that offer grants, fellowships, artist-in-residence programs, etc., to painters, sculptors, printmakers, photographers, playwrights, poets, fiction writers, filmmakers, video artists, and choreographers.

Money for Artists: A Guide to Grants and Awards for Individual Artists edited by Rebecca Lewis and Rita K. Roosevelt. New York: Center for Arts Information, 1285 Avenue of the Americas, New York, New York 10019, 1987. Includes over 3,500 grants, awards, fellowships, and artist-in-residence programs for visual and performing artists and writers.

The National Directory of Grants and Aid to Individuals in the Arts. P.O. Box 15240, Washington, D.C. 20003. Published annually.

The Private Funding Advisor Newsletter. The Taft Group, 5130 MacArthur Boulevard, Washington, D.C. 20016. Published monthly.

A Quick Guide to Loans and Emergency Funds. Center for Arts Information, 1285 Avenue of the Americas, New York, New York 10019, revised 1986. Describes loans and emergency funds for artists.

Washington International Arts Letter. P.O. Box 15240, Washington, D.C. 20003. Newsletter published ten times a year with information on grants and assistance by government and private foundations.

What Makes a Good Proposal? by F. Lee Jacquette and Barbara L. Jacquette. The Foundation Center, 79 Fifth Avenue, New York, New York 10003, 1973. Booklet.

What Will a Foundation Look for When You Submit a Grant Proposal? by Robert A. Mayer. The Foundation Center, 79 Fifth Avenue, New York, New York 10003, 1972.

ORGANIZATIONS

The Foundation Center, 79 Fifth Avenue, New York, New York 10003. A national service organization that provides information on foundation funding. Services include dissemination of information on foundations and publishing reference books on foundations and foundation grants.

The Foundation Center, Kent H. Smith Library, 1422 Euclid Avenue, Cleveland, Ohio 44115.

The Foundation Center, 312 Sutter Street, San Francisco, California 94108.

The Foundation Center, 1001 Connecticut Avenue, NW, Suite 938, Washington, D.C. 20036.

National Endowment for the Arts, 1100 Pennsylvania Avenue, NW, Washington, D.C. 20506.

National Endowment for the Humanities, 1100 Pennsylvania Avenue, NW, Washington, D.C. 20506.

Health Hazards

PUBLICATIONS

Art Hazard News. Center for Occupational Hazards, 5 Beekman Street, New York, New York 10038. Published ten times a year.

Artist Beware: The Hazards and Precautions in Working with Art and Craft Materials by Michael McCann. New York: Watson-Guptill, 1979.

Health Hazards Manual for Artists by Michael McCann. Foundation for the Community of Artists, 280 Broadway, New York, New York 10007, revised 1979.

Reproductive Hazards in the Arts and Crafts by Nancy Clark, Jean Ann McGrane, and Thomas Cutter. Center for Occupational Hazards, 5 Beekman Street, New York, New York 10038, 1985.

Safe Practices in the Arts and Crafts: A Studio Guide by Julian A. Waller, M.D. College Art Association, 149 Madison Avenue, New York, New York 10016, revised 1985. Lists art processes alphabetically with ways of minimizing hazards.

Ventilation: A Practical Guide. Center for Occupational Hazards, 5 Beekman Street, New York, New York 10038, 1984.

Artists Health Project, The Artists Foundation, Inc., 110 Broad Street, Boston, Massachusetts 02110. A program that teaches artists about hazardous art materials and alternatives for safe use.

Center for Occupational Hazards, 5 Beekman Street, New York, New York 10038. National organization that disseminates information on hazards of arts and crafts materials. Informs artists and the public on suitable precautions.

Insurance and Medical Plans

PUBLICATIONS

Group Health Insurance for Artists by John Thompson. Center for Art Information, 1285 Avenue of the Americas, New York, New York 10019, revised 1985.

Insurance Project: Feasibility Study for a Nationwide Health Insurance Plan for Independent Artists. National Endowment for the Arts, 1100 Pennsylvania Avenue, NW, Washington, D.C. 20506, 1986.

ORGANIZATIONS

American Craft Council, 40 West 53rd Street, New York, New York 10019. Offers members group rates on insurance programs, including major medical, life insurance, and total studio protection.

American Institute of Graphic Arts, 1059 Third Avenue, New York, New York 10021. Offers members special group rates on medical insurance.

Artists Equity Association of New York, 32 Union Square East, #1103, New York, New York 10003. Offers members major medical, group hospital indemnity, dental, and term life insurance.

The Artists Foundation, Inc., 110 Broad Street, Boston, Massachusetts 02110. Offers a group health insurance plan.

Chicago Artists' Coalition, 5 West Grand Avenue, Chicago, Illinois 60610. Offers members group medical insurance.

College Art Association of America, 149 Madison Avenue, New York, New York 10016. Offers members medical and life insurance at group rates.

Cultural Alliance of Greater Washington, 633 E Street, NW, Washington, D.C. 20004. Offers members health and dental insurance.

Deaf Artists of America, Inc., P.O. Box 2332, Westfield, New Jersey 07091. Offers members a health insurance plan.

Doctors for Artists, 123 West 79th Street, New York, New York 10024. A nonprofit referral service developed to aid performing and visual artists with health care at reduced rates. Program offers a 20-percent discount on medical services in fourteen areas, including internal medicine, ophthalmology, psychiatry, pediatrics, and plastic surgery.

Foundation for the Community of Artists, 280 Broadway, New York, New York 10007. Group hospitalization plan for members.

Graphic Artists Guild, 30 East 20th Street, New York, New York 10003. Offers members basic hospital and medical benefits, major medical, term life, and disability income insurance.

International Sculpture Center, 1050 Potomac Street, NW, Washington, D.C. 20007. Offers members "all-risk" fine-art insurance and health insurance.

National Artists Equity Association, P.O. Box 28068, Central Station, NW, Washington, D.C. 20038. Offers members group insurance, including major medical, hospital indemnity, term life, and "all-risk" fine-art studio coverage and while work is in transit.

National Home Life Assurance Company of New York. One Marine Midland Plaza, Binghamton, New York 13901.

PEN American Center, 568 Broadway, New York, New York 10012. Offers members medical insurance at group rates.

Support Systems Alliance, P.O. Box 130, Schoharie, New York 12157. Offers members Blue Cross/Blue Shield, group life and accidental death and dismemberment, dental, vision care, and short-term disability income insurance, and major medical.

Also see "Pension Plans."

Interior Design and Architecture

PUBLICATIONS

Architectural Design, 42 Leinster Gardens, London W2, England.

Architectural Digest, 5700 Wilshire Boulevard, Los Angeles, California 90036.

Architectural Record, 1221 Avenue of the Americas, New York, New York 10020.

Architectural Review, 9 Queen Anne's Gate, Westminster, England.

L'Architecture d'Aujourd'hui, 67 avenue de Wagram, 75017 Paris, France.

Architecture Intérieure Créé, 106 boulevard Malesherbes, 75017 Paris, France.

Arts and Architecture, The Schindler House, 835 North Kings Road, Los Angeles, California 90069.

Baumeister, Verlag G. D. W. Callwey KG, Streitfeldstrasse 35, Postfach 800409, 8000 Munich 80, West Germany.

Casabella, Via Goldoni 1, 20129 Milan, Italy.

Contract, 1515 Broadway, New York, New York 10036.

Corporate Design, 850 Third Avenue, New York, New York 10022.

Designers Magazine, 114 East 42nd Street, New York, New York 10017.

Designers Report, 17 West 20th Street, New York, New York 10011.

Designers West, 50 East 89th Street, New York, New York 10028.

Detail, Verlag Architektur und Baudetail GmbH, Franz Joseph Strasse 9, 8000 Munich 40, West Germany.

Domus, Via Achille Grandi 5/7, 20121 Milan, Italy.

House Beautiful, 1700 Broadway, New York, New York 10019.

House and Garden, 350 Madison Avenue, New York, New York 10017.

Interior Design, 850 Third Avenue, New York, New York 10022.

Interiors, 1515 Broadway, New York, New York 10036.

Japan Architect, 31-2 Yushima 2-chome, Bunkyo-ku, Tokyo 113, Japan.

Lotus International, Via Goldoni 1, 20129 Milan, Italy.

Metropolis, 177 East 87th Street, New York, New York 10128.

Metropolitan Home, 750 Third Avenue, New York, New York 10017.

Modo, Via Roma 21, 20094 Corsico, Milan, Italy.

Process: Architecture, 3-1-3 Koishiakawa, Bunkyo-ku, Tokyo, Japan.

Progressive Architecture, 600 Summer Street, Stamford, Connecticut 06904.

Quadrens d'Arquitectura i Urbanismo, Placa Nova 5, Barcelona 2, Spain.

Residential Interiors, 1515 Broadway, New York, New York 10036.

Also see "Corporate Art."

Juried Exhibitions

PUBLICATIONS

Exhibition Directory. The Exhibit Planners, Box 55, Delmar, New York 10254. Calendar listing 286 selected national and regional juried art and photography exhibitions. Contains information on entry dates, media, awards, fees, and method of art delivery.

National Calendar of Open Competitive Art Exhibitions. Published by Henry Niles, 5423 New Haven Avenue, Fort Wayne, Indiana 46803. Quarterly publication.

National Policy Guidelines for Juried Exhibitions. National Artists Equity Association, Inc., P.O. Box 28068, Central Station, Washington, D.C. 20038, 1984.

Also see "Competitions."

Law

PUBLICATIONS

Art and Law. Volunteer Lawyers for the Arts, Third Floor, 1285 Avenue of the Americas, New York, New York 10019. Published quarterly.

The Art Law Primer by Caryn Leland. Foundation for the Community of Artists, 280 Broadway, New York, New York 10007, 1981. Compilation of the best law and art articles that have appeared in *Artworkers News,* including articles on contracts, agreements, leases, and general legal advice for artists.

The Artist-Gallery Partnership: A Practical Guide to Consignment by Tad Crawford and Susan Mellon. American Council for the Arts, 1285 Avenue of the Americas, New York, New York 10019, 1981.

An Artist's Guide to Small Claims Court. Volunteer Lawyers for the Arts, Third Floor, 1285 Avenue of the Americas, New York, New

York 10019, 1985. A step-by-step guide for preparing a case in small claims court, applicable to New York City.

An Artist's Handbook on Copyright by Robert C. Lower and Jeffrey E. Young. Georgia Volunteer Lawyers for the Arts, P.O. Box 1131, Atlanta, Georgia 30301-1131, 1982.

Community Legal Clinics in Ontario, compiled by Dino Tsantis. Canadian Artists' Representation Ontario (CARO), 345-67 Mowat Avenue, Toronto, Ontario, Canada M6K 3E3, 1981.

Contracts for Artists by William Gignilliat. Atlanta, Georgia: Words of Art, 1983.

Copyright Information Kit. Copyright Office, Library of Congress, Washington, D.C. 20559.

"Council on the Arts" by Martin Bressler, *American Artist*, February–April 1983. Series of articles on wills for artists.

"Domestic and International Copyright for the Visual Artist" by Elizabeth Reeves, *Art and Artists*, March-April 1985.

How to Register a Copyright and Protect Your Creative Work by Robert B. Chickering and Susan Hartman. New York: Charles Scribner's Sons, 1980.

"International Copyright" by Elizabeth Reeves, *Art and Artists*, May/June 1985.

An Introduction to Contracts for Visual Artists by Norman H. Stone. Bay Area Lawyers for the Arts, Fort Mason Center, Building C, Room 255, San Francisco, California 94123, 1979.

An Introduction to Copyright by Cyndra MacDowall. Canadian Artists' Representation Ontario (CARO), 345-67 Mowat Avenue, Toronto, Ontario, Canada M6K 3E3, 1981.

The Law (in Plain English) for Craftspeople by L. B. DuBoff. Madrona Publishers, Inc., Box 22667, Seattle, Washington 98122, 1984. Business skills and legal principles relating to the sale and use of work.

Legal Guide for Emerging Artists. Philadelphia Volunteer Lawyers for the Arts, 251 South 18th Street, Philadelphia, Pennsylvania 19103, 1982.

Legal Guide for the Visual Artist by Tad Crawford. New York: Madison Square Press, revised 1986. Includes information on the newly revised copyright law, general rights of artists, sales (by artist, gallery,

agent), reproduction rights, publishing and dealer contracts, loft leases, estate planning, income taxation, etc. Model contracts also included.

Legal Primer for the Arts and Craftsperson by John R. Goodwin. Publishing Horizons, 2950 North High Street, P.O. Box 02190, Columbus, Ohio 48202-9990, revised 1986.

Making It Legal: A Law Primer for the Craftmaker, Visual Artist, and Writer by Marion Davidson and Martha Blue. New York: McGraw-Hill, 1980.

Model Agreements for Visual Artists: A Guide to Contracts in the Visual Arts by Paul Sanderson. Canadian Artists' Representation Ontario (CARO), 345-67 Mowat Avenue, Toronto, Ontario, Canada M6K 3E3, 1982. An introduction to Canadian art law and professional business practices. Includes twenty-three model contracts and checklists, each accompanied by a commentary clarifying particular provisions.

Protecting Your Heirs and Creative Work by Tad Crawford. Graphic Artists Guild, 30 East 20th Street, New York, New York 10003, 1980. Deals with crucial problems that artists face when planning their estates.

The Rights of Authors and Artists by Kenneth P. Norwick and Jerry Simon Chasen. American Civil Liberties Union, 1984. Available from Volunteer Lawyers for the Arts, Third Floor, 1285 Avenue of the Americas, New York, New York 10019. Explains how authors and visual artists can protect themselves and their works under the present law; discusses copyright, libel, privacy, and obscenity law. Discusses contracts between writers and artists and their agents, collaborators, publishers, and galleries.

The Visual Artist's Guide to the New Copyright Law by Tad Crawford. Graphic Artists Guild, 30 East 20th Street, New York, New York 10003, 1981.

NATIONAL ORGANIZATIONS

National Artists Equity Association Collection Service, P.O. Box 280681, Central Station, Washington, D.C. 20038.

National Resource Center for Consumer Legal Services, 3254 Jones Court, NW, Washington, D.C. 20007.

Visual Artists and Galleries Association, Inc., One World Trade Center, Suite 1535, New York, New York 10048. Nonprofit organization that works to protect its members' rights in the reproduction of their work.

ORGANIZATIONS BY STATE

Alabama
Alabama Volunteer Lawyers for the Arts Committee, c/o Sirote, Permutt, Friend, Friedman, Held and Apolinksky, P.A., 2222 Arlington Avenue South, P.O. Box 55727, Birmingham, Alabama 35255.

California
Artlaw Foundation, Suite C, 1295 Prospect Street, La Jolla, California 92037. Provides education about legal issues of concern to the arts community. Offers lectures, workshops, and educational materials.

Bay Area Lawyers for the Arts, Fort Mason Center, Building C, Room 255, San Francisco, California 94123.

San Diego Lawyers for the Arts, 1205 Prospect Street, Suite 400, La Jolla, California 92037.

Volunteer Lawyers for the Arts of Los Angeles, P.O. Box 57008, Los Angeles, California 90057.

Colorado
Colorado Lawyers for the Arts, P.O. Box 300428, Denver, Colorado 80203.

Connecticut
Connecticut Volunteer Lawyers for the Arts, Connecticut Commission on the Arts, 190 Trumbull Street, Hartford, Connecticut 06103-2206.

District of Columbia
Lawyers Committee for the Arts—Volunteer Lawyers for the Arts, 918 16th Street, NW, Suite 503, Washington, D.C. 20036.

Washington Area Lawyers for the Arts, Suite 608, 2025 I Street, NW, Washington, D.C. 20006.

Florida
Business Volunteers for the Arts, c/o Greater Miami Chamber of Commerce, 1601 Biscayne Boulevard, Miami, Florida 33132.

Florida Volunteer Lawyers for the Arts, Florida Bar Association, 600 Appalachee Parkway, Tallahassee, Florida 32301-8226.

Volunteer Lawyers for the Arts, Broward Arts Council, 100 South Andrews Avenue, Fort Lauderdale, Florida 33301.

Volunteer Lawyers for the Arts, Pinellas County Arts Council, 400 Pierce Boulevard, Clearwater, Florida 33516.

Georgia
Georgia Volunteer Lawyers for the Arts, P.O. Box 1131, Atlanta, Georgia 30301-1131.

Illinois
Lawyers for the Creative Arts, Suite 300-N, 623 South Wabash Avenue, Chicago, Illinois 60605.

Iowa
Volunteer Lawyers for the Arts, 491 West Fourth Street, P.O. Box 741, Dubuque, Iowa 52201.

Volunteer Lawyers for the Arts Committee, Cedar Rapids/Marion Arts Council, 424 First Avenue, NE, P.O. Drawer 4860, Cedar Rapids, Iowa 52407.

Kentucky
Volunteer Lawyers for the Arts, Lexington Council of the Arts, 161 North Mill Street, Lexington, Kentucky 40507.

Community Arts Council, 609 West Main Street, Louisville, Kentucky 40202.

Louisiana
Louisiana Volunteer Lawyers for the Arts, Arts Council of New Orleans, WTM Building, Suite 936, 2 Canal Street, New Orleans, Louisiana 70130.

Maine
Maine Volunteer Lawyers for the Arts Project, Maine State Commission on the Arts and the Humanities, 55 Capitol Street, State House Station 25, Augusta, Maine 04333.

Maryland
Maryland Volunteer Lawyers for the Arts, University of Baltimore School of Law, 1420 North Charles Street, Baltimore, Maryland 21201.

Massachusetts
Lawyers/Accountants for the Arts, c/o The Artists Foundation, Inc., 110 Broad Street, Boston, Massachusetts 02110.

Michigan
Michigan Volunteer Lawyers for the Arts, 1283 Leeward Drive, Okemos, Michigan 48864.

Minnesota
Minnesota Volunteer Lawyers for the Arts, Suite 1500, 100 South Fifth Street, Minneapolis, Minnesota 55402.

Missouri
St. Louis Volunteer Lawyers and Accountants for the Arts, St. Louis Regional Arts Commission, 329 North Euclid Avenue, St. Louis, Missouri 63108.

Montana
Montana Volunteer Lawyers for the Arts, P.O. Box 8687, Missoula, Montana 69807.

New Jersey
Volunteer Lawyers for the Arts of New Jersey, Center for Non-Profit Corporations, 36 West Lafayette Street, Trenton, New Jersey 08608.

New York
Arts Council in Buffalo and Erie County, 700 Main Street, Buffalo, New York 14202.

Dutchess County Arts Council, 39 Market Street, Poughkeepsie, New York 12601.

Huntington Arts Council, 213 Main Street, Huntington, New York 11743.

Volunteer Lawyers for the Arts, Third Floor, 1285 Avenue of the Americas, New York, New York 10019.

Volunteer Lawyers for the Arts Program, Albany League of Arts, 19 Clinton Avenue, Albany, New York 12207.

North Carolina
North Carolina Volunteer Lawyers for the Arts, P.O. Box 590, Raleigh, North Carolina 27602.

Ohio
Cincinnati Area Lawyers for the Arts, ML003, University of Cincinnati, Cincinnati, Ohio 45221.

Volunteer Lawyers for the Arts, Suite D, 421 North Michigan Street, Toledo, Ohio 43624.

Volunteer Lawyers for the Arts Program, Cleveland Bar Association, Mall Building, 118 St. Clair Avenue, Cleveland, Ohio 44114.

Oklahoma
Volunteer Lawyers for the Arts, State Arts Council of Oklahoma, Room 640, Jim Thorpe Building, Oklahoma City, Oklahoma 73105-4987.

Pennsylvania
Philadelphia Volunteer Lawyers for the Arts, 251 South 18th Street, Philadelphia, Pennsylvania 19103.

Rhode Island
Ocean State Lawyers for the Arts, 96 Sachem Road, Narragansett, Rhode Island 02882.

South Carolina
South Carolina Lawyers for the Arts, P.O. Box 10023, Greenville, South Carolina 29603.

Tennessee
Volunteer Lawyers for the Arts, Tennessee Arts Commission, 320 Sixth Avenue North, Nashville, Tennessee 37219.

Texas
Austin Lawyers for the Arts, P.O. Box 2577, Austin, Texas 78768.

Texas Accountants and Lawyers for the Arts, 1540 Sul Ross, Houston, Texas 77006.

Utah
Utah Lawyers for the Arts, Suite 900, 50 South Main Street, Salt Lake City, Utah 84144.

Washington
Washington Volunteer Lawyers for the Arts, 428 Joseph Vance Building, 1402 Third Avenue, Seattle, Washington 98101.

Loans

ORGANIZATIONS

Small Business Loan Programs, Financing Division, Office of Finance, Small Business Administration, 1441 L Street, NW, Washington, D.C.

20416. Provides a limited number of loans and loan guarantees to independently owned and operated profit-making small businesses, including culture-related businesses (teaching studios, performing arts schools, or retail music, art, and crafts shops), which are evaluated on the basis of marketing feasibility, job-producing potential, and community benefits. Loans may be used to purchase real estate, buildings, machinery, equipment, and inventory, as well as to cover construction or expansion costs.

Mailing Lists

ORGANIZATIONS

Art News, GMI Unimail, Lincoln Plaza, 5th Floor, New York, New York 10023.

Arts Extension Service, Division of Continuing Education, University of Massachusetts, Goddell Building, Amherst, Massachusetts 01003. Provides mailing lists that include the names of individual artists, by discipline, in visual and performing arts; arts councils; craft organizations; and lawyers and other professionals who serve the arts.

Dependable List Compilation, Inc., 33 Irving Place, New York, New York 10003. Lists include art magazine subscribers and museum contributors.

Max Lent Productions, 24 Wellington Avenue, Rochester, New York 14611-3018. Specializes in mailing lists of interest to photographers, including photography exhibition spaces, organizations, bookstores, and portfolio publishers.

Media Distribution Co-op, 1745 Louisiana Street, Lawrence, Kansas 66044. Offers specialized lists for artists, photographers, filmmakers, musicians, and writers. In addition, offers a list of over fifty mailing-list brokers.

National Association of Artists' Organizations (NAAO), 1007 D Street, NE, Washington, D.C. 20002. Sells mailing lists on labels, in zip-code order, of all organizations included in *The Directory of Artists' Organizations*.

National Women's Mailing List, 1195 Valencia Street, San Francisco, California 94110.

Resources Mailing Lists, P.O. Box 134, Harvard Square, Cambridge, Massachusetts 02238-0134.

Unique Programs, Art Market Lists, P.O. Box 9910, Marina del Rey, California 90295.

Women in the Arts, 325 Spring Street, New York, New York 10013. Offers a comprehensive mailing list which includes New York City newspapers and galleries that show contemporary art; magazines and radio and television stations; art and women's organizations; art critics, art writers, and art and arts-related press.

Nonprofit Organizations

PUBLICATIONS

Beyond Profit: The Complete Guide to Managing the Nonprofit Organization by Fred Setterberg and Kary Schulman. New York: Harper & Row, 1985.

How to Apply for Recognition of Exemption for an Organization. Published by the Internal Revenue Service. Contact your local IRS for a copy.

The Nonprofit Organization by Thomas Wolf. New York: Prentice-Hall, 1984.

To Be or Not to Be: An Artist's Guide to Not-for-Profit Incorporation. Volunteer Lawyers for the Arts, 1285 Avenue of the Americas, New York, New York 10019, revised 1986. Explains the pros and cons of corporate status, legal responsibilities and requirements, and alternatives to incorporation.

Pension Plans

PUBLICATIONS

Buyer's Guide on IRAs/Keoghs and Advice on Evaluating the Economic Desirability of Establishing IRA or Keogh. Pamphlet published by the Federal Trade Commission, Washington, D.C. 20580.

Legal Guide for the Visual Artist by Tad Crawford. New York: Madison Square Press, revised 1986. See chapter on retirement plans.

A Tax Guide for Artists and Arts Organizations by Herrick K. Lidstone. Lexington Books, D. C. Heath & Co., 125 Spring Street, Lexington, Massachusetts 02173, 1979. See chapter on retirement plans.

ORGANIZATIONS

Pension Benefit Guaranty Corporation, 2020 K Street, NW, Washington, D.C. 20006.

Also see "Insurance and Medical Plans."

Periodicals

Afterimage. 31 Prince Street, Rochester, New York 14607. Regional coverage. For photographers and independent filmmakers and video artists. Nine issues, published monthly except July through September.

American Ceramics. 15 West 44th Street, New York, New York 10019. Published quarterly.

American Craft. American Craft Council, 40 West 53rd Street, New York, New York 10019. Articles on all aspects of crafts, and information on grants, marketing, and exhibitions. Published bimonthly.

Art and Artists (formerly *Artworkers News*). Foundation for the Community of Artists, 280 Broadway, New York, New York 10007. National focus. Published ten times a year.

Art Calendar. Box 872, Great Falls, Virginia 22066. Lists nationwide professional opportunities for visual artists, including juried shows, grants and awards, residencies, public art programs, art consultancies, internships, slide registries, and job openings. Published eleven times a year.

Art New England: A Resource for Visual Arts. 353 Washington Street, Brighton, Massachusetts 02135. Focuses on artists in New England. Published ten times a year.

Art Papers. P.O. Box 77348, Atlanta, Georgia 30357. Focuses on artists in the Southeast. Published bimonthly.

The Art Post. 192 Spadina Avenue, Toronto, Ontario, Canada M5T 2C2. Current-events coverage of the visual arts. Published bimonthly.

Artist Update. Foundation for the Community of Artists, 280 Broadway, New York, New York 10007. Lists grants and competitions, exhibition and performance opportunities, job openings, workshops and seminars, and resources and services. Published monthly.

The Artists Magazine. 9933 Alliance Road, Cincinnati, Ohio 45242. Published monthly.

Artpaper. The Visual Arts Information Service, 119 North Fourth Street, #303, Minneapolis, Minnesota 55401. An artists' newspaper featuring national grants and competitions, articles, news, and opportunities for artists in Minnesota and bordering states. Published ten times a year.

The Arts Journal. 324 Charlotte Street, Asheville, North Carolina 28801. Published monthly.

ARTS Review. Superintendent of Documents, U.S. Government Printing Office, Washington, D.C. 20402. Official newsletter of the National Endowment for the Arts. Includes NEA news, information on grant deadlines and legislation; book reviews; and other sections of interest to artists. Published quarterly.

Arts Washington. Cultural Alliance of Greater Washington, 633 E Street, NW, Washington, D.C. 20004. Published monthly.

Artviews. Visual Arts Ontario, 439 Wellington Street West, Toronto, Ontario, Canada M5V 1E7. Explores current issues and events in Ontario's arts community. Published quarterly.

Artweek. 168 Telegraph Avenue, Oakland, California 94612. Regional focus: Northwest, Southwest, Alaska, and Hawaii. Includes information on competitions, exhibitions, and festivals for visual and performance artists. Forty-four issues, published weekly September through May; biweekly June through August.

Association of Hispanic Arts Newsletter. Association of Hispanic Arts, 200 East 87th Street, New York, New York 10028. Published ten times a year.

Boston Visual Artists Union News. 700 Beacon Street, Boston, Massachusetts 02115. Focuses on art news, events, and opportunities in the Boston area. Published monthly.

CARO Bulletin. Canadian Artists' Representation Ontario (CARO), 345-67 Mowat Avenue, Toronto, Ontario, Canada, M6K 3E3. Reports on ongoing programs and current events affecting the arts community. Discusses issues of concern to artists, financial opportunities, and other practical information. Published eight times a year.

Chicago Artists' Coalition Newsletter. Chicago Artists' Coalition, 5 West Grand Avenue, Chicago, Illinois 60610. Published monthly.

Craft International. 247 Centre Street, New York, New York 10013. Published quarterly.

Discriminating Palette. Visual Arts Ontario, 439 Wellington Street West, Toronto, Ontario, Canada M5V 1E7. Packed with career-opportunity information for artists. Published quarterly.

Entry. P.O. Box 7648, Ann Arbor, Michigan 48107. Newsletter containing information on photographic competitions and juried exhibitions worldwide. Published ten times a year.

For Your Information. Center for Arts Information, 1285 Avenue of the Americas, New York, New York 10019. Published by the Center for Arts Information in cooperation with the New York City Department of Cultural Affairs and the New York Foundation for the Arts. Published quarterly.

The Goodfellow Newsletter. P.O. Box 4520, Berkeley, California 94704. Covers ceramics, batik, leather, quilting, stained glass, woodworking, etc.; includes craft news, marketing tips, and book reviews. Published monthly.

Graphic Artists Guild Newsletter. 30 East 20th Street, Room 405, New York, New York 10003. Focuses on graphic-arts news throughout the country, and features legal and financial advice, book reviews, and conference reports. Published monthly.

International Sculpture. International Sculpture Center, 1050 Potomac Street, NW, Washington, D.C. 20007. Published bimonthly.

The New Art Examiner. 300 West Grand Street, Chicago, Illinois 60610. Eleven issues, published monthly except August.

Sculptworld News. Sculpture Associates Limited, 40 East 19th Street, New York, New York 10003. National focus. Includes news on opportunities, apprenticeships, courses, publications, workshops, new exhibitions, literature, and exhibition opportunities. Published bimonthly.

Shuttle, Spindle and Dyepot. Handweavers Guild of America, 65 LaSalle Road, West Hartford, Connecticut 06107. International magazine of the Handweavers Guild of America. For weavers, spinners, and dyers. Contains technical and historical articles as well as marketing and business information. Published quarterly.

Strategies for Self-Promotion for Fine Art Photographers. The Simm Gallery, 20 Church Street, Montclair, New Jersey 07042. Published monthly.

Sunshine Artists U.S.A. 501–503 North Virginia Avenue, Winter Park, Florida 32789. Lists and discusses shows for artists and craftspeople throughout the country. Articles on arts in education and business, and government legislation affecting the arts. Published monthly.

Umbrella. Umbrella Associates, P.O. Box 3692, Glendale, California 91201. Art news, reviews, and information. Focuses on nationwide news and events related to mail art, art periodicals, and artists' books. Bimonthly newsletter.

Vantage Point (formerly *American Arts*). American Council for the Arts, 1285 Avenue of the Americas, New York, New York 10019.

Includes articles about significant art events and problems, features on major art developments and news. Published bimonthly.

Views. Photographic Resource Center, 602 Commonwealth Avenue, Boston, Massachusetts 02215. Newsletter for photographers. Published monthly.

Westart. P.O. Box 6868, Auburn, California 95604. For artists, craftspeople, and art patrons. Provides an overview of the West Coast art scene. Published bimonthly.

Women Artists News. P.O. Box 3304, Grand Central Station, New York, New York 10163. Published quarterly.

Women in the Arts Foundation, Inc., Bulletin/Newsletter. Women in the Arts, Inc., 325 Spring Street, New York, New York 10013. Articles of interest and news pertaining to women in the arts. Ten issues a year.

Also see "Career Management, Business, and Marketing."

Pricing Work

PUBLICATIONS

The Artist in the Marketplace by Patricia Frischer and James Adams. New York: M. Evans, 1980. See chapter on "Pricing."

The Artists' Survival Manual: A Complete Guide to Marketing Your Work by Toby Judith Klayman and Cobbett Steinberg. New York: Charles Scribner's Sons, 1984. See chapter "Getting Ready: Pricing Your Work."

Crafts/Pricing and Promotion by E. Patrick McGuire and Lois Morgan. American Craft Council Publications, 40 West 53rd Street, New York, New York 10019, 1979. Discusses craft-related business situations, and suggests marketing practices.

Pricing and Ethical Guidelines. Graphic Artists Guild, 30 East 20th Street, New York, New York 10003. Revised biannually.

The Professional Artist's Manual by Richard Hyman. New York: Van Nostrand Reinhold, 1980. See chapter on "Pricing."

Public Art

PUBLICATIONS

Art in Architecture in Ontario by Jeanne Parkin. Visual Arts Ontario, 439 Wellington Street West, Toronto, Ontario, Canada M5V 1E7, 1981.

Art in Public Places by John Beardsley. Washington, D.C.: Partners for Livable Places, 1981. Available from the American Council for the Arts, 1285 Avenue of the Americas, New York, New York 10019.

Commissioning a Work of Public Art: An Annotated Model Agreement by the Committee on Art Law of the Association of the Bar of the City of New York. New York: Columbia University School of Law and Volunteer Lawyers for the Arts, 1985. Available from the American Council for the Arts, 1285 Avenue of the Americas, New York, New York 10019. Outlines a standard working contract for a municipality, private corporation, real estate developer, or foundation when commissioning an individual artist to create a work of public art.

Insights/On Sites. Perspectives on Art in Public Places edited by Stacy Paleologos Harris. Washington, D.C.: Partners for Livable Places, 1984. Available from the American Council for the Arts, 1285 Avenue of the Americas, New York, New York 10019. Perspectives on art in public places.

National Percent for Arts Newsletters. Technoart, 311 East 17th Street, Spokane, Washington 99203. Lists open competitions for public art projects through Percent for Arts programs across the U.S. Published quarterly.

ORGANIZATIONS

Social and Public Arts Resource Center, 685 Venice Boulevard, Venice, California 90291. Membership organization that aids in the production of public art on a local, state, national, and international level. Houses a visual arts gallery and mural resource center.

Urban Arts, P.O. Box 1658, Boston, Massachusetts 02205. A public arts agency that accepts contracts to put art in public places. Houses a nationwide slide registry of artists in all disciplines.

NATIONAL PERCENT FOR ART PROGRAMS

Art-in-Architecture Program, General Services Administration, 18th and F Streets, NW, Washington, D.C. 20405.

Art-in-Architecture Program, Veterans Administration, Washington, D.C. 20420.

Art in Public Places, Visual Arts Program, National Endowment for the Arts, 1100 Pennsylvania Avenue, NW, Washington, D.C. 20506.

STATE AND MUNICIPAL PERCENT FOR ART PROGRAMS
*(*Open to out-of-state residents; †slide registry)*

Alaska
*Alaska State Council on the Arts, 619 Warehouse Avenue, #220, Anchorage, Alaska 99501-1682.†

Municipality of Anchorage, Office of Community Affairs, Pouch 6-650, Anchorage, Alaska 99502-0650.

Arizona
Arizona Commission on the Arts, 417 West Roosevelt Avenue, Phoenix, Arizona 85003.

Glendale Arts Commission, 5850 West Glendale Avenue, Glendale, Arizona 85301.†

California
Alameda County Arts Commission, 399 Elmhurst Street, Hayward, California 94544.

California Arts Council, 1901 Broadway, Suite A, Sacramento, California 95818.†

*City of Beverly Hills, 444 North Rexford Drive, Beverly Hills, California 90210.†

City of Los Angeles,˙ Community Redevelopment Agency, 354 South Spring Street, Los Angeles, California 90016.

Inter-Arts of Marin, 1000 Sir Francis Drake Boulevard, San Anselmo, California 94960.

*Sacramento Metropolitan Arts Commission, 800 Tenth Street, Sacramento, California 95814.†

*San Francisco Arts Commission, 45 Hyde Street, Room 319, San Francisco, California 94102.†

*Santa Barbara County Arts Commission, County Courthouse, 1100 Ancapa Street, Santa Barbara, California 93101.†

Santa Monica Arts Commission, 215 Santa Monica Pier, Santa Monica, California 90401.†

Colorado
*Colorado Council on the Arts and Humanities, 770 Pennsylvania Street, Denver, Colorado 80203.†

Connecticut
*Connecticut Commission on the Arts, 190 Trumbull Street, Hartford, Connecticut 06103.†

Florida
*Arts Council of Florida, Division of Cultural Affairs, Department of State, The Capitol, Tallahassee, Florida 32301.†

*Broward Arts Council, 100 South Andrews Avenue, Fort Lauderdale, Florida 33301.†

*Department of Community Development, 1145 Northwest Boulevard, Miami, Florida 33136.†

Miami/Dade County Art in Public Places Program, 140 West Flagler Street, Miami, Florida 33130.

Georgia
Department of Cultural Affairs, 151 Ellis Street, Atlanta, Georgia 30303.

Hawaii
Mayor's Cultural and Arts Office, City Hall, 4th Floor, Honolulu, Hawaii 96813.

*State Foundation on Culture and Arts, 335 Merchant Street, Room 202, Honolulu, Hawaii 96813.†

Illinois
Capitol Development Board, Stratton Office Building, 401 South Spring Street, Springfield, Illinois 62706.†

*Chicago Office of Fine Arts, 78 East Washington Street, Chicago, Illinois 60602.

Iowa
*Iowa Arts Council, State Capitol Complex, 1223 East Court Avenue, Des Moines, Iowa 50319.†

Louisiana
*Arts Council of New Orleans, WTM Building, Suite 936, 2 Canal Street, New Orleans, Louisiana 70130.†

Maine
*Maine State Commission on the Arts and the Humanities, 55 Capitol Street, State House Station 25, Augusta, Maine 04333.†

Maryland
*Civic Design Commission, 702 Municipal Building, Baltimore, Maryland 21202.

Massachusetts
*Cambridge Arts Council, 57 Inman Street, Cambridge, Massachusetts 02139.

Massachusetts Council on the Arts, Percent for Art Program, 80 Boylston Street, Boston, Massachusetts 02116.†

Michigan
*Commission on Art in Public Places, 1200 Sixth Avenue, Detroit, Michigan 48226.

Missouri
Municipal Arts Commission, City Hall, 26th Floor, Kansas City, Missouri 64106.

Montana
*Montana Arts Council, 35 South Last Chance Gulch, Helena, Montana 59620.

New Hampshire
New Hampshire Commission on the Arts, 40 North Main Street, Concord, New Hampshire 03301.†

New Jersey
*New Jersey State Council on the Arts, 109 West State Street, Trenton, New Jersey 08625.†

New Mexico
*Kimo Theatre—City of Albuquerque, P.O. Box 1293, Albuquerque, New Mexico 87103.†

New York
*Percent for Art Program, 2 Columbus Circle, New York, New York 10019.†

Ohio
*Art Commission of Greater Toledo, 618 North Michigan Street, Toledo, Ohio 43604.†

Oklahoma

*Arts Commission of the City of Tulsa, 2210 South Main Street, Tulsa, Oklahoma 74114.†

Oklahoma City Arts Commission, 400 West California, Oklahoma City, Oklahoma 73102.

Oregon

*Oregon Arts Commission, 835 Summer Street, NE, Salem, Oregon 97301.

Pennsylvania

Department of Parks and Recreation, Grant Street, 400 City-Co Building #30, Pittsburgh, Pennsylvania 15219.

*Redevelopment Authority of Philadelphia, 1234 Market Street, Philadelphia, Pennsylvania 19107.†

South Carolina

*South Carolina Arts Commission, 1800 Gervais Street, Columbia, South Carolina 29201.†

Utah

Salt Lake City Council for the Arts, 54 Finch Lane, Salt Lake City, Utah 84101.

Washington

Bellevue Arts Commission, P.O. Box 1768, Bellevue, Washington 98009.

*City of Everett, 3002 Wetmore Avenue, Everett, Washington 98020.

Edmonds Arts Commission, 700 Main Street, Edmonds, Washington 98020.

Fine Arts Commission, Parks and Recreation Department, 5303 228th Street, SW, Mountlake Terrace, Washington 98403.

King County Arts Commission, 828 Alaska Building, 612 Second Avenue, Seattle, Washington 98104.†

Municipal Arts Commission, 200 Mill Avenue, S-City Hall, Renton, Washington 98055.

*Spokane Arts Commission, 808 Spokane Falls Boulevard, Spokane, Washington 99201.†

Tacoma-Pierce County Arts Commission, 740 St. Helens Avenue, Tacoma, Washington 98402.

Washington State Arts Commission, Mail Stop GH-11, Ninth and Columbia Building, Olympia, Washington 98504.

Wisconsin
Milwaukee Arts Commission, P.O. Box 324, Milwaukee, Wisconsin 53201.

*Wisconsin Arts Board, 107 South Butler Street, Madison, Wisconsin 53703.†

Canada
Visual Arts Program, Archive, Department of the City Clerk, City of Ottawa, 111 Sussex Drive, Ottawa, Canada K1N 5A1.

MASS TRANSIT AGENCIES

Arts for Transit, 347 Madison Avenue, New York, New York 10017.

Arts on the Line, 57 Inman Street, Cambridge, Massachusetts 02139.

Downtown Seattle Transit Project, Mail Stop 131, 821 Second Avenue, Seattle, Washington 98104.

Also see "Slide Registries."

Slide Registries

ORGANIZATIONS

American Craft Council, 40 West 53rd Street, New York, New York 10019. National organization. Operates a slide registry, an indexed portfolio system of biographical and pictorial data on practicing American craftspeople.

Artbank, Arts on the Line, 57 Inman Street, Cambridge, Massachusetts 02139. Slide registry is used as a basic resource for all Massachusetts Bay Transit Authority art selection and purchase. Open to all visual artists in all mediums.

Art-in-Architecture Program, General Services Administration, Public Buildings Service, Washington, D.C. 20405.

Art-in-Architecture Program, Veterans Administration, Washington, D.C. 20420.

Art Information Center, 280 Broadway, New York, New York 10007. Operates two registries: Unaffiliated Artists, an open file of slides and

résumés of unaffiliated artists, for dealers seeking new works; and Affiliated Artists, to help artists, dealers, museum personnel, the press, collectors, and public locate the work of living artists. Houses up-to-date files on approximately 45,000 gallery-affiliated artists.

Artists Space, 233 West Broadway, New York, New York 10013. Sponsors a computerized slide registry of New York State artists who are not represented by commercial or co-op galleries.

Association of Artist-Run Galleries, 164 Mercer Street, New York, New York 10012. Slide registry contains the works of all AARG gallery members, available for viewing by curators, critics, artists, and collectors.

Chicago Artists' Coalition, 5 West Grand Avenue, Chicago, Illinois 60610. Sponsors a slide registry.

The Drawing Center, 35 Wooster Street, New York, New York 10012. Exhibition, research, and study center for contemporary drawings. International organization. Operates a slide registry that contains résumés and photographs of artists' work and is available for public reference.

International Sculpture Center, 1050 Potomac Avenue, NW, Washington, D.C. 20007. Sponsors "Sculpture Source," a computerized slide registry for sculptors.

National Center on Arts and the Aging, 600 Maryland Avenue, SW, Washington, D.C. 20024. Sponsors a slide registry for artists over sixty-five years of age.

Women in Photography, P.O. Box 27142, Los Angeles, California 90027. Operates a slide registry for curators, researchers, and instructors for various exhibitions on contemporary women photographers.

Also see "Public Art."

Surplus-Material Programs

PUBLICATIONS

Materials for the Arts: A Handbook. New York City, Department of Cultural Affairs, 2 Columbus Circle, New York, New York 10019, undated.

ORGANIZATIONS

The Emergency Materials Fund, Artists Space/Committee for the Visual Arts, Inc., 223 West Broadway, New York, New York 10013.

Materials for the Arts, New York City Department of Cultural Affairs, 2 Columbus Circle, New York, New York 10019.

NOTES

1. Tom Wolfe, *The Painted Word* (New York: Farrar, Straus & Giroux, 1980), 14.

2. Betty Chamberlain, *The Artist's Guide to His Market* (New York: Watson-Guptill, 1983), 18.

3. Ralph Charell, *How to Make Things Go Your Way* (New York: Simon & Schuster, 1979), 149.

4. Judith Appelbaum and Nancy Evans, *How to Get Happily Published* (New York: Harper & Row, 1978), 12.

5. Tad Crawford, *Legal Guide for the Visual Artist* (New York: Madison Square Press, 1986), 1.

6. Ibid., 163.

7. Ibid.

8. Richard Hyman, *The Professional Artist's Manual* (New York: Van Nostrand Reinhold, 1980), 76.

9. Ibid.

10. A. MacDonald, C.P.A., "A Great Idea for the Artist—The Pension Plan," *Artworkers News*, June 1981, 42.

11. From press release issued by Laura Foreman and John Watts for *Wallwork*, New York City, 1 May 1981.

12. Ibid.

13. Jack Anderson, " 'Sold Out' Performances That Never Actually Took Place," *The New York Times*, 12 July 1981, 13.

14. Daniel Grant, "The Publicity of Art and the Art of Publicity," *Artworkers News*, March 1981, 1.

15. From press release by Integral Consciousness Institute for "Synthesis," exhibition at the Soho Center for Visual Artists, New York City, June 1979.

16. "Barbara Rose," interview by Eva Cockcroft, *Artworkers News*, April 1980, 13.

17. "John Perrault," interview by Walter Weissman, *Artworkers News*, April 1980, 19.

18. Edith DeAk and Walter Robinson, "Alternative Periodicals," *The New Artspace, A Summary of Alternative Visual Arts Organizations*. Prepared in conjunction with a conference April 26–29, 1978 (Los Angeles: Los Angeles Institute of Contemporary Art, 1978), 38.

19. Lisa Gubernick, "I Was an Artist for The Village Voice," *The Village Voice*, 7–13 October 1981, 71.

20. Jane Barowitz, " 'Emerging Artists' Show Draws Anger but Few Crowds," *Artworkers News*, December 1981/January 1982, 9.

21. Ellen Baum, "The Whitney: Acquisitions Policies and Attitude Toward Living Artists," *Artworkers News*, December 1980, 13.

22. Ibid.

23. From the press release of an exhibition entitled "A, E, Eye, O, U, and Sometimes Why," organized by the Organization of Independent Artists, curated by Deborah Gardner and Karen Loftus, May 15–June 20, 1980.

24. An exhibition held at Ronald Feldman Fine Arts, New York City, March 1981.

25. From the press release of an exhibition entitled "Top Secret: Inquiries into the Biomirror," issued by Ronald Feldman Fine Arts, New York City, March 1981.

26. Prepared by the Task Force on Discrimination in Art, a CETA Title VI project, sponsored by the Foundation for the Community of Artists in conjunction with Women in the Arts, 1979.

27. Nancy Jervis and Maureen Shild, "Survey of NYC Galleries Finds Discrimination," *Artworkers News*, April 1979, A7.

28. Ibid.

29. Ibid., A7–A8.

30. Ibid., A8.

31. "Richard Lerner," interview by Jean E. Breitbart, *Artworkers News*, March 1981, 29.

32. "Lucy Lippard," interview by David Troy, *Artworkers News*, April 1980, 16.

33. Contribution by Jane Madson, *The Artist's & Critics Forum* 1, 1 (1982).

34. Billy Curmano, "Rejecting Rejection," *Artworkers News*, January 1981, 34.

35. Ibid.

36. Ibid.

37. Steve Penny, *How to Get Grants in Films* (Santa Barbara, California: Film Grants Research, 1978), 1–2.

38. Jane C. Hartwig, "Betting on Foundations," *Foundation Grants to Individuals*, ed. C. M. Kurzig, J.B. Steinhoff, and A. Bonavoglia. (New York: The Foundation Center, 1979), xiii.

39. Funding guidelines of the John F. and Anna Lee-Stacey Scholarship Fund.

40. Hartwig, ibid.

INDEX